IMPRESSIONIST PARIS

For Jean-Paul,
my wonderful + artistic
French father.
with love,
Lucy
Father's Day 2010

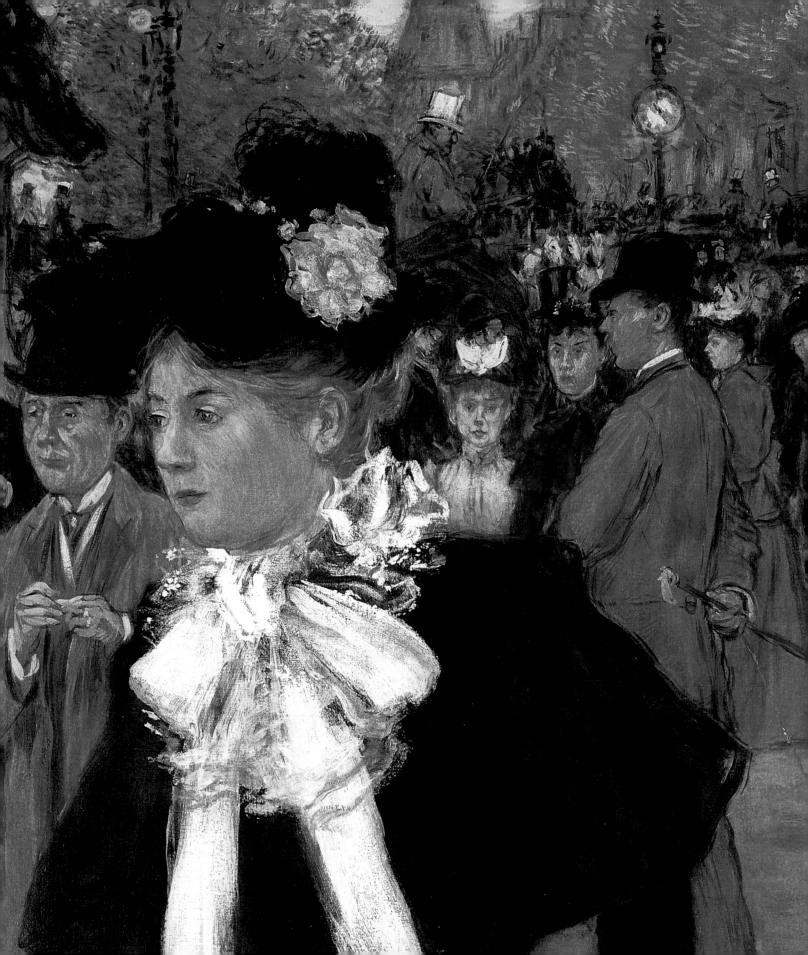

Impressionist Paris

CITY *of* LIGHT

James A. Ganz

FINE ARTS MUSEUMS
OF SAN FRANCISCO

DELMONICO BOOKS • PRESTEL
MUNICH BERLIN LONDON NEW YORK

Published in 2010 by the
Fine Arts Museums of San Francisco
and DelMonico Books, an imprint
of Prestel Publishing, on the
occasion of the exhibition
Impressionist Paris: City of Light.

LEGION OF HONOR
June 5–September 26, 2010

Impressionist Paris: City of Light
was produced through the
Publications Department of the
Fine Arts Museums of San Francisco:
Ann Heath Karlstrom, *Director of Publications*
Karen A. Levine, *Editor in Chief*

Fine Arts Museums of San Francisco
Golden Gate Park
50 Hagiwara Tea Garden Drive
San Francisco, CA 94118-4502

Prestel, a member of Verlagsgruppe
Random House GmbH

Prestel Verlag
Königinstrasse 9
80539 Munich
Germany
Tel: 49 89 24 29 08 300
Fax: 49 89 24 29 08 335
www.prestel.de

Prestel Publishing Ltd.
4 Bloomsbury Place
London WC1A 2QA
United Kingdom
Tel: 44 20 7323 5004
Fax: 44 20 7636 8004

Prestel Publishing
900 Broadway, Suite 603
New York, NY 10003
Tel: 212 995 2720
Fax: 212 995 2733
E-mail: sales@prestel-usa.com
www.prestel.com

*Produced by Wilsted & Taylor
Publishing Services*
Project management: Christine Taylor
Production assistance: LeRoy Wilsted
Copy editing: Melody Lacina
Design and composition: Yvonne Tsang
Proofreading: Nancy Evans
Indexing: Andrew Joron
Printer's devilment: Lillian Marie Wilsted
Printed in Hong Kong by Regal Printing Ltd.
through QuinnEssentials, Inc.

Impressionist Paris: City of Light

PRESENTING SPONSOR

BANK OF THE WEST

LEAD SPONSOR

BOUCHERON
PARIS

The catalogue is published with the assistance of the
Andrew W. Mellon Foundation Endowment for Publications.

Unless otherwise noted in captions, all artworks reproduced in this catalogue
are from the collection of the Fine Arts Museums of San Francisco.

Unless otherwise indicated below, all photography is by Joseph McDonald,
courtesy the Fine Arts Museums of San Francisco. Fig. 8: photo by Michael
Agee, © 2009 The Sterling and Francine Clark Art Institute, Williamstown,
Massachusetts, all rights reserved; figs. 10, 11: © 2003 The Sterling and Francine
Clark Art Institute, Williamstown, Massachusetts, all rights reserved; fig. 13:
photo by Ali Elai, courtesy the lender; figs. 21–23, 27–29, 69, 78, 83, 86, 87, 92,
93, 95, 101: © 2010 Artists Rights Society (ARS), New York / ADAGP, Paris;
fig. 24: photo courtesy Christie's; fig. 75: photo by Schopplein Studio, courtesy
the Fine Arts Museums of San Francisco.

LIBRARY OF CONGRESS CATALOGING-IN-PUBLICATION DATA
Ganz, James A.
 Impressionist Paris : city of light / James A. Ganz.
 p. cm.
 "Published in 2010 by the Fine Arts Museums of San Francisco on the
occasion of the exhibition *Impressionist Paris: City of Light*, curated by
James A. Ganz."
 Includes bibliographical references and index.
 ISBN 978-3-7913-5081-3 (hardcover)
 1. Art and society—France—Paris—History—19th century. 2. Paris
(France)—Civilization—19th century. I. Title.
 N72.S6G36 2010
 709.44′07479461—dc22 2010003988

FRONTISPIECE: Jean-François Raffaëlli, *Elégante sur le boulevard des Italiens, Paris
(Fashionable Young Woman on Boulevard des Italiens, Paris)*, ca. 1899, detail of fig. 24

CONTENTS

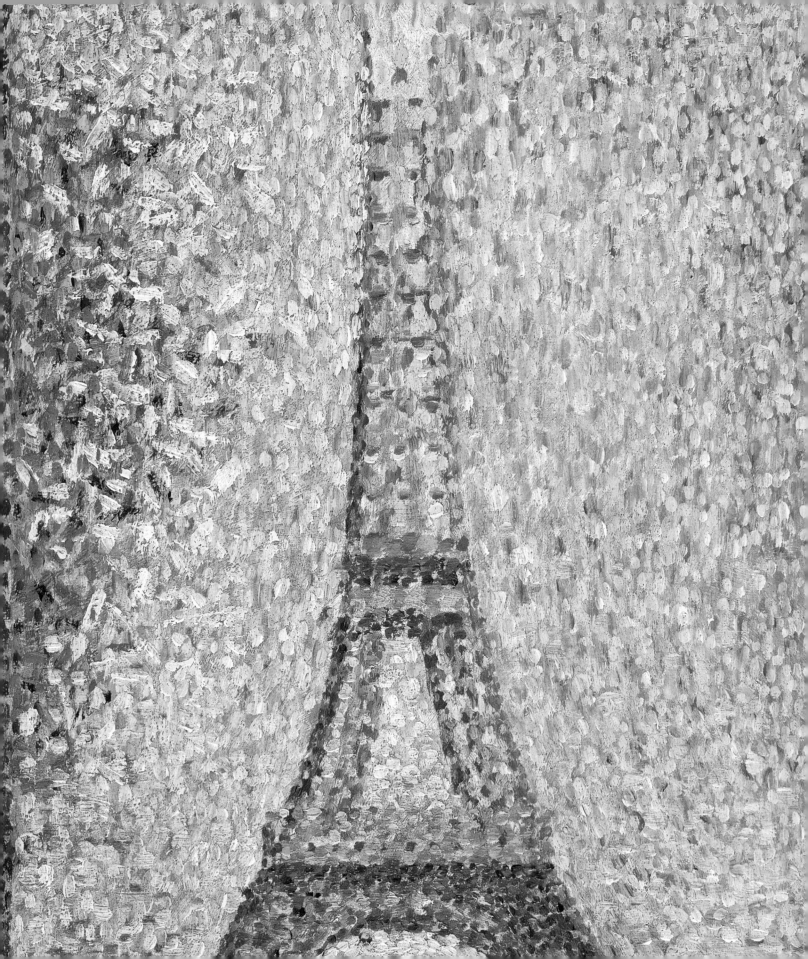

FOREWORD

I CANNOT IMAGINE A MORE FITTING AMERICAN museum than the California Palace of the Legion of Honor to present *Impressionist Paris: City of Light*. Opened to the public in 1924 in a metropolis often described as the "Paris of the West," the Legion of Honor emulates the venerable Palais de la Légion d'Honneur located on the left bank of the river Seine. Visitors to San Francisco's Legion of Honor enter through a grand courtyard, passing Auguste Rodin's *Thinker* as well as a small glass pyramid that evokes the main entrance to another Parisian landmark, the Musée du Louvre. It is beneath this pyramidal skylight that our own tribute to the City of Light, an ambitious exhibition of works on paper and paintings, brings to life the world of the Impressionists.

The occasion for *Impressionist Paris* is an extraordinary pair of consecutive exhibitions devoted to the Musée d'Orsay's masterpieces of Impressionist and Post-Impressionist painting that will appear at the Fine Arts Museums of San Francisco's other venue, the de Young Museum, from May 2010 through January 2011. Our curator of the Achenbach Foundation for Graphic Arts, Dr. James A. Ganz, has immersed himself in the Museums' rich

holdings of prints, drawings, and photographs—the largest collection of graphic arts in the western United States—to assemble this magnificent array of treasures. I applaud his exceptional efforts to broaden and deepen our understanding of the fertile environment that produced the Impressionist revolution through this visually engaging selection, which also includes paintings and other materials from both the Museums' holdings and private collections.

Our high aspirations for *Impressionist Paris* could not have been fulfilled without the support and participation of a number of friends of the Fine Arts Museums of San Francisco. First and foremost we must thank our presenting sponsor, Bank of the West, without whom this exhibition would not have been possible. Additional support has been provided by Boucheron. We are also grateful to the distinguished private collectors who have graciously allowed us to expand our exhibition with several key loans. Our deepest thanks go to Ronald E. Bornstein, Marie and George Hecksher, Mrs. Roger S. Meier, the Troob Family Foundation, Jack and Margrit Vanderryn, and Diane B. Wilsey for helping us tell this fascinating story.

We would like to express our appreciation to all of the staff of the Fine Arts Museums of San Francisco who have contributed their talents to this project. Special recognition must go to Colleen Terry, curatorial assistant in the Achenbach, for her extraordinary efforts in coordinating the catalogue and exhibition. Thanks also to Jorge Bachman, Victoria Binder, Karin Breuer, Krista Brugnara, Melissa Buron, Martin Chapman, Therese Chen, Julian Drake, Debra Evans, Christina Finlayson, Mark Garrett, Susan Grinols, Robert Haycock, Ann Karlstrom, Karen Levine, Stephen Lockwood, Joseph McDonald, Lynn Federle Orr, Elizabeth Scott, Linda Waterfield, Bill White, and the Marketing and Design team. And beyond the Museums we wish to extend our thanks to Esther Bell, Tim Brown, Jay Clarke, Sarah Hammond, Brian Isobe, Mattie Kelley, Richard Kendall, Melody Lacina, Sarah Lees, Mari Mazzucco, Anne de Mondenard, Gil Parsons, Jill Quasha, Martin Salazar, Christine Taylor, Yvonne Tsang, and LeRoy Wilsted.

John E. Buchanan, Jr.
Director of Museums
Fine Arts Museums
of San Francisco

IMPRESSIONIST PARIS

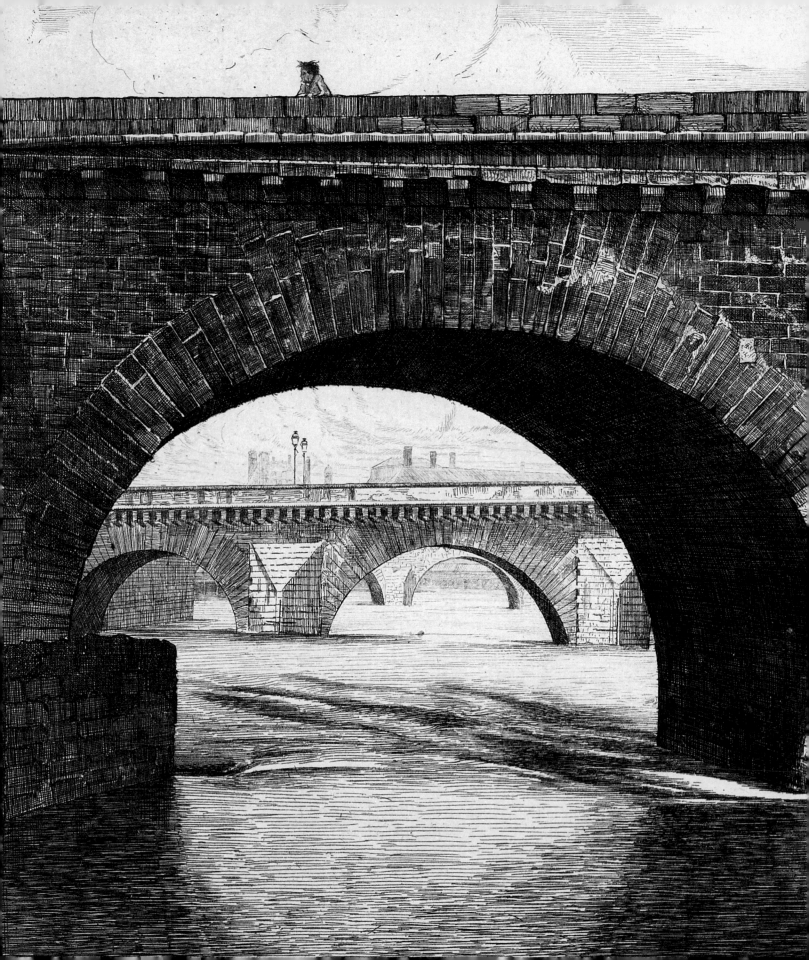

City of Light and Shadow

THE PARIS THAT GAVE BIRTH TO THE Impressionist generation was not yet the City of Light. In his often-quoted utopian volume *Paris n'existe pas* (1857), Paul-Ernest de Rattier described the true Paris as "by nature a dark, miry, malodorous city, confined within its narrow lanes . . . swarming with blind alleys, culs-de-sac, and mysterious passages, with labyrinths that lead you to the devil."[1] For all its quaint charms, *l'ancien Paris* was marked by social and physical barriers, segregation and congestion, and a disproportionate number of inhabitants living in poverty. The central neighborhoods suffered especially from such byproducts of overcrowding as runaway sewage, choking air pollution from coal-burning fireplaces, and regular traffic jams. Previously cherished for its pure blue water, the river Seine flowed green on its serpentine passage through the capital. Rattier went on to describe "a city where the pointed roofs of the somber houses join together up there near the clouds and thus begrudge you the bit of blue which the northern sky would give in alms to the great capital."[2]

If there is a central theme to the modernization of Paris in the

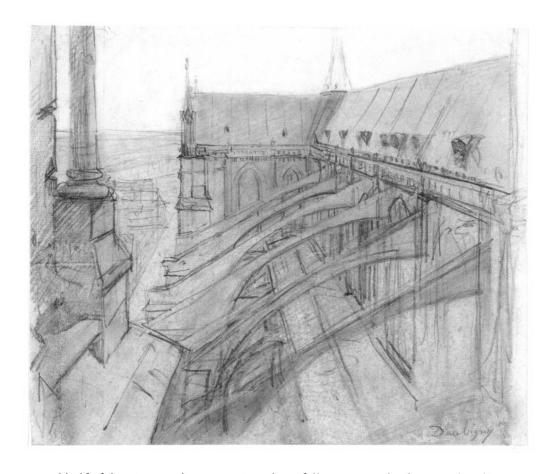

second half of the nineteenth century, it is that of illumination, both natural and artificial: "Light before all else," proclaimed the great urban planner Georges-Eugène Haussmann.[3] Gothic architects had gone to extremes to allow light to permeate their imposing stone cathedrals (fig. 1), while the neighborhoods surrounding them filled in like rabbit warrens. The replacement of these narrow medieval streets with wide boulevards brought sunlight into neighborhoods that had been enveloped in dark shadows and soot for generations, while the proliferation of gas lamps lit up the streets at night. Although plans for an electrified "sun tower" meant to illuminate the entire city failed to materialize,[4] Gustave Eiffel's monumental tower constructed for the Exposition Universelle of 1889 rose to become the ultimate symbol of the *ville lumière*.

For Parisian writers like Charles Baudelaire and the Goncourt brothers, born in the early decades of the nineteenth century, the fragility of old Paris in the face of modernization became a source of anxiety and nostalgia as they attained middle age. "No

human heart changes half so fast as a city's face," Baudelaire lamented in his poem "The Swan."[5] Their melancholic contemporary, the virtuoso etcher Charles Meryon, was among the most obsessive chroniclers of the medieval city. In his meticulously rendered views, Meryon lavished attention on the great Gothic monuments as well as the less celebrated elements of the city's archaic infrastructure (fig. 2). The Goncourts described Meryon as a "poor unhappy madman, [who] during the clear moments beyond his lunacy, takes endless walks to capture the picturesque strangeness of shadows in the great cities."[6] The artist's progressive psychosis is reflected in the macabre evolution of certain of his etching plates, such as his 1854 view of the Pont-au-Change in which he introduced, in a later state, a menacing flock of black birds (figs. 3, 4).

Following in Meryon's footsteps, the two most prolific specialists in representations of old Paris were the etcher Adolphe Martial Potémont and the photographer Charles Marville. Martial's magnum opus was his series of three hundred prints entitled *L'ancien Paris* (*Old Paris*) published in the mid-1860s. In these topographically accurate views Martial attempted to preserve the picturesque detail as well as the ambience of the narrow old passages and architectural relics. Within the plates' inscription fields, Martial usually credited his visual sources when he had to rely on earlier witnesses to previously demolished sites. In a number of plates he cited otherwise unspecified "originals" belonging to the city government. The original source for his view of the old Pont Notre-Dame as it appeared in 1850 (fig. 5) was a photograph by Henri Le Secq,

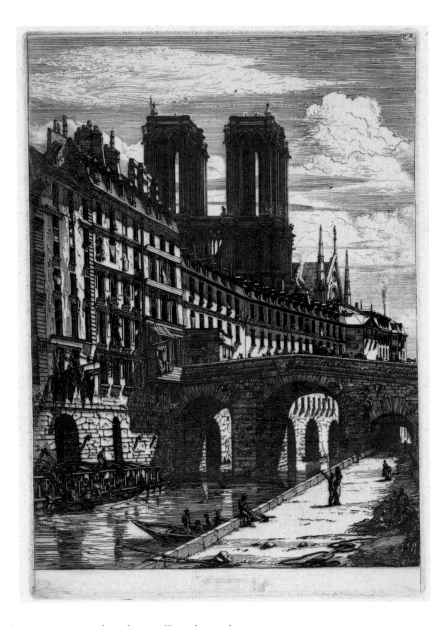

FIG. 2.
Charles Meryon, *Le Petit Pont*, 1850. Etching with engraving on blue paper, 26 × 18.9 cm (10¼ × 7⁷⁄₁₆ in.)

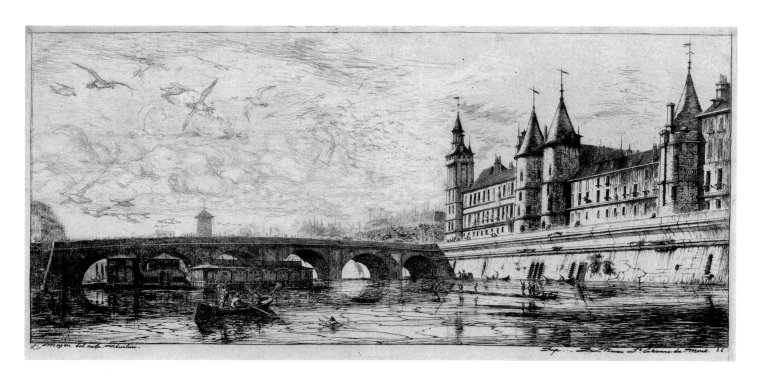

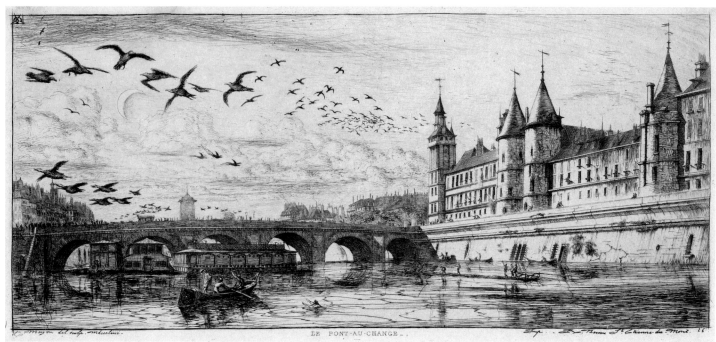

LE PONT-AU-CHANGE.

FIG. 3.
Charles Meryon, *Le Pont-au-Change*, 1854.
Etching with drypoint and graphite,
15.5 × 33.5 cm (6⅛ × 13³⁄₁₆ in.)

FIG. 4.
Charles Meryon, *Le Pont-au-Change*, 1854.
Etching with drypoint on China paper,
15.5 × 33.5 cm (6⅛ × 13³⁄₁₆ in.)

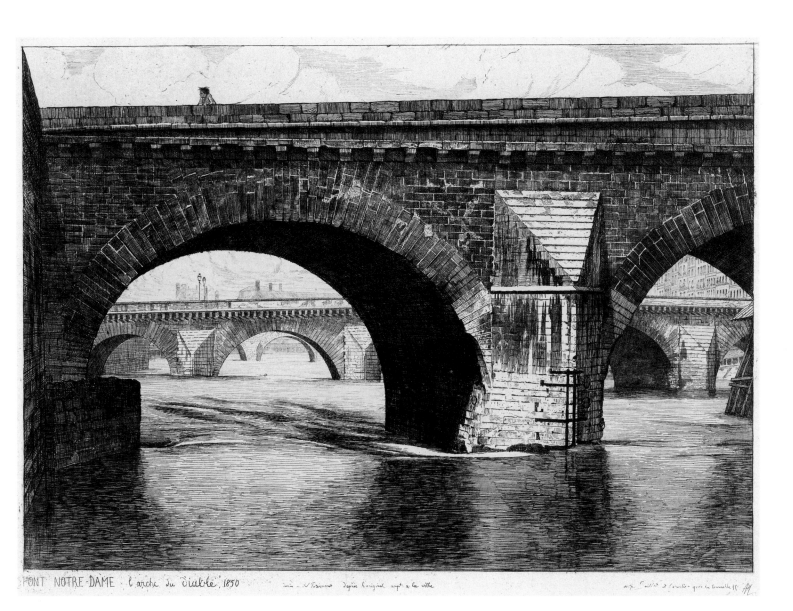

PONT NOTRE-DAME *l'arche du diable, 1850*

FIG. 5.
Adolphe Martial Potémont after
Henri Le Secq, *Pont Notre-Dame,
l'arche du diable, 1850* (*Pont Notre-
Dame, the Devil's Arch, 1850*), from
the series *L'ancien Paris* (*Old Paris*),
ca. 1864. Etching, 21.5 × 29.3 cm
(8⁷⁄₁₆ × 11⁹⁄₁₆ in.)

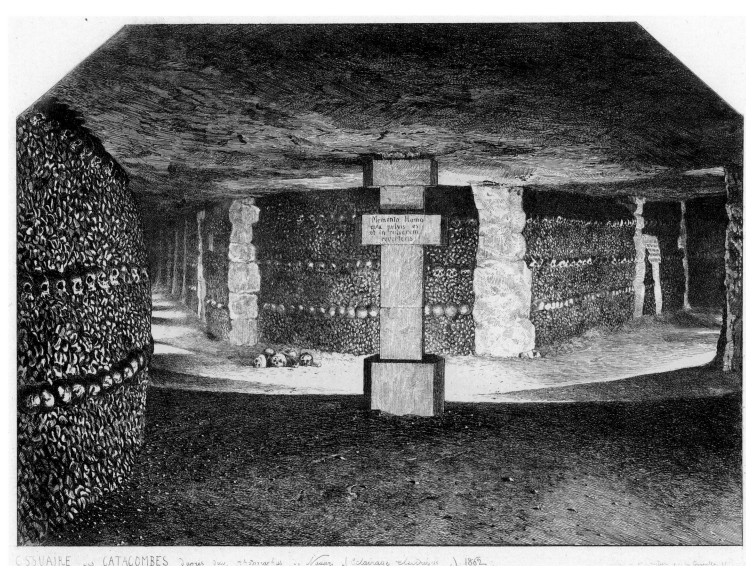

OSSUAIRE des CATACOMBES d'après une photographie de Nadar (Éclairage électrique,) 1862

FIG. 6.
Adolphe Martial Potémont
after Gaspard-Félix Tournachon
(Nadar), *Ossuaire des catacombes*
(*Ossuary in the Catacombs*), 1862,
from the series *L'ancien Paris*
(*Old Paris*), ca. 1864. Etching,
21.5 × 29.1 cm (8⁷⁄₁₆ × 11⁷⁄₁₆ in.)

one of the first generation of architectural photographers to receive official government commissions. Le Secq was hired to document the preliminary demolitions for the urban modernization projects of Jean-Jacques Berger, Baron Haussmann's predecessor as prefect of the Seine during the Second Republic.[7] Martial also referenced the innovative subterranean photographs by Nadar in his etchings of the Catacombs (fig. 6).

Could Martial have rubbed shoulders with Marville as the two men independently chronicled some of the same besieged neighborhoods? They could have met on rue Tirechape, a narrow street connecting rue Saint-Honoré and rue de Rivoli, which had already been described by Eugène Sue back in 1831 as "retired" and "gloomy" (fig. 7).[8] Marville photographed the street around the same time that Martial drew and etched it. Unlike Martial and Meryon, who both preserved an essentially romantic vision of old Paris, Marville pursued a fundamentally progressive agenda. In his role as official photographer of the city of Paris under Napoléon III, he was charged with documenting the widening of the meandering medieval streets and the construction of the new axial boulevards. His obstructed view of the Panthéon at the end of dark and grimy rue des Sept-Voies was meant to demonstrate the necessity of broadening such uninviting passages (fig. 8).[9]

The great urban renewal projects of the Second Empire were documented by etchers and photographers alike. Maxime Lalanne recorded the demolitions for extending boulevard Saint-Germain in one of the most chaotic cityscapes of the nineteenth century (fig. 9). Neither a nostalgic image of *l'ancien Paris* nor a celebration of the grand boulevards, Lalanne's etching captures

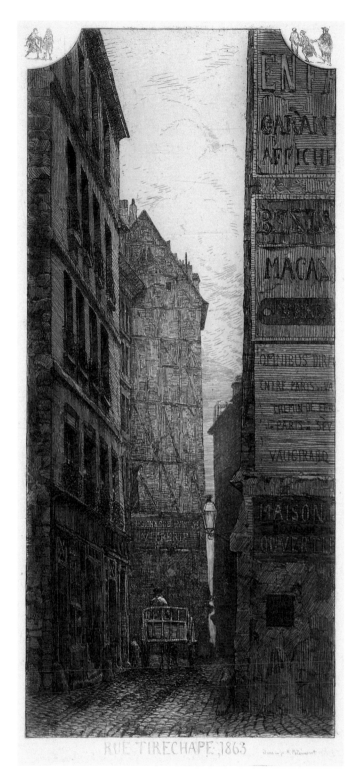

FIG. 7.
Adolphe Martial Potémont, *Rue Tirechape*, 1863, from the series *L'ancien Paris (Old Paris)*, ca. 1864. Etching, 21.5 × 9.8 cm (8⁷⁄₁₆ × 3⁷⁄₈ in.)

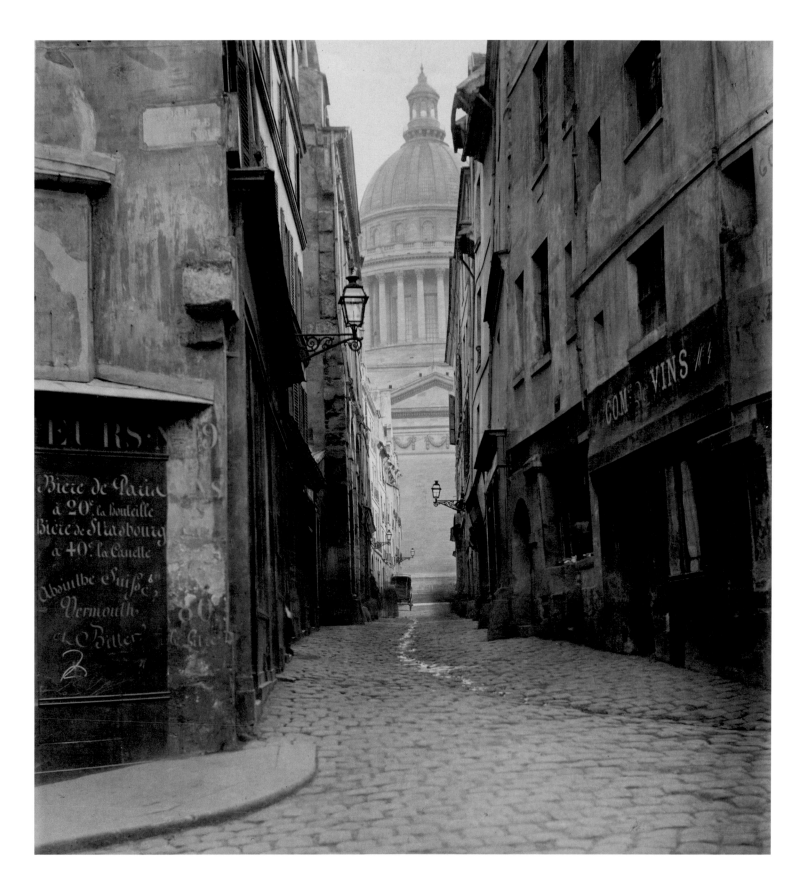

the harsh reality of life in a construction zone. Photographer Edouard Baldus turned his lens on a number of major building projects, the largest of which was the linking of the Louvre with the Tuileries Palace. Baldus's commission was all embracing, down to the recording of stone benches and decorative vases within the new gardens (fig. 10). In setting up his photographs of Victor Geoffroy-Dechaume's statues prior to their installation on the exterior of the Sainte-Chapelle, Auguste Mestral isolated the stone angels against a white drapery that provided, if inadvertently, an ethereal quality to his utilitarian images (figs. 11, 12). Such prosaic fragmentary views made in the name of architectural documentation can offer their own unique poetry.

NOTES

1. Paul-Ernest de Rattier, *Paris n'existe pas* (Paris, 1857), 12, 17–19, quoted in Walter Benjamin, *The Arcades Project*, trans. Howard Eiland and Kevin McLaughlin (Cambridge, Mass.: Belknap Press of Harvard University Press, 1999), 523.

2. Rattier quoted in Benjamin, *The Arcades Project*, 524.

3. Michel Carmona, *Haussmann: His Life and Times, and the Making of Modern Paris*, trans. Patrick Camiller (Chicago: Ivan R. Dee, 2002), 404.

4. Wolfgang Schivelbusch, *Disenchanted Night: The Industrialization of Light in the Nineteenth Century*, trans. Angela Davies (Berkeley: University of California Press, 1988), 128–134.

5. Charles Baudelaire, "The Swan," in *Les fleurs du mal*, trans. Richard Howard (Boston: David R. Godine, 1983), 90.

6. Quoted in James D. Burke, *Charles Meryon Prints and Drawings*, exh. cat. (New Haven: Yale University Art Gallery, 1974), 7.

7. The Le Secq photograph is illustrated in Eugenia Parry Janis and Josiane Sartre, *Henri Le Secq, photographe de 1850 à 1860* (Paris: Flammarion, 1986), 18. See also Anne de Mondenard, "La photographie, témoin visuel des transformations urbaines au XIXe siècle," in Isabelle Duquenne et al., *Le Blondel—un regard photographique sur Lille au XIXe siècle*, exh. cat. (Lille, France: Bibliothèque Municipale de Lille, 2005), 128–139.

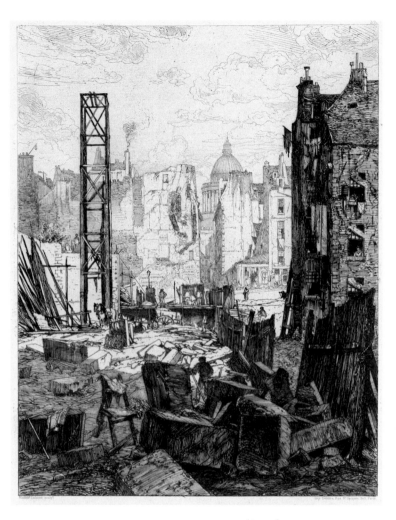

FIG. 8 (*facing*).
Charles Marville, *Rue des Sept-Voies de la rue Saint-Hilaire* (*Rue des Sept-Voies from rue Saint-Hilaire*), ca. 1865. Albumen silver print from wet-collodion-on-glass negative on lithographed mount, 28.7 × 26.7 cm (11⁵⁄₁₆ × 10½ in.). Collection of the Troob Family Foundation

FIG. 9 (*above*).
Maxime Lalanne, *Démolitions pour le percement du boulevard Saint-Germain* (*Demolition for Cutting through Boulevard Saint-Germain*), 1862. Etching, 31.8 × 23.9 cm (12½ × 9⁷⁄₁₆ in.)

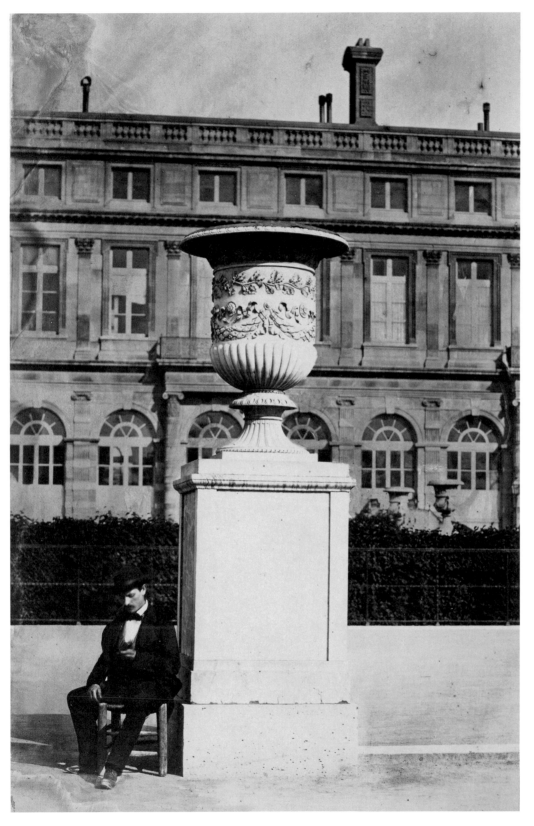

FIG. 10.
Edouard Baldus, *Decorative Vase with Seated Man in the Tuileries*, ca. 1856. Salt print from wet-collodion-on-glass negative, 22.5 × 15 cm (8⅞ × 5⅞ in.). Collection of the Troob Family Foundation

FIG. 11 *(left facing)*.
Auguste Mestral, *Statue of an Angel, Sainte-Chapelle*, 1852–1853. Salted paper print from wax paper negative, 34.7 × 20.9 cm (13¹¹⁄₁₆ × 8¼ in.). Collection of the Troob Family Foundation

FIG. 12 *(right facing)*.
Auguste Mestral, *Statue of an Angel, Sainte-Chapelle*, 1852–1853. Salted paper print from wax paper negative, 35.3 × 20.6 cm (13⅞ × 8⅛ in.)

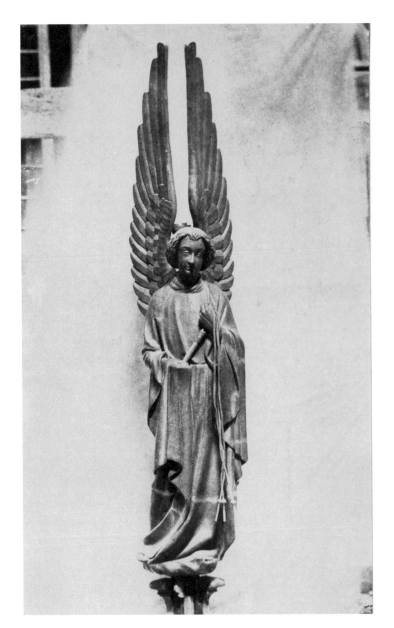 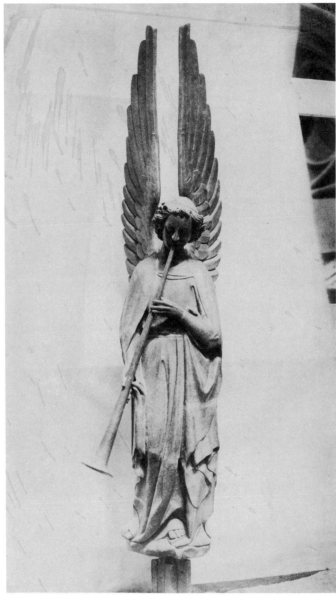

8. Eugène Sue, *Atar-Gull, a Nautical Tale*, trans. William Henry Herbert (New York: Henry L. Williams, 1846), 85. A print of Marville's view of rue Tirechape from rue Saint-Honoré is in the collection of the J. Paul Getty Museum, accession number 84.XM.346.13. Martial also etched a view of rue Tirechape from rue Saint-Honoré based on his own drawing, a print cited by Walter Benjamin in his *Arcades Project*; Benjamin, 522.

9. This portion of rue des Sept-Voies was renamed rue Valette in 1879.

Street Life

IMPRESSIONISM WAS AS MUCH AN ART OF THE streets as it was of the studios. Among the most evocative passages in Emile Zola's novel *L'oeuvre* (*The Masterpiece*, 1886) are those in which the young protagonist Claude Lantier, a figure loosely fashioned on the recently deceased Edouard Manet, rambles around Paris for hours on end. In one memorable scene, Lantier and several artist friends pause in the middle of place de la Concorde. Zola's description of a river of humanity flowing through avenue des Champs-Elysées calls to mind the painterly surfaces of Impressionist cityscapes:

> The Avenue itself was filled with a double stream of traffic, rolling on like twin rivers, with eddies and waves of moving carriages tipped like foam with the sparkle of a lamp-glass or the glint of a polished panel down to the Place de la Concorde with its enormous pavements and roadways like big, broad lakes, crossed in every direction by the flash of wheels, peopled by black specks which were really human beings, and its two splashing fountains breathing coolness over all its feverish activity.[1]

Taking all of this in, Zola's band of young artists is almost overcome with emotion:

Claude was quivering with delight. "Ah! This Paris!" he cried. "It's ours! All ours for the taking!" Each one of them was thrilled almost beyond words as they looked on the scene with eyes that shone with desire. Did they not feel glory being wafted over the whole vast city from the top of that Avenue? Paris was here, and they meant it to be theirs.[2]

This strong personal connection with the city of Paris—an overwhelming sense of civic pride bordering on romantic fixation—inspired countless artists of the nineteenth century to take to the streets and embrace their urban environment as a recurring theme.

For instance, the ordinary stone facade of a typical Parisian building is the backdrop to a sumptuous painting by Jean-François Raffaëlli that evokes the experience of strolling the sidewalks on a winter day (fig. 13). An exhibitor with the Impressionists in 1880 and 1881, Raffaëlli was best known for his Realist subject matter, concentrating on rag pickers, absinthe drinkers, and other déclassé urban dwellers. In this painting, an elderly couple walking their dog braces against the chill as they pass beneath the partially legible plaque proclaiming *gaz à tous les étages* ("gas on all floors"). The small sign indicating the presence of interior gaslights, then the prevalent form of artificial illumination, provides a warning in the event of a gas leak or a blaze. It also imparts a subtle symbol of modernity.

On the streets of Paris, gas lighting had become a necessity by the 1870s. A foreign correspondent with the *New York Times* wrote from the French capital after the Prussian siege of 1870: "Paris hopes to have gas-light by the 1st of March, and without gas, civilization seems impossible. They managed somehow in the dark ages by lamp and candle light, but to one who walks about Paris now, and remembers what Paris was, all the ante-gaseous period is a mystery."[3]

Photographer Charles Marville made his living photographing the city streets. In his final government commission, he was assigned to record the various designs of the new gaslights as they sprang up in each *quartier*.[4] From the 1850s to the 1870s, thousands of such lamps were installed throughout Paris and its immediate environs, making the streets safer for nighttime strolling and encouraging businesses to extend their hours well past dusk. From the desolate outskirts of Sceaux (fig. 14) to the bustling place de l'Opéra (fig. 15), Marville transported his large-format camera to portray the forms of

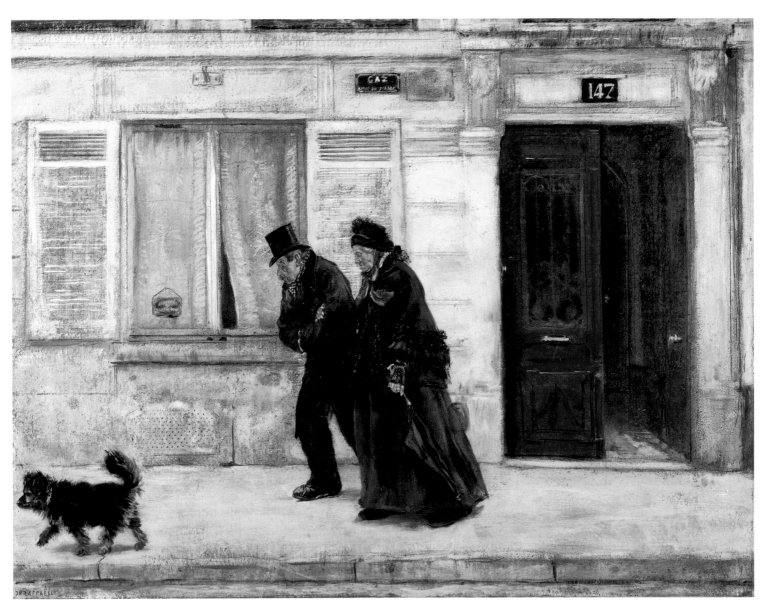

FIG. 13.
Jean-François Raffaëlli,
*Street Scene with Two Figures
and a Dog*, ca. 1890. Oil on canvas,
50.5 × 66.4 cm (19⅞ × 26⅛ in.).
Private collection

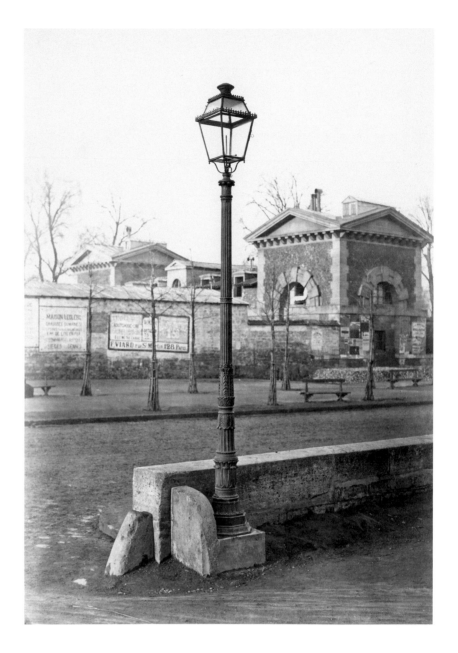

FIG. 14.
Charles Marville, *Street Lamp,
Courtyard of the Railway Station
at Sceaux*, 1870s. Albumen silver
print from wet-collodion-on-
glass negative, 36.5 × 26 cm
(14⁵⁄₁₆ × 9½ in.)

each type of lamp and its relationship to its surroundings. Exhibited to acclaim in the Exposition Universelle of 1878, Marville's street-lamp photographs have come to transcend their original documentary function to stand as icons of the City of Light.

Painter-printmaker Auguste Louis Lepère, one of the greatest masters of the delicate medium of wood engraving, paid homage to Parisian street life in his portfolio *Le long de la Seine et des boulevards (Along the Seine and the Boulevards)* of 1890. Lepère's view of place de l'Opéra (fig. 16) captures the lively atmosphere of one of the central arteries in

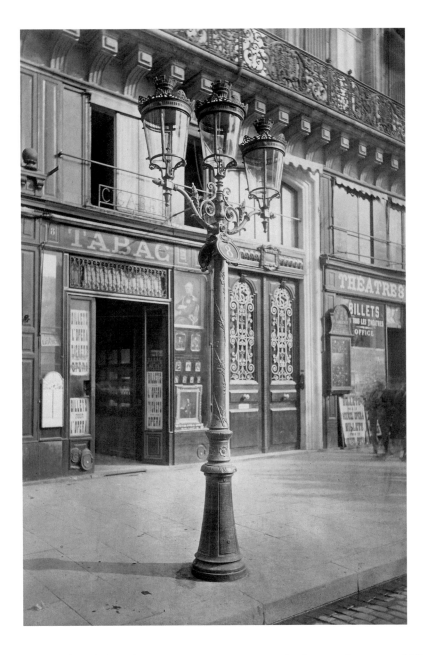

modern Paris. At decade's end, Lepère went on to provide the wood-engraved illustrations for Jean Richepin's collection of short stories *Paysages et coins de rue* (*Landscapes and Street Corners*, 1899). His preliminary watercolor study of crowds scurrying about rue de la Paix (fig. 17), another thoroughfare in the Opéra *quartier*, gives the flavor of a blustery Parisian day.

Félix Hilaire Buhot's most celebrated etching, *L'hiver à Paris, ou La neige à Paris* (*Parisian Winter, or Paris in the Snow*) (fig. 18), offers a dark vision of the hardships

FIG. 15.
Charles Marville, *Street Lamp, 8 Place de l'Opéra*, 1870s. Albumen silver print from wet-collodion-on-glass negative, 36.3 × 24.1 cm (14⁵⁄₁₆ × 9½ in.)

FIG. 16.
Auguste Louis Lepère, *Place de l'Opéra*, from the portfolio *Le long de la Seine et des boulevards (Along the Seine and the Boulevards)*, 1890. Wood engraving on gampi tissue, 11.8 × 20.1 cm (4⅝ × 7¹⁵⁄₁₆ in.)

FIG. 17.
Auguste Louis Lepère, *Brouillard (Fog)*, 1899. Transparent and opaque watercolor and black chalk over graphite, 22.3 × 27 cm (8¾ × 10⅝ in.)

FIG. 18.
Félix Hilaire Buhot, *L'hiver à Paris, ou La neige à Paris (Parisian Winter, or Paris in the Snow)*, 1879. Etching, drypoint, aquatint, and roulette, 23.8 × 34.7 cm (9⅜ × 13¹¹⁄₁₆ in.)

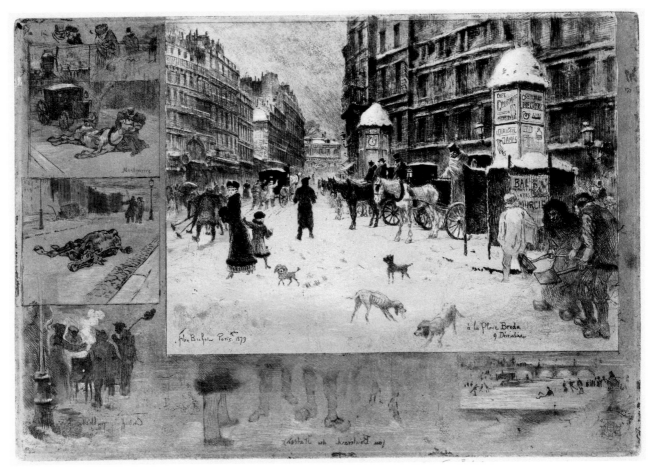

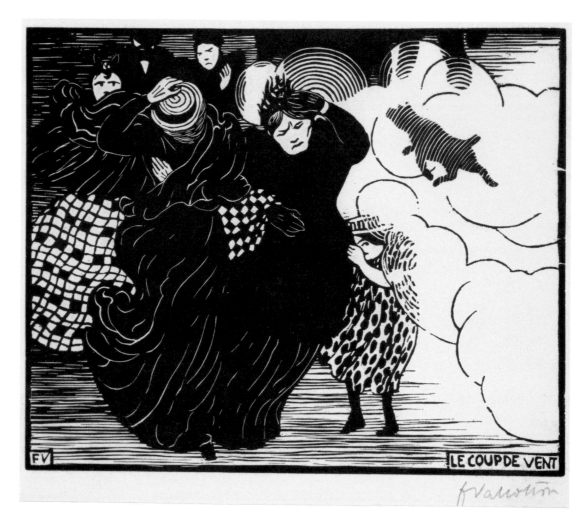

FIG. 19.
Félix Vallotton, *Le coup de vent*
(*The Gust of Wind*), 1894.
Woodcut, 17.8 × 22.3 cm
(7 × 8¾ in.). Collection of
Jack and Margrit Vanderryn

associated with the unusually severe winter of 1879–1880. The image is structured
in a distinctive format favored by Buhot in which he frames his primary subject,
a Montmartre *place* with starving dogs prowling the streets, with a series of smaller
vignettes of cab horses dying in the snow. Figures slip and slide on the frozen surface
of the Seine, an extraordinary circumstance that would later produce the dramatic ice
floes painted by Claude Monet at Vétheuil.

The Swiss-born artist Félix Vallotton delighted in representing the occasional incon-
veniences and miseries of life in the metropolis. His *Le coup de vent* (*The Gust of Wind*)
(fig. 19) adds a comic note to the foul-weather theme with the inclusion of a small dog
that has taken flight. In a more disturbing composition entitled *L'accident* (*The Accident*)
(fig. 20), a zincograph from the series *Paris Intense* (1894), a cab horse tramples an elderly

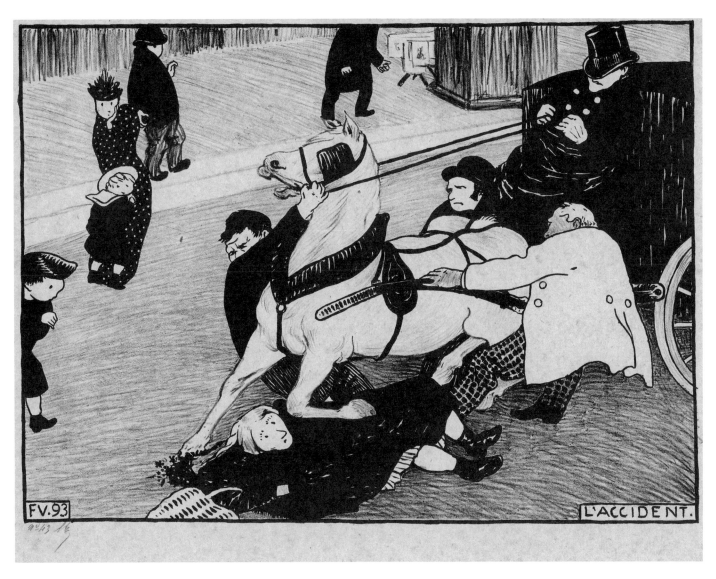

FIG. 20.
Félix Vallotton, *L'accident*
(*The Accident*), 1893, from
the series *Paris Intense*, 1894.
Zincograph on tan paper,
22.2 × 31.1 cm (8¾ × 12¼ in.)

woman crossing the street. Vallotton's reductive graphic language bespeaks his membership in a circle of progressive young artists of the 1890s, including Pierre Bonnard and Edouard Vuillard, who called themselves the Nabis, a term they co-opted from the Hebrew for "prophet." The Nabis shared a vision of the future of art as moving toward a more personal distillation of the real world, unshackled from the burden of literal reproduction.

Early in his career as a dealer, Ambroise Vollard commissioned print albums from several of the Nabi artists. Taken as a whole, the thirteen prints composing the portfolio *Quelques aspects de la vie de Paris* (*Some Scenes of Parisian Life*), published by Vollard in 1899, represent Pierre Bonnard's definitive statement in the medium of color lithography. Executed over the course of several years, with the technical support of Vollard's master printer, Auguste Clot, Bonnard's color lithographs offer a series of views of the neighborhoods he frequented during this extraordinary decade of creativity (figs. 21, 22). His close friend Vuillard's dazzling album *Paysages et intérieurs* (*Landscapes and Interiors*), also published by Vollard in 1899, similarly represents one of the high points in the "color

FIG. 21.
Pierre Bonnard, *Rue le soir sous la pluie* (*Street on a Rainy Evening*), 1896–1897, from the album *Quelques aspects de la vie de Paris* (*Some Scenes of Parisian Life*), 1899. Color lithograph with scraping, 25.6 × 35.1 cm (10⅛ × 13¹³⁄₁₆ in.)

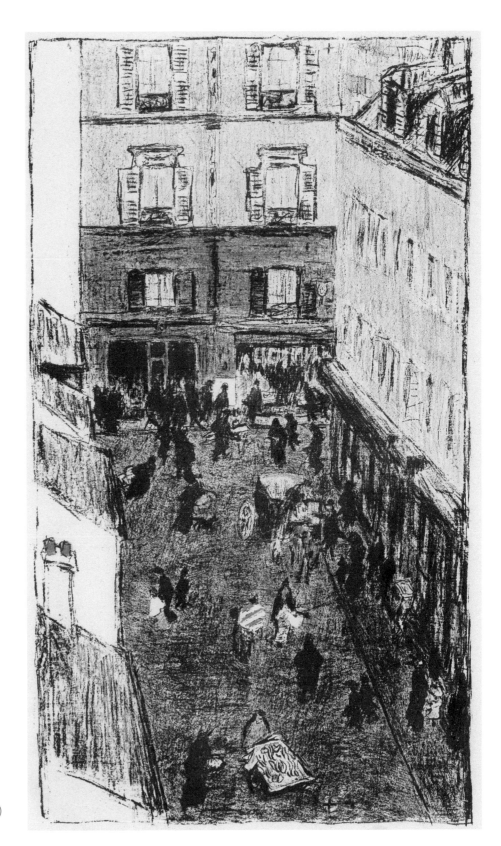

FIG. 22.
Pierre Bonnard, *Coin de rue vue d'en haut* (*Street Corner Seen from Above*), 1896–1897, from the album *Quelques aspects de la vie de Paris* (*Some Scenes of Parisian Life*), 1899. Color lithograph with scraping, 37 × 21 cm (14⁹⁄₁₆ × 8¼ in.)

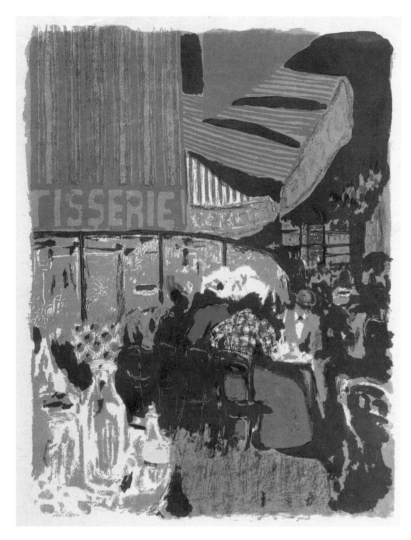

revolution" that characterized French printmaking of the fin de siècle (fig. 23).

Jean-François Raffaëlli's career as a painter and printmaker flourished well into the twentieth century, as did his love affair with the city of Paris. In his later work he moved away from the overtly gritty subject matter that he had favored as a young man. His large fin-de-siècle painting of an *élégante*, a chic young woman of the demi-monde strolling along boulevard des Italiens (fig. 24), epitomizes the stylishness of his later street scenes. The setting of this picture is one of the most fashionable of the grand boulevards, a broad thoroughfare teeming with pedestrians and a loaded omnibus, and lined with some of the best shops, restaurants, and hotels that the city had to offer. From the time that they left the artist's studio, such characteristically Parisian canvases were especially prized by foreign collectors. This painting made its debut in Pittsburgh at the Carnegie International exhibition of 1899 and was purchased out of the show by the Carnegie Art Gallery. Some indication of Raffaëlli's reputation as the foremost painter of the French capital is given by an item in the *New York Times* announcing his arrival by steamer to serve as a juror for the Carnegie International. The headline simply proclaims, "'Painter of Paris' here."[5]

NOTES

1. Emile Zola, *The Masterpiece*, trans. Thomas Walton (Ann Arbor: University of Michigan Press, 1968), 75.
2. Ibid.
3. "Foreign News by Mail: Pictures of Paris," *New York Times*, March 13, 1871.
4. See Marie de Thézy, *Charles Marville Réverbères* (Paris: Tête d'affiche, 1993).
5. *New York Times*, October 9, 1899.

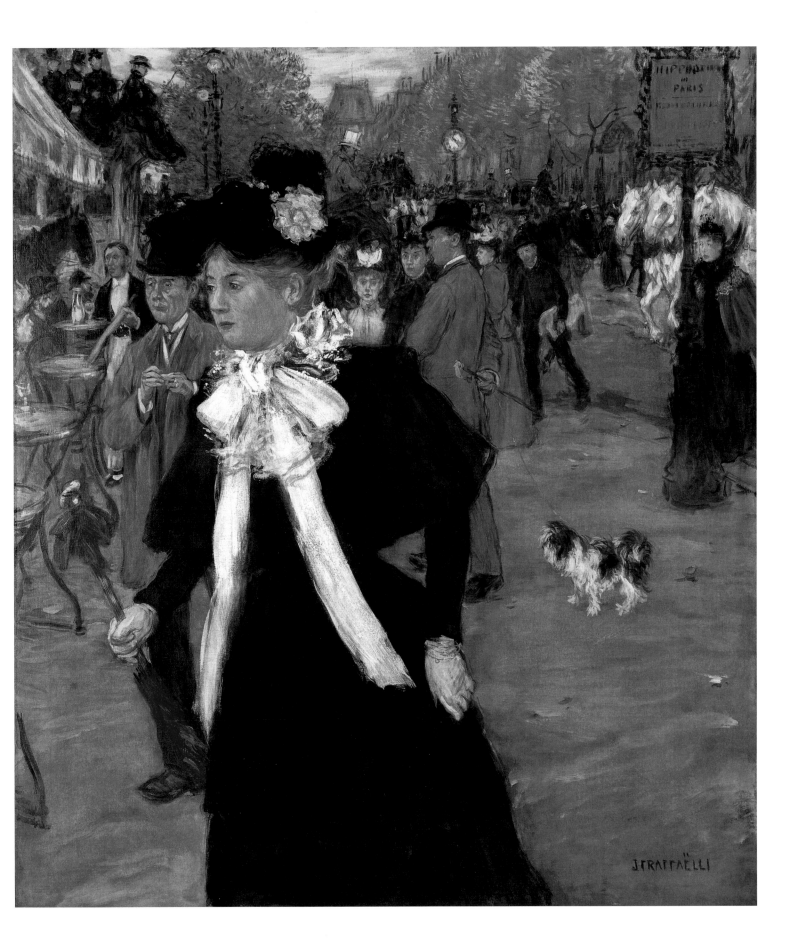

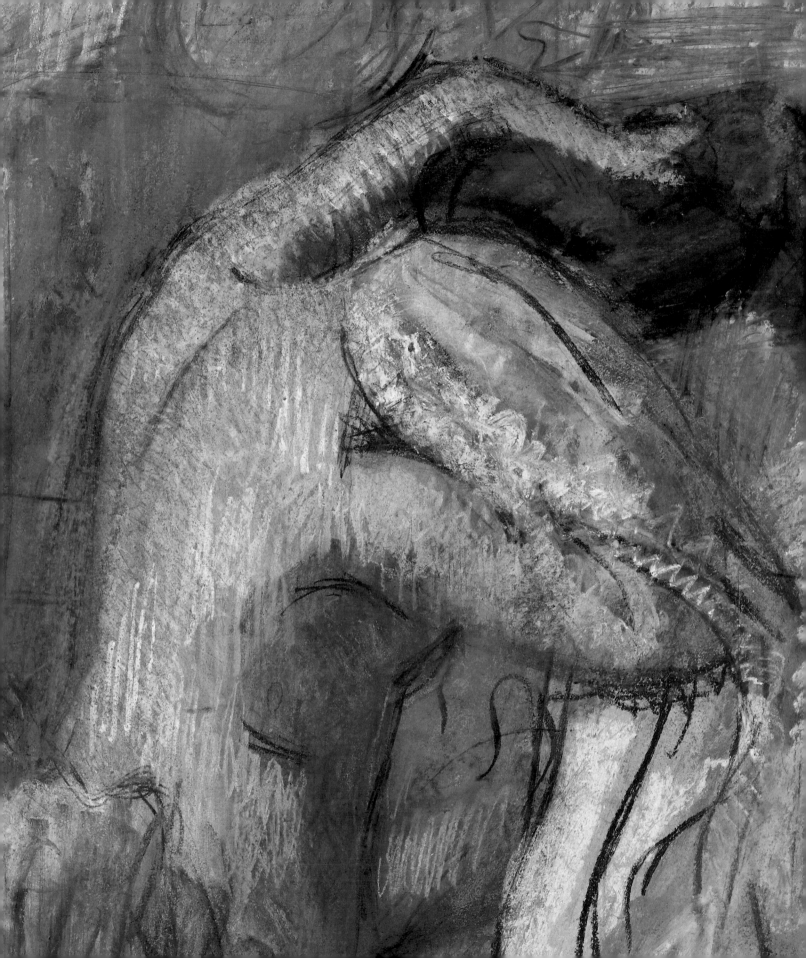

Privileged Views

A POWERFUL UNDERCURRENT OF VOYEURISM permeated French Realist literature of the mid-nineteenth century and was carried over into the works of visual artists of the Impressionist and Post-Impressionist eras. The private lives of contemporary Parisians chronicled by Balzac and Flaubert were similarly laid bare in the paintings and works on paper of artists like Edgar Degas and Edouard Vuillard. And just as writers based many of their fictional characters on close friends and colleagues, so too did artists reveal aspects of their personal lives in the pages of their portfolios and on the walls of their exhibitions. While the sitters might be anonymous, and the settings unspecified, the impression given is that of privileged entrée into a world literally behind closed doors.

Paul Signac's lithograph *Le dimanche* (*Sunday*, 1887–1888) (fig. 25) gives one such glimpse into a typical bourgeois interior. Seen from the back, the artist's future wife, Berthe Roblès, gazes on the city beyond her window. Signac elaborated on the composition in an oil painting, *Un dimanche* (*Sunday*, 1888–1890), by adding an emotionally detached male companion tending a fireplace.[1]

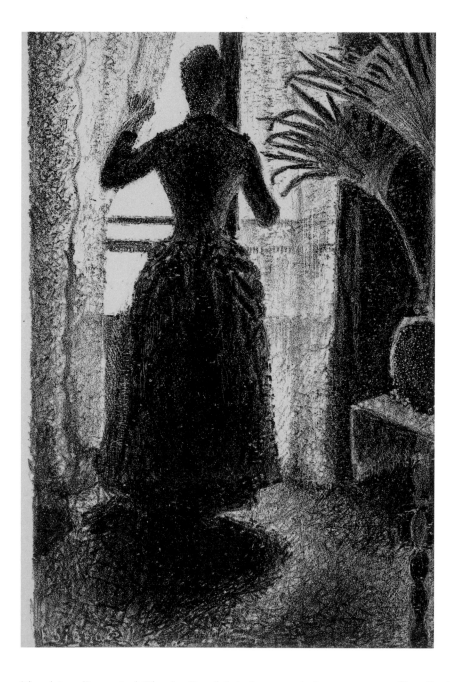

FIG. 25.
Paul Signac, *Le dimanche* (*Sunday*),
1887–1888, published in *La Revue
Indépendante*, January 1888.
Crayon lithograph, 17.3 × 12 cm
(6¹³⁄₁₆ × 4¾ in.)

Scenes like this call to mind Charles Baudelaire's voyeuristic prose poem "Les fenêtres" ("Windows"): "What one can see out in the sunlight is always less interesting than what goes on behind a windowpane," he observes. Baudelaire's mood darkens as he contrives a narrative from his stolen glances: "Across the ocean of roofs I can see a middle-aged woman, her face already lined, who is forever bending over something and who never goes out. Out of her face, her dress, and her gestures, out of practically nothing at all,

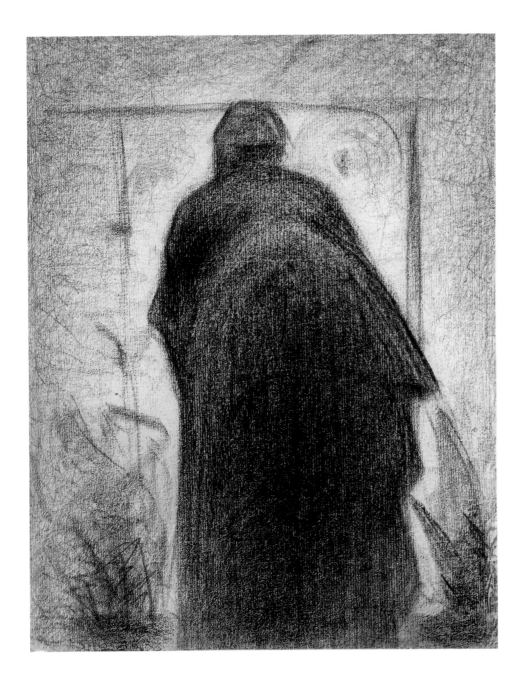

I have made up this woman's story, or rather legend, and sometimes I tell it to myself and weep."[2] Baudelaire's words echo, too, within the dense layers of conté crayon comprising Georges Seurat's candid study of a solitary woman, bending while engaged in some unseen labor (fig. 26). That Signac's and Seurat's figures turn away from us contributes to a feeling of isolation and helps elevate them from portraits of individuals to more generic Parisian types, emblems of the age.

FIG. 26.
Georges Seurat, *Woman Bending, Viewed from Behind*, ca. 1881–1882. Conté crayon, 31.1 × 24.2 cm (12¼ × 9½ in.)

If Signac's and Seurat's works are merely suggestive of psychological alienation in the modern city, then Pierre Bonnard's *Maison dans la cour* (*House in the Courtyard*) (fig. 27), from his album *Quelques aspects de la vie de Paris* (*Some Scenes of Parisian Life*, 1899), propels the urban-window theme to an almost existentialist extreme. The lithograph captures an essential, yet rarely depicted, aspect of Parisian life: an apartment dweller's private view across an internal courtyard. Honoré de Balzac succinctly described this typical arrangement: "In Paris, unless one lives in one's own townhouse, between a courtyard and a garden, all lives are coupled. On every floor of a house, one household faces another in the house opposite. Everyone plunges his gaze at will into his neighbor's household."[3] Indeed, Bonnard's open window reveals little more than an array of analogous windows in a minimalist composition edging toward abstraction. The absence of a vanishing point and the interlocking geometry of outlines and relatively flat areas of color strongly suggest the artist's debt to the aesthetic of Japanese *ukiyo-e* prints.

Vuillard's Parisian interiors are no less remarkable in their bold abstraction. *La cuisinière* (*The Cook*) (fig. 28) represents the artist's mother washing dishes in the kitchen of their shared apartment, her compact figure locked into a geometric framework. Even judged against the consistent brilliance of the other lithographs in his 1899 series of *Paysages et intérieurs* (*Landscapes and Interiors*), *The Cook* stands out as a singular tour de force that encapsulates Vuillard's approach to color, design, and *intimiste* subject matter. From the same album, *La partie de dames* (*The Game of Checkers*) (fig. 29) represents the dramatist Tristan Bernard and an unidentified figure hunched over a checkerboard in a warm-toned interior decorated with floral wallpaper. The setting is likely the apartment of Vuillard's patron Thadée Natanson on rue Saint-Florentin, and the scene is presided over by Natanson's wife, Misia, a leading light of the fin-de-siècle art world who happened to be the object of Vuillard's unrequited love.

For Degas, private rituals of the opposite sex were a source of fascination crossing over into fanaticism. He engaged professional models to pose in their most intimate and, at the same time, most mundane activities: dressing and undressing, grooming, bathing, and sleeping. His voluminous boudoir subjects span much of his career (see figs. 30, 31). In the eighth and final Impressionist exhibition of 1886, Degas showed a group of pastel nudes, "at once a terror and a delight to behold," in the estimation of one British critic.[4] Octave Mirbeau noted their "ferocity that speaks clearly of a disdain for women and a horror of love."[5] And in the most fickle of reviews, Jules Desclozeaux wrote of

FIG. 27 (*facing*).
Pierre Bonnard, *Maison dans la cour* (*House in the Courtyard*), 1895–1896, from the album *Quelques aspects de la vie de Paris* (*Some Scenes of Parisian Life*), 1899. Color lithograph, 34.7 × 26 cm (13¹¹⁄₁₆ × 10¼ in.)

FIG. 28 (*overleaf left*).
Edouard Vuillard, *La cuisinière* (*The Cook*), from the album *Paysages et intérieurs* (*Landscapes and Interiors*), 1899. Color lithograph on China paper, 35.6 × 27.3 cm (14 × 10¾ in.)

FIG. 29 (*overleaf right*).
Edouard Vuillard, *La partie de dames* (*The Game of Checkers*), from the album *Paysages et intérieurs* (*Landscapes and Interiors*), 1899. Color lithograph on China paper, 34 × 26.5 cm (13⅜ × 10⁷⁄₁₆ in.)

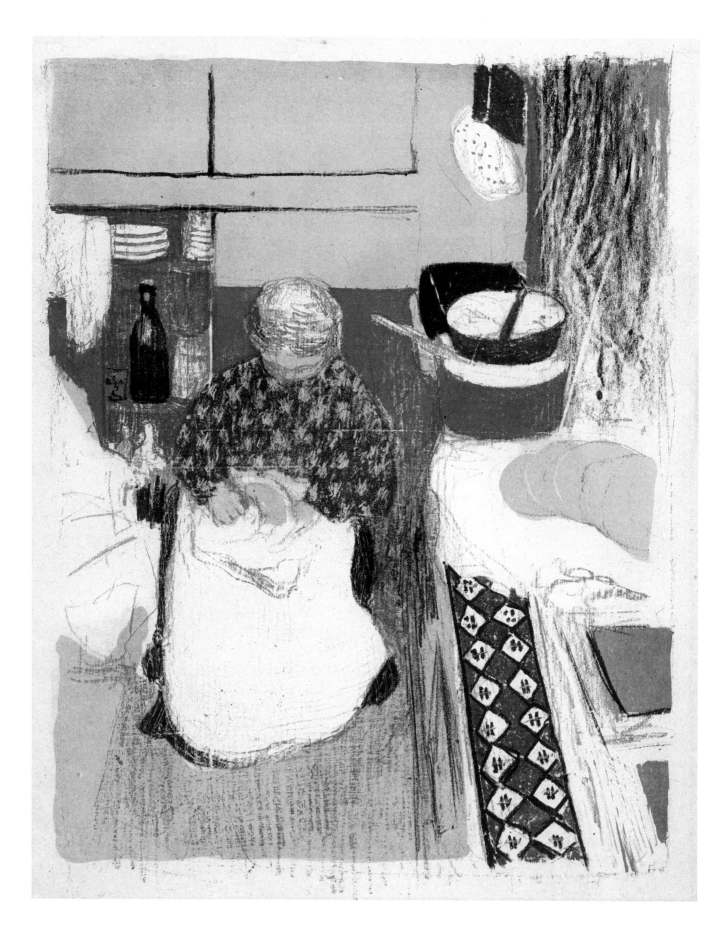

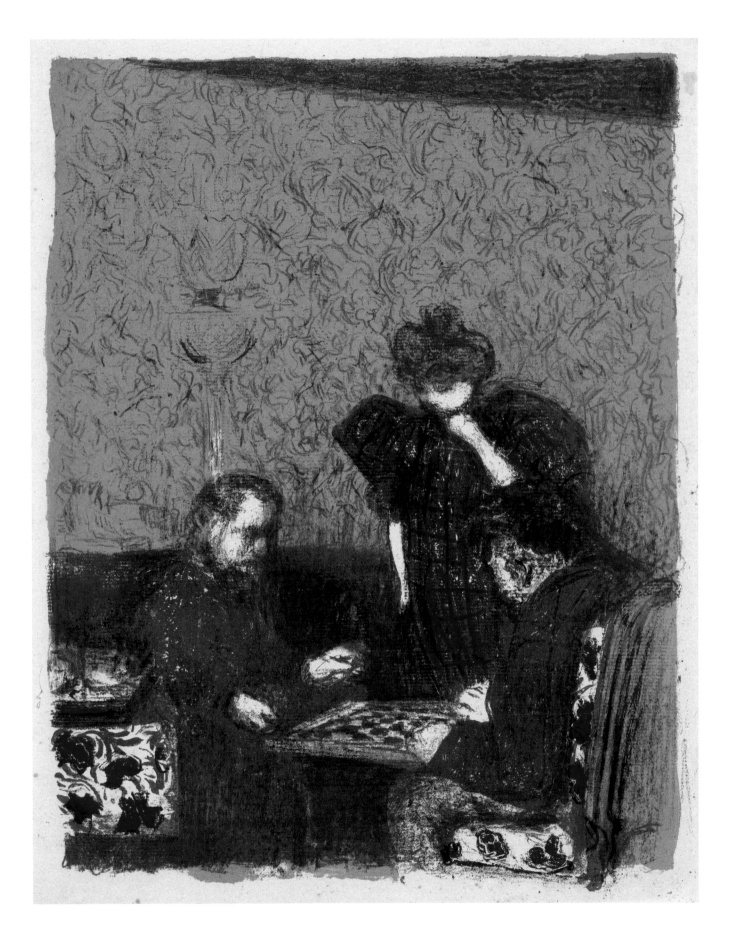

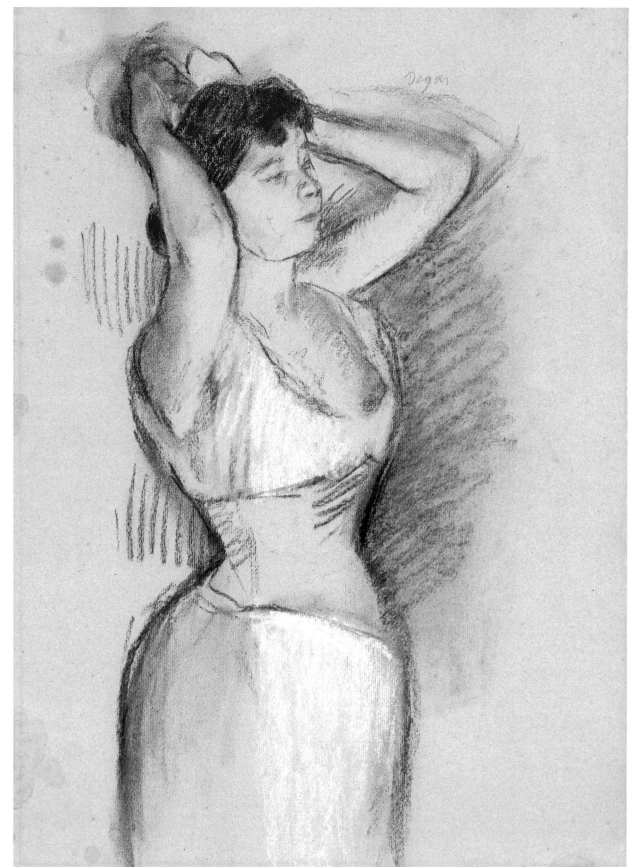

FIG. 30.
Edgar Degas,
La coiffure (Woman Dressing), ca. 1885.
Charcoal and pastel on gray paper, 58.5 × 43 cm
(23 1/16 × 16 15/16 in.)

FIG. 31 *(facing)*.
Edgar Degas, *Femme s'essuyant (Seated Bather Drying Her Neck)*, ca. 1905–1910. Charcoal and pastel on two joined sheets of tracing paper mounted on board, 68.7 × 58.1 cm
(27 1/16 × 22 7/8 in.)

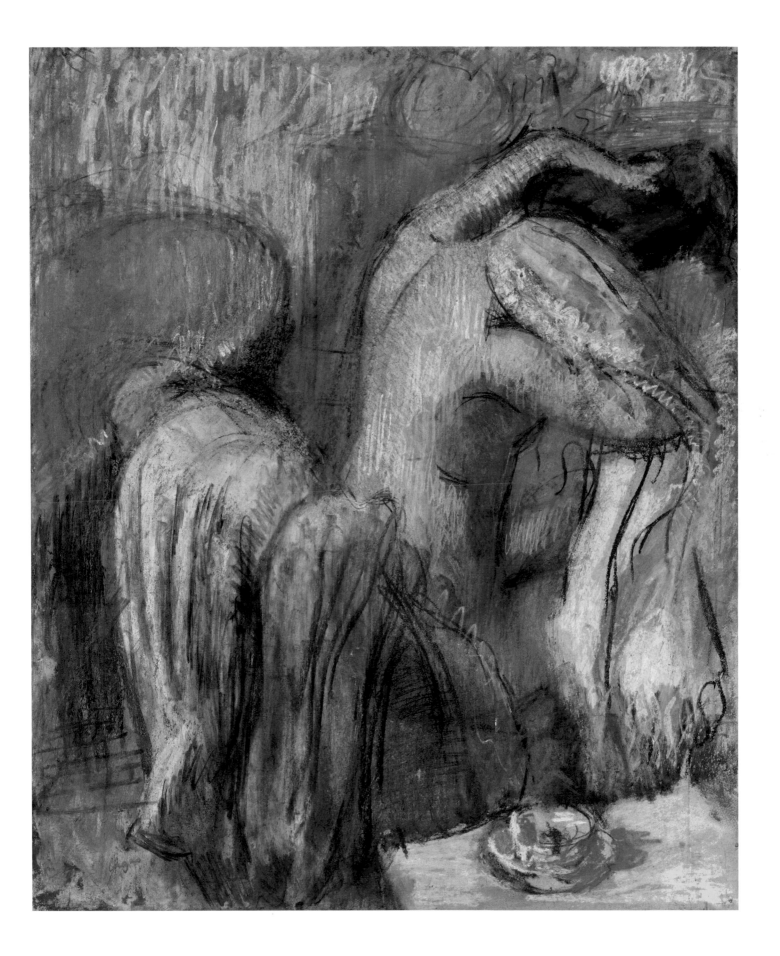

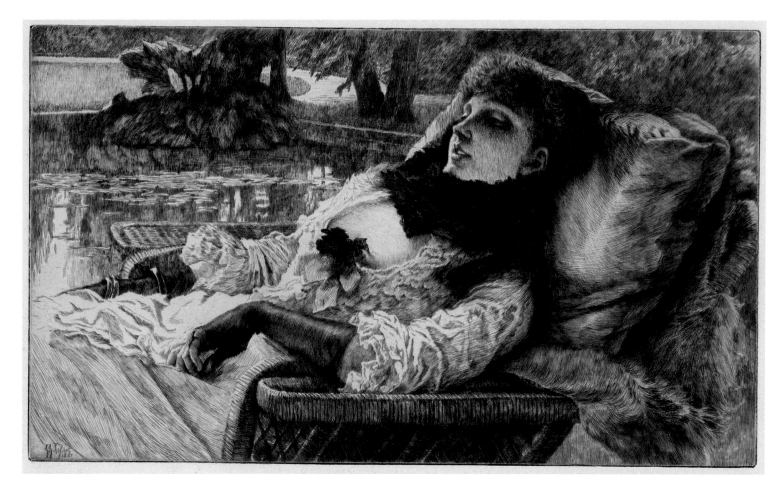

FIG. 32.
James Tissot, *Soirée d'été*
(*Summer Evening*), 1882.
Drypoint and etching,
23 × 39.7 cm (9¹/₁₆ × 15⅝ in.)

their "arrogant and repugnant truth" and "sad bestiality" while praising their "exorbitant intensity" of observation.[6]

Compared with Degas's increasingly expressionistic pastels and his emphasis on pose and gesture at the expense of personality, James Tissot's painted and etched representations of English and French women in their private moments offer greater delicacy, tranquility, and emotional intimacy. Exiled to London during the Commune, Tissot stayed for more than a decade, maintaining his contacts with the Parisian art world as he built his reputation and clientele in England. In *Soirée d'été* (*Summer Evening*) (fig. 32), his young lover Kathleen Newton rests in a wicker chaise, breathing the warm summer air as her life slowly drains from tuberculosis. The etching reproduces an oil of the same subject that Tissot exhibited in his one-man show at the Dudley Gallery in 1882, now in the collection of the Musée d'Orsay. Tissot was not alone in finding artistic inspiration within the depths of a broken heart: among his contemporaries, similar deathbed portraits by Monet (of his wife, Camille) and Whistler (of his wife, Beatrice) come to mind. Within a week of Newton's death in November 1882, Tissot fled London and relocated to Paris.

NOTES

1. Marina Ferretti-Bocquillon et al., *Signac, 1863–1935*, exh. cat. (New York: Metropolitan Museum of Art, 2001), 149–155.

2. Charles Baudelaire, "Windows," in *Paris Spleen*, trans. Louise Varèse (New York: New Directions, 1947), 77.

3. Honoré de Balzac, *Philosophie de la vie conjugale à Paris* (1846), quoted in Sharon Marcus, *Apartment Stories: City and Home in Nineteenth-Century Paris and London* (Berkeley: University of California Press, 1999), 57–58.

4. "Half-a-Dozen Enthusiasts," *The Bat*, May 25, 1886, 185–186, reprinted in *The New Painting: Impressionism 1874–1886; Documentation*, ed. Ruth Berson (San Francisco: Fine Arts Museums of San Francisco, 1996), vol. 1, 436.

5. Octave Mirbeau, "Exposition de peinture (1, rue Laffitte)," *La France*, May 21, 1886, 1–2, translated in Charles S. Moffett et al., *The New Painting: Impressionism 1874–1886*, exh. cat. (San Francisco: Fine Arts Museums of San Francisco, 1986), 453.

6. Jules Desclozeaux, "Chronique: Les impressionistes," *L'Opinion*, May 27, 1886, 2–3, translated in Moffett, *The New Painting*, 453.

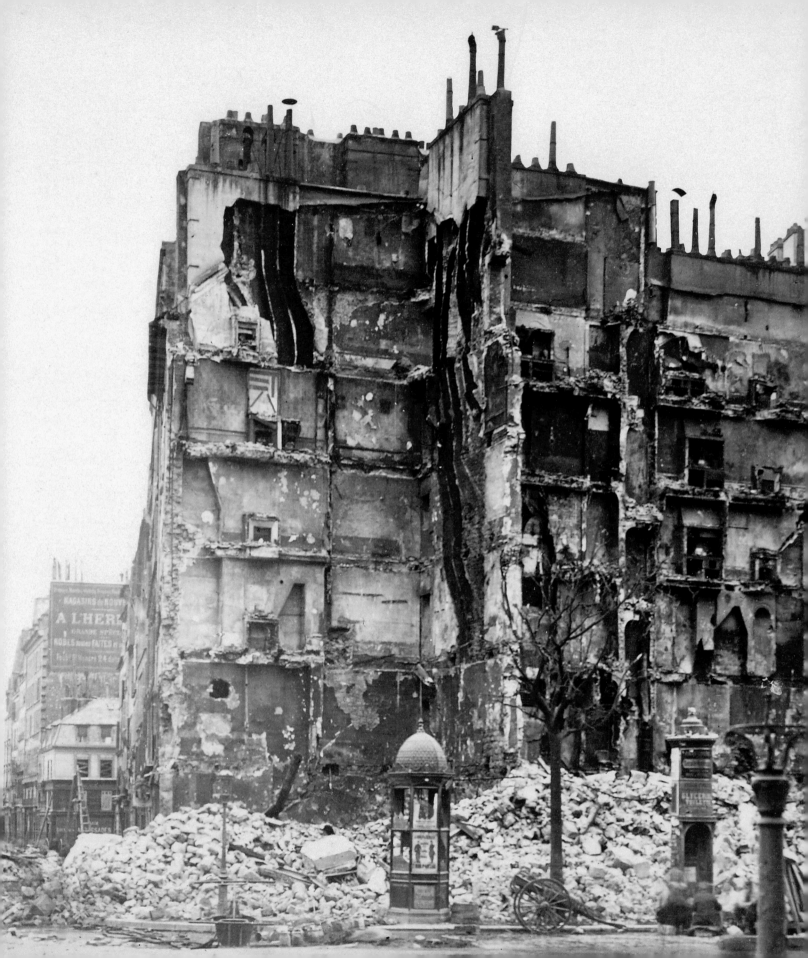

1871: A City of the Dead

EIGHTEEN SEVENTY-ONE WAS A DARK YEAR
for the City of Light. On January 15, Edouard Manet
wrote to his wife, Suzanne, who was safely ensconced
in the Pyrenees: "You've no idea how sad Paris is. There
are hardly any carriages now; all the horses are being eaten. We are
worried about keeping ours. I have a very pretty, very gentle one
that naturally costs me nothing. No more gas; black bread, and
bombarding all day and all night. The poor *quartier* Saint-Germain
is in a sad way."[1] Manet's words reverberate in the testimony of
another inhabitant, the reverend William Gibson, whose vivid let-
ters were published in a London newspaper: "In walking through
some of the streets of the city, usually full of bustle and business,
it seemed to be that I was walking through a city of the dead—no
carriages on the roadway, no foot-passengers on the causeways,
all silent and deserted, nothing to be heard but the echo of my
footstep."[2] In the aftermath of the Prussian assault on the French
capital during the winter of 1870–1871, the city spiraled into a
virtual dystopia of barricades, food shortages, and civil war. An
uprising of working-class Parisians, in concert with the city's

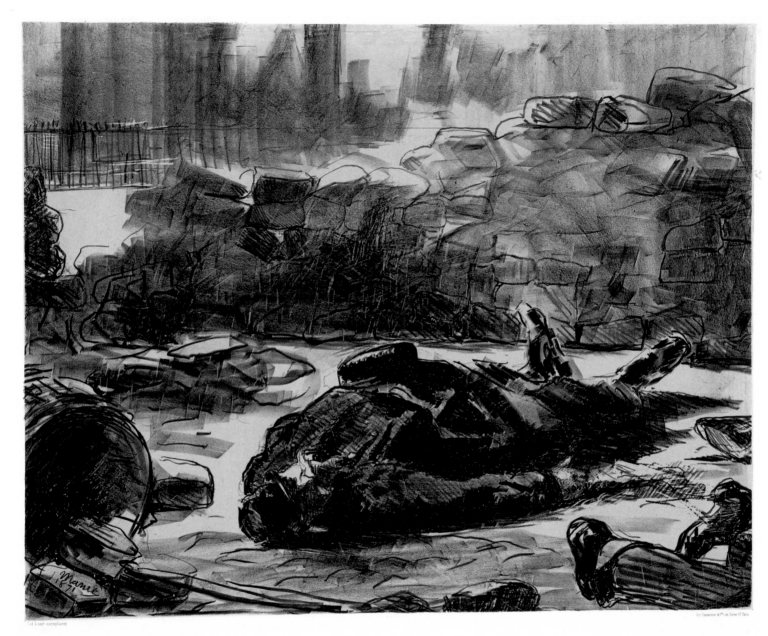

GUERRE CIVILE

FRONTISPIECE
François-Marie-Louis-Alexandre
Franck, *Rue Royale, Paris*, 1871,
detail of fig. 39

FIG. 33.
Edouard Manet, *Guerre civile
(Civil War)*, 1871–1874.
Crayon lithograph with scraping
on chine collé, 39.9 × 50.7 cm
(15$\frac{11}{16}$ × 19$\frac{15}{16}$ in.)

armed National Guard, led to the declaration of the Paris Commune, an independent regime that lasted a mere two months before it was crushed by French government forces at the end of May. This second siege rivaled the first in bloodshed and destruction, with the death toll continuing to rise as thousands of public executions followed the restoration of order.

Perhaps the most powerful icon of this disastrous period in French history is Manet's lithograph *Guerre civile* (*Civil War*) (fig. 33), an unblinking depiction of the corpse of a soldier lying near a ruined barricade. Manet had served in the National Guard fighting against the Prussians but left to join his family in the west of France after the city surrendered. He was back in Paris during the bloody defeat of the Communards in late May and, according to his friend and biographer, Théodore Duret, based this print on his eyewitness sketch of a specific scene at the intersection of rue de l'Arcade and boulevard Malesherbes.[3] The date of 1871 on the print most likely refers to the original drawing rather than to Manet's execution of the lithograph, which was not published until 1874. In both its medium and its message, Manet's *Civil War* recalls Honoré Daumier's infamous lithograph *Rue Transnonain, le 15 avril 1834* (1834), another blunt portrayal of the victim of an earlier government massacre.

The Franco-Prussian War and Commune would provide Daumier with the opportunity to demonstrate in the twilight of his career that he had lost neither his stomach nor his touch for hard-nosed political caricature. The ironically titled *L'empire c'est la paix* (*The Empire Means Peace*) (fig. 34), first published in *Le Charivari* on October 19, 1870, combines a scene of bodies lying in the ruined streets of Paris with Napoléon III's famous proclamation made almost twenty-eight years earlier to the day. *Epouvantée de*

L'EMPIRE C'EST LA PAIX.

FIG. 34.
Honoré Daumier, *L'empire c'est la paix* (*The Empire Means Peace*), 1870, from the series *Actualités* (*Current Events*), published in *L'album du siège*, ca. 1871. Gillotage, 23 × 18.5 cm (9¹⁄₁₆ × 7⁵⁄₁₆ in.)

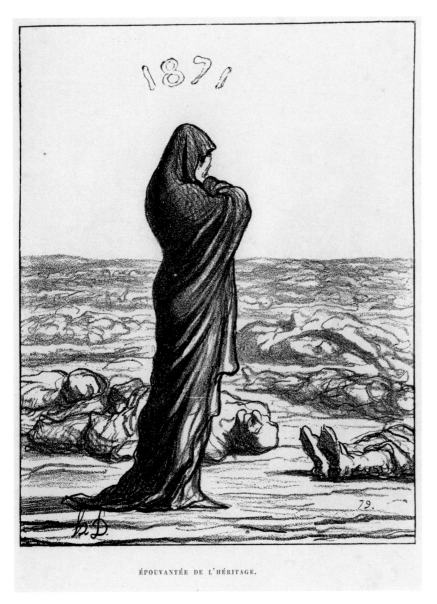

1871

ÉPOUVANTÉE DE L'HÉRITAGE.

FIG. 35.
Honoré Daumier, *Epouvantée de l'héritage* (*Appalled by the Legacy*), 1871, from the series *Actualités* (*Current Events*), published in *L'album du siège*, ca. 1871. Gillotage, 23 × 18 cm (9¹⁄₁₆ × 7¹⁄₁₆ in.)

l'héritage (*Appalled by the Legacy*) (fig. 35), which appeared in the same paper on January 11, 1871, ushered in the new year with the bereaved allegorical figure of France looking over an apocalyptic landscape, a literal city of the dead.

Manet's and Daumier's dark visions inspired by the events of 1870–1871 are countered by an even larger body of popular illustrations and caricatures that provided much-needed comic relief to battered Parisians. The Belgian-born artist Jules Renard, who reversed the letters of his surname to create his pseudonym, Draner, produced the amusing print series *Paris assiégé, scènes de la vie parisienne pendant le siège* (*Paris Besieged, Scenes of Parisian Life during the Siege*) for the journal *L'Eclipse*. Many of the prints center on chronic shortages of supplies, emphasizing, for instance, the increasingly perilous standing of household pets. A *Menu de siège* (fig. 36) features a variety of strange gastronomic delights, including monkey cutlets and donkey ears. During the war, temporary field hospitals were set up in hotels, restaurants, and other public buildings throughout the city. In Draner's view of a theater lobby converted into an infirmary (fig. 37), a wounded soldier flatters his pretty attendant by referring to a poster for the play *The Grand Duchess*, stating, "On my honor, Miss, you could never have fulfilled that role better than the one to which you have been entrusted." Similar imagery appears in the printed oeuvre of James Tissot, who fought in the National Guard and afterward fled to London. While there, he produced a richly detailed etching that recalls the extraordinary juxtaposition of wounded men and marble busts of literary heroes in the gallery of the Comédie-Française (fig. 38).

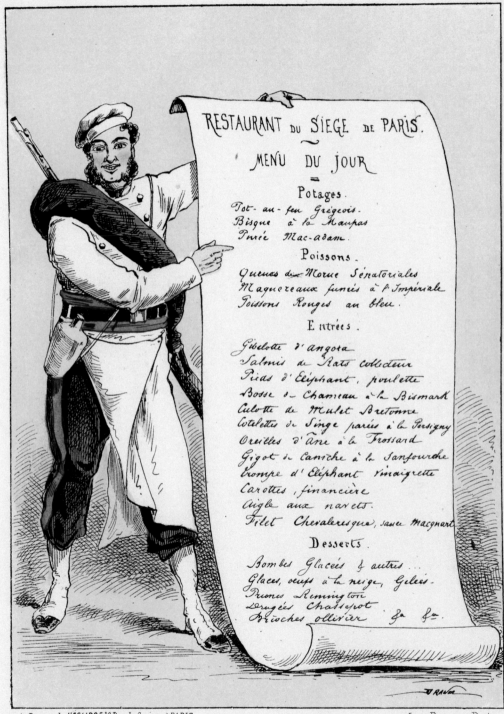

FIG. 36.
Draner (pseudonym of Jules Renard), *Menu de siège* (*Menu of the Siege*), from the series *Paris assiégé, scènes de la vie parisienne pendant le siège* (*Paris Besieged, Scenes of Parisian Life during the Siege*), ca. 1871. Pen lithograph with hand-coloring, 21.8 x 15.9 cm (8⁹⁄₁₆ x 6¼ in.)

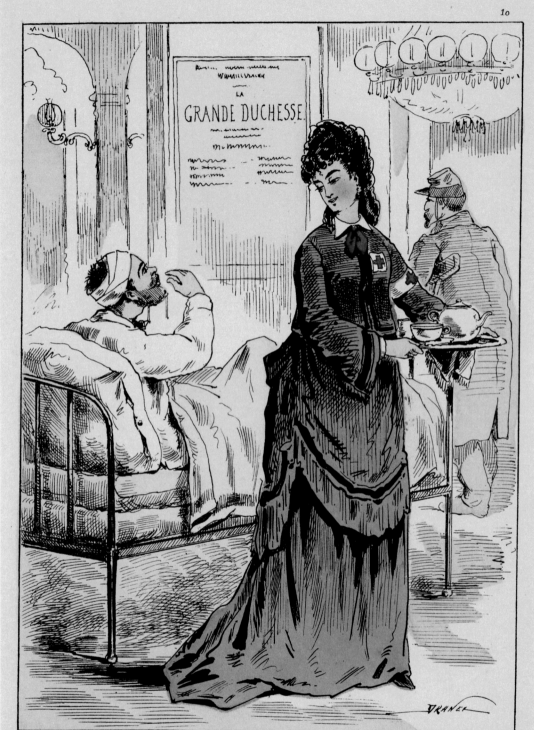

LA
GRANDE DUCHESSE.

Au Bureau de L'ECLIPSE,16,Rue du Croissant,PARIS

Imp. Barousse, Paris.

LES AMBULANCES DE THÉÂTRE.
_Sur mon honneur, Mademoiselle, jamais vous n'avez mieux rempli le rôle qui vous a été confié.

FIG. 37.
Draner (pseudonym of Jules Renard), *Les ambulances de théâtre* (*The Field Hospital Theaters*), from the series *Paris assiégé, scènes de la vie parisienne pendant le siège* (*Paris Besieged, Scenes of Parisian Life during the Siege*), ca. 1871. Pen lithograph with hand-coloring, 21.5 × 15.8 cm (8⁷⁄₁₆ × 6¼ in.)

FIG. 38 (*facing*).
James Tissot, *Le foyer de la Comédie-Française pendant le siège de Paris* (*The Green Room of the Comédie-Française during the Siege of Paris*), 1877. Etching, 38.1 × 27.6 cm (15 × 10⅞ in.)

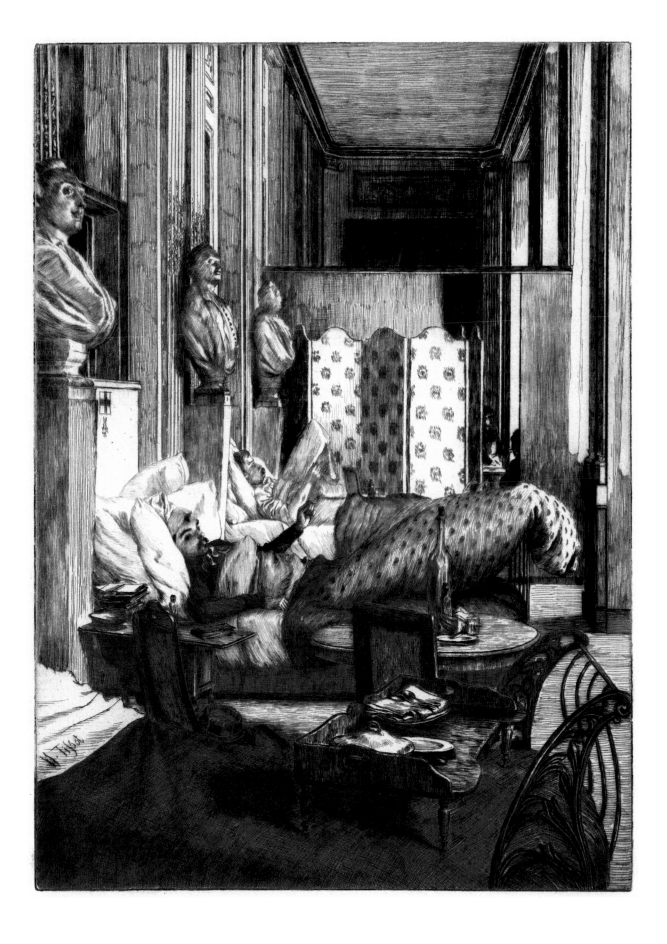

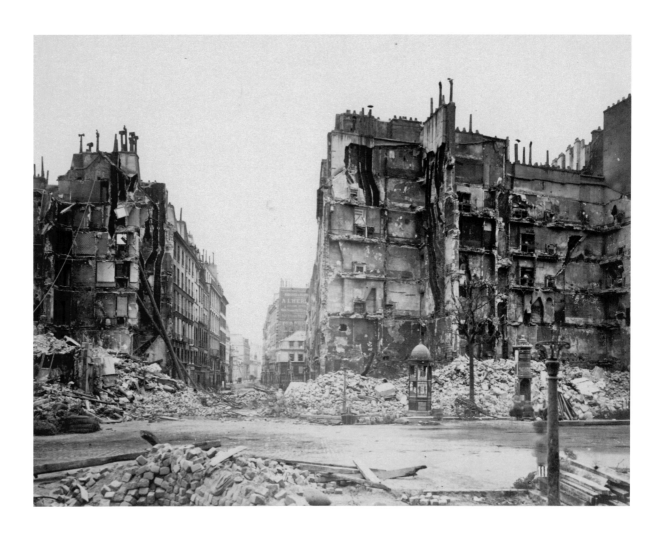

FIG. 39.
François-Marie-Louis-Alexandre
Franck, *Rue Royale, Paris*, 1871.
Albumen silver print from wet-
collodion-on-glass negative,
19 × 25 cm (7½ × 9¹³⁄₁₆ in.)

In the immediate aftermath of the war and the Commune, scores of professional photographers fanned out over the city, fulfilling the role of bearing witness to the devastation. In early June 1871, William Gibson recorded his own observations of the damage, noting, "Photographers were busy, so that those who cannot be eye-witnesses of the destruction will be able, by means of those faithful delineations, to form a good idea of the amount of mischief that has been done," adding, "No ruins in Paris are more complete than those of the Rue Royale"[4] (fig. 39). Photographers had to act fast, as the healing process began without delay. Signs of renewal are clearly visible in a view of a badly damaged building on rue de Rivoli (fig. 40) from a photographic series entitled *Insurrection de Paris, 1871* (*Paris Insurrection, 1871*). In Gibson's prophetic words, "Not-withstanding this fearful destruction, anyone who takes in his hand a map of Paris and compares what has been destroyed with what remains, will see but little of the city has been devastated. The finest monuments, the Madeleine, Notre Dame, the Sainte

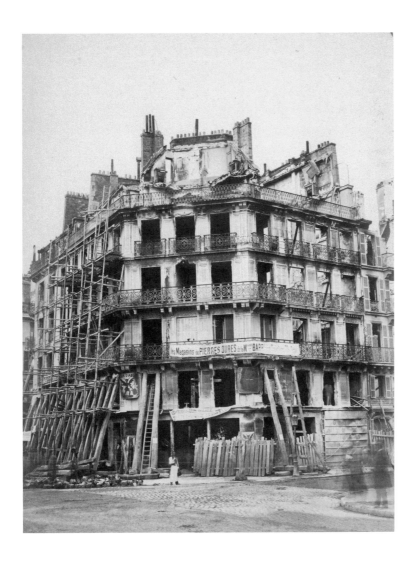

Chapelle, the Church of the Invalides, the Arc de Triomphe, &c., &c. still remain, and I venture to predict that, although I have no hope that this city will be rebuilt in a year, in twenty years from this time Paris will be more magnificent than ever."[5]

NOTES

1. Mina Curtiss, trans. and ed., "Letters of Edouard Manet to His Wife during the Siege of Paris: 1870–71," *Apollo* 13, no. 232 (June 1981): 388.

2. Letter dated May 10, 1871, originally published in the *Watchman and Wesleyan Advertiser*, 1871, republished in William Gibson, *Paris during the Commune, 1871: Being Letters from Paris and Its Neighbourhood, Written Chiefly during the Time of the Second Siege* (London: Whittaker and Co., 1872), 135–136.

3. Théodore Duret, *Histoire d'Edouard Manet et de son oeuvre* (Paris: H. Floury, 1902), 127.

4. Gibson, *Paris during the Commune*, 191, 194.

5. Ibid., 170.

FIG. 40.
J. Wulff, jeune, *Rue de Rivoli*, from the series *Insurrection de Paris, 1871 (Paris Insurrection, 1871)*, 1871. Albumen silver print from wet-collodion-on-glass negative, 21.2 × 16.3 cm (8⅜ × 6⁷⁄₁₆ in.)

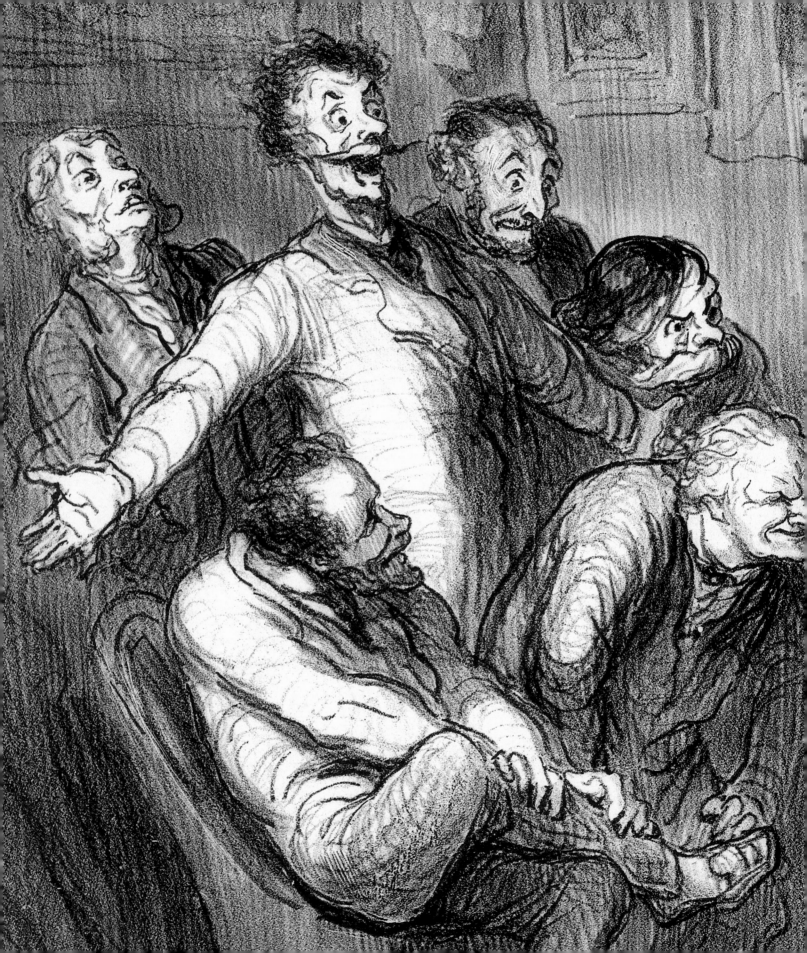

Power of the Press

I FIND THAT IF ONE ADDRESSES THE PUBLIC and is greeted with silence and indifference, then that is a failure. As for me, I pay almost no attention to the opinions of the journals but it is important to recognize that in our epoch, you can't do anything without the press."[1] So wrote an anxious Claude Monet to Paul Durand-Ruel in response to the dearth of critical commentary during the opening week of his 1883 exhibition at Durand-Ruel's gallery. The Impressionist era coincided with explosive growth in the field of illustrated art journalism, and artists like Monet and dealers like Durand-Ruel fully understood the power of the press within the modern art market. At the same time, the appraisal of contemporary art was hardly limited to the inner circles of artists, official juries, and professional critics; it was truly a spectator sport.

The enormous demand for reviews of exhibitions, especially those passing judgment in a spirited manner, was met by an abundance of competing periodicals. Published in the November 7, 1858, issue of *L'Artiste*, one of the most distinguished French journals devoted to art criticism, Félix Bracquemond's etching *Margot la*

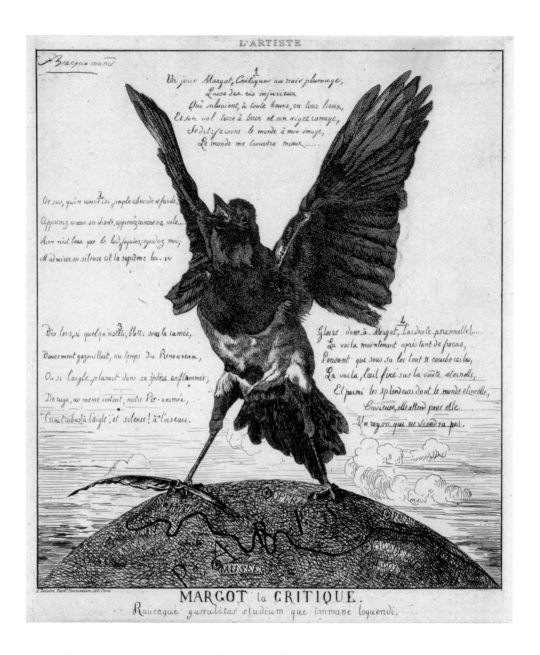

critique [*Une pie*] (*Margot the Critic* [*A Magpie*]) (fig. 41) is a compelling visual allegory of the power of the press. The print casts a screeching magpie in the role of conceited critic, a quill in its talon, perched astride a globe labeled with Parisian institutions, including *Opéra*, *Musée*, and *Académie*. In the accompanying text, Margot proclaims, "Let us remake the world in my image / and the world will be a better place" and "Nothing is as

beautiful as the ugly . . . the supreme law is to admire me in silence."[2] The weekly *Journal Amusant* employed a stable of leading caricaturists to provide systematic coverage of the latest exhibitions. In 1874, Louis Pierre Gabriel Morel-Retz, who published under the pseudonym Stop, contributed a multipart series based on the current Salon, taking on an array of now-forgotten artists as well as such recognizable figures as Edouard Manet and Mary Cassatt, whose works were accepted in that year (fig. 42).

FIG. 42.
Stop (pseudonym of Louis Pierre Gabriel Morel-Retz), *Le Salon de 1874*, published in *Le Journal Amusant*, 1874. Gillotage, 44.1 × 31.6 cm (17⅜ × 12⁷⁄₁₆ in.)

For half a century, from the 1820s through the 1870s, the French artist who enjoyed the most extensive and enduring presence in the Parisian press was undoubtedly the caricaturist Honoré Daumier. A painter, sculptor, and professional illustrator who contributed thousands of lithographs and wood engravings to a number of French newspapers, Daumier earned a reputation as an incisive observer of contemporary culture, politics, and daily life. No institution escaped his notice, and the art world in all of its colorful pretensions—from behind-the-scenes images of artists' studios to the rituals of gallery-goers and connoisseurs—provided a ready supply of source material. In his lithograph *A travers les ateliers* (*Around the Studios*) (fig. 43), originally published in the weekly illustrated journal *Le Boulevard*, Daumier places his own nose inches away from a canvas provoking astonished reactions from his fellow artists: "My word! Fantastic! Good heavens! Superb! It speaks!" While Daumier's own paintings incited precious little reaction from his contemporaries, lithographs such as this one were instantly treasured by his fellow artists and print collectors.

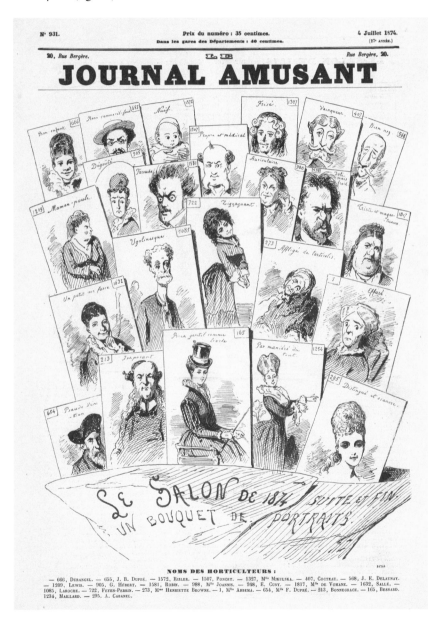

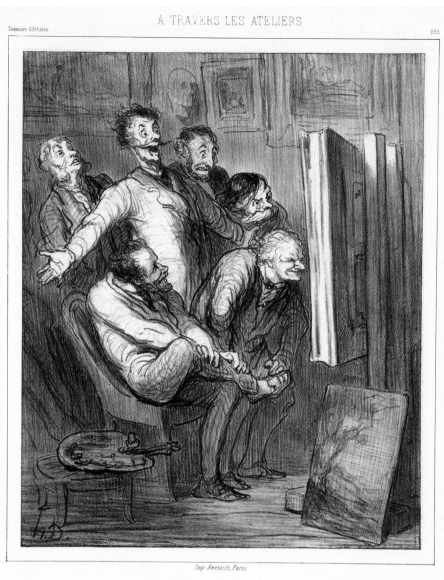

Imp. Bertauts, Paris

Fichtre !... Epatant !... Sapristi !... Superbe !... ça parle !...

FIG. 43.
Honoré Daumier, *A travers les ateliers* (*Around the Studios*), 1862, from the series *Souvenirs d'artistes*. Crayon lithograph with scraping, 25.2 × 21 cm (9¹⁵⁄₁₆ × 8¼ in.)

In the illustrated press, political caricature was at various times the target of government censorship, especially during the early years of the Third Republic. Caricaturist Gill published his work in a variety of anti-Bonapartist newspapers, including *La Lune* and its successor, *L'Eclipse*, both of which frequently ran afoul of the authorities. On the front page of *L'Eclipse* from November 26, 1871 (fig. 44), Gill showed the blindfolded editor Francis Polo tiptoeing among eggshells labeled with such controversial topics as "the Prussian question," "monetary crisis," "Bonapartism," and "Commune." Although

Quatrième année — N° 161 Un numéro : 10 centimes Dimanche 26 Novembre 1871

RÉDACTEUR EN CHEF
F. POLO

ABONNEMENTS
PARIS

52 numéros 6 fr.
26 numéros 3 —

Les abonnements partent du
1er de chaque mois

BUREAUX
16, rue du Croissant, 16

DIRECTEUR
F. POLO

ABONNEMENTS
DÉPARTEMENTS

52 numéros 8 fr.
26 numéros 5 —

ANNONCES
Fermage exclusif de la publicité
ADOLPHE EWIG
10, rue Taitbout, 10

L'ÉCLIPSE ET LA CENSURE, PAR GILL

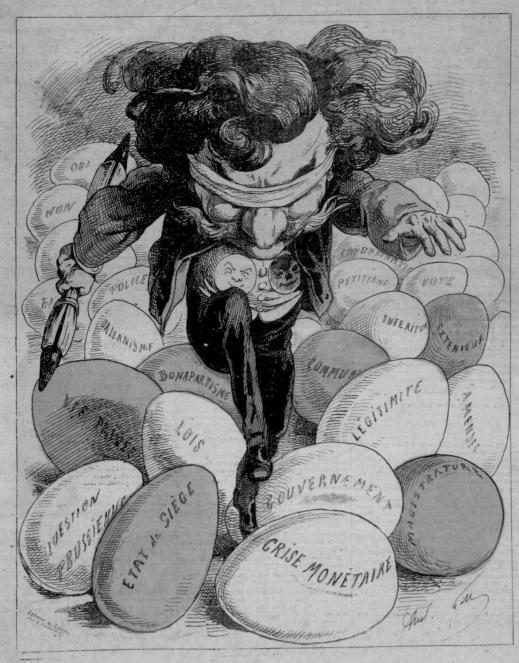

FIG. 44.
Gill (pseudonym of André Gosset de Guines), *L'Eclipse et la censure* (*L'Eclipse and Censorship*), 1871, published in *L'Eclipse*, November 26, 1871. Gillotage with pochoir, 33.3 × 26.7 cm (13⅛ × 10½ in.)

censorship was discontinued after the passage of an 1881 law securing the freedom of the press, radical artists like Paul Signac often employed metaphorical imagery in their most politically charged works. Signac's powerful *Les démolisseurs* (*The Wreckers*) of 1896 (fig. 45), published in the anarchist paper *Les Temps Nouveaux*, depicts a pair of muscular workers engaged in a demolition project that was understood to represent the symbolic destruction of the capitalist state.[3] An only child, Signac dedicated the impression of this print in the Achenbach collection to a brother-in-arms: *à mon cher frère / en espoir / Décembre 96* ("to my dear brother / in hope / December 96").

From a technical perspective, the insertion of prints in periodicals of the late nineteenth century encompassed a variety of techniques ranging from traditional etching and steel engraving to lithography, wood engraving, and photomechanical processes. While Signac's lithograph appeared in *Les Temps Nouveaux* in its original form, Manet's lithograph *Le rendez-vous des chats* (*The Cats' Rendezvous*)—an advertisement for Champfleury's book *Les Chats* (*The Cats*)—was published in *La Chronique Illustrée* as a gillotage (fig. 46). In this process, Manet's lithographic image would have been transferred to a zinc plate for printing in relief. For serials, the advantage of gillotage plates, which were also employed for many of Daumier's published illustrations after the mid-1860s, was that they could be printed on the same relief presses as the type with relatively minimal degradation in the quality of the image.

Etchings made regular appearances in art journals from the 1840s through the turn of the twentieth century, feeding a continuing demand from print collectors. From the late 1850s, such plates were typically steel-faced in order to survive the printing of relatively large editions. Bracquemond, an artist who exhibited with the Impressionists, was widely admired for his highly detailed depictions of flora and fauna. One of the most technically accomplished printmakers of his generation, he was also a frequent supplier of etched reproductions of paintings to periodicals. To Philip Gilbert Hamerton's London journal *The Portfolio* (1872), he contributed the beautifully atmospheric etching *Le lièvre* (*The Hare*) after a painting by Albert de Balleroy (fig. 47).[4] Both *Margot the Critic* and *The Hare* were among his submissions to the first Impressionist exhibition of 1874.[5]

When *L'Art* was founded in Paris in 1875, it approximated the size and format of *The Portfolio* and employed many of the same reproductive etchers. Among its contributors was Bracquemond's talented follower Paul-Adolphe Rajon, whose etched

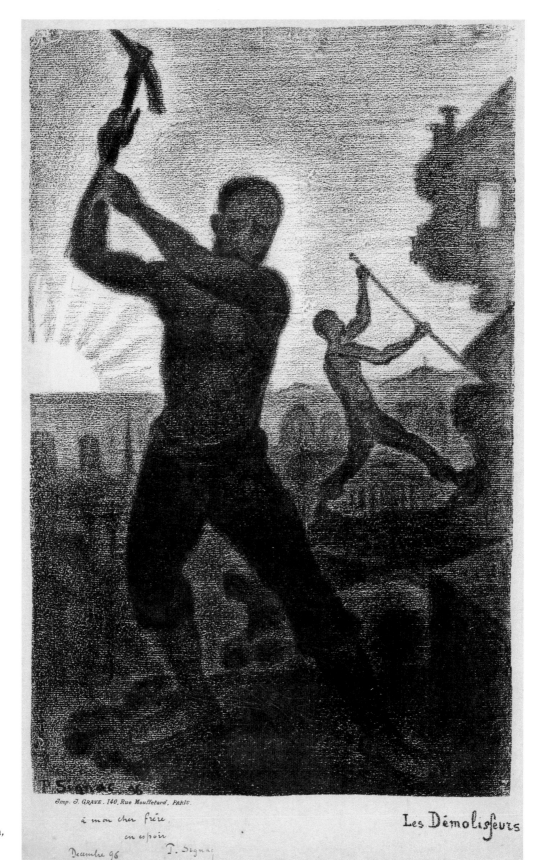

Imp. J. GRAVE. 140, Rue Mouffetard, PARIS.

à mon cher frère,

en espoir

Decembre 96 P. Signac

Les Démolisseurs

FIG. 45.
Paul Signac, *Les démolisseurs*
(*The Wreckers*), 1896, published
in *Les Temps Nouveaux*,
October 1, 1896. Crayon lithograph,
47 × 30.5 cm (18½ × 12 in.)

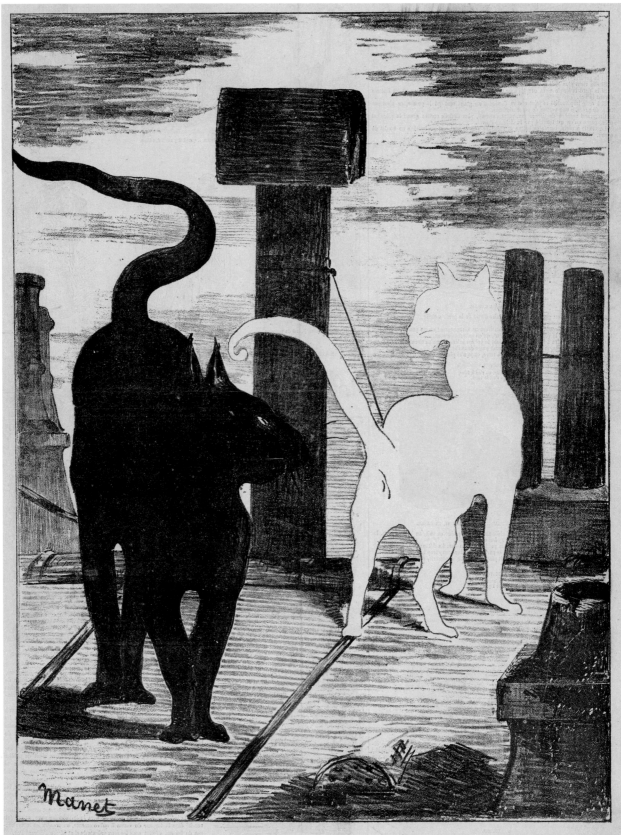

LE RENDEZ-VOUS DES CHATS. — DESSIN ORIGINAL DE **MANET**.

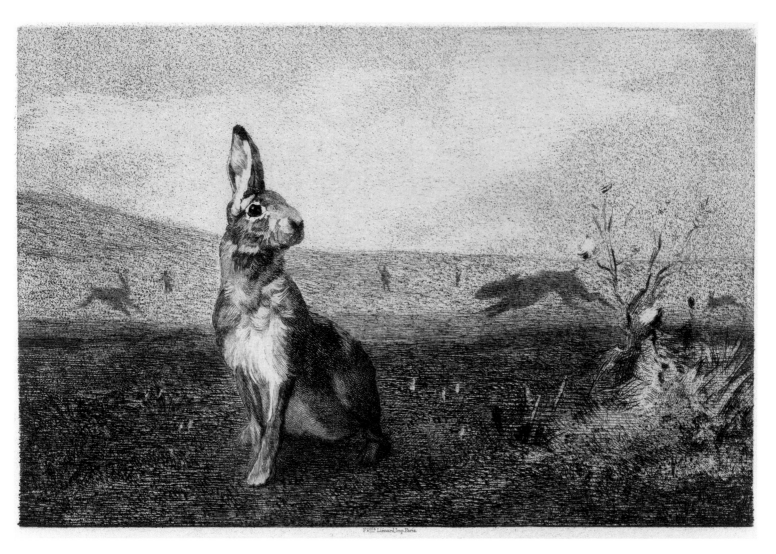

FIG. 46 (*facing*).
Edouard Manet, *Le rendez-vous des chats* (*The Cats' Rendezvous*), 1868, published in *La Chronique Illustrée*, October 25, 1868. Gillotage, 44 × 33.5 cm (17⁵⁄₁₆ × 13³⁄₁₆ in.)

FIG. 47 (*above*).
Félix Bracquemond after Albert de Balleroy, *Le lièvre* (*The Hare*), 1872, published in *The Portfolio*, 1872. Etching, 17.9 × 25.2 cm (7¹⁄₁₆ × 9¹⁵⁄₁₆ in.)

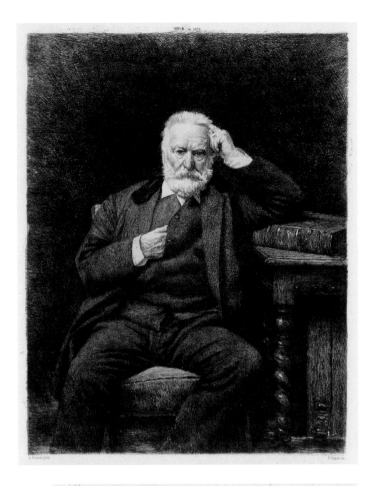

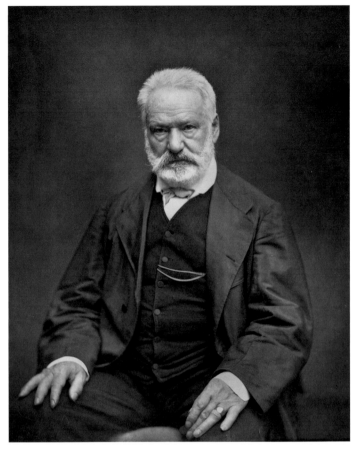

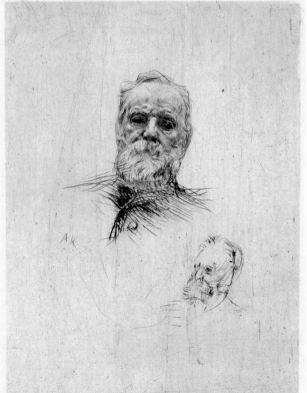

(clockwise from top left)

FIG. 48.
Paul-Adolphe Rajon after
Léon Bonnat, *Victor Hugo*, 1879,
published in *L'Art*, 1879.
Etching, 31 × 22.8 cm (12³⁄₁₆ × 9 in.)

FIG. 49.
Etienne Carjat, *Victor Hugo*,
ca. 1876, published in *Galerie
Contemporaine, Littéraire,
Artistique*, 1876. Woodburytype
from wet-collodion-on-glass negative,
23.7 × 19.2 cm (9⁵⁄₁₆ × 7⁹⁄₁₆ in.)

FIG. 50.
Auguste Rodin, *Victor Hugo,
de face (Victor Hugo, Front View)*,
1885, published in the *Gazette
des Beaux-Arts*, March 1889.
Drypoint, 22.5 × 17.5 cm (8⅞ × 6⅞ in.)

portrait of Victor Hugo after a painting by Léon Bonnat appeared in its pages in 1879 (fig. 48). Two more portraits of Hugo published in the *Galerie Contemporaine, Littéraire, Artistique* (1876) (fig. 49) and the *Gazette des Beaux-Arts* (1889) (fig. 50) demonstrate the diversity in methods of illustration, from autographic to photographic, in journals of the period. Published between 1876 and 1884, Ludovic Baschet's *Galerie Contemporaine* comprised a rich pantheon of France's cultural luminaries through photographic portraits by Nadar, Etienne Carjat, and others. Their original negatives were used to create woodburytypes, a patented form of photomechanical facsimile that converted the negative image into a positive mold for printing in relief. The results were striking in their similarity to actual photographs, and most general readers would not have known the difference. At the same time, the venerable *Gazette des Beaux-Arts* continued to incorporate original prints as it had done from its inception in 1859. Auguste Rodin's drypoint of Hugo was one of the most exquisite prints to appear in its pages. Normally a drypoint plate would show significant wear after little more than a dozen impressions, but the steel-facing process made it possible for such a delicate matrix to yield the requisite number of impressions for the run of the journal. In their own distinct ways, *L'Art*, the *Galerie Contemporaine*, and the *Gazette des Beaux-Arts* contributed to the establishment of Paris as a leading center of art journalism in the nineteenth century.

NOTES

1. Daniel Wildenstein, *Claude Monet: Biographie et catalogue raisonné* (Lausanne and Paris: Bibliothèque des arts, 1979), vol. 2, 227, letter 338, dated March 6, 1883.

2. For an extended analysis of this print, see Jean-Paul Bouillon, *Félix Bracquemond: Le réalisme absolu* (Geneva: Albert Skira, 1987), 86–89.

3. Robert L. Herbert and Eugenia W. Herbert, "Artists and Anarchism: Unpublished Letters of Pissarro, Signac, and Others," *Burlington Magazine* 102 (November–December 1960): 479; Marina Ferretti-Bocquillon et al., *Signac, 1863–1935*, exh. cat. (New York: Metropolitan Museum of Art, 2001), 206–207.

4. The print appeared in *The Portfolio* 3, May 1872, 65, with the title *The Hare, a Misty Morning*.

5. Ruth Berson, ed., *The New Painting*: Impressionism 1874–1886; *Documentation* (San Francisco: Fine Arts Museums of San Francisco, 1996), vol. 2, 17, no. 1-25b (*Le lièvre*), and 19, no. 1-27c (*Margot la critique*).

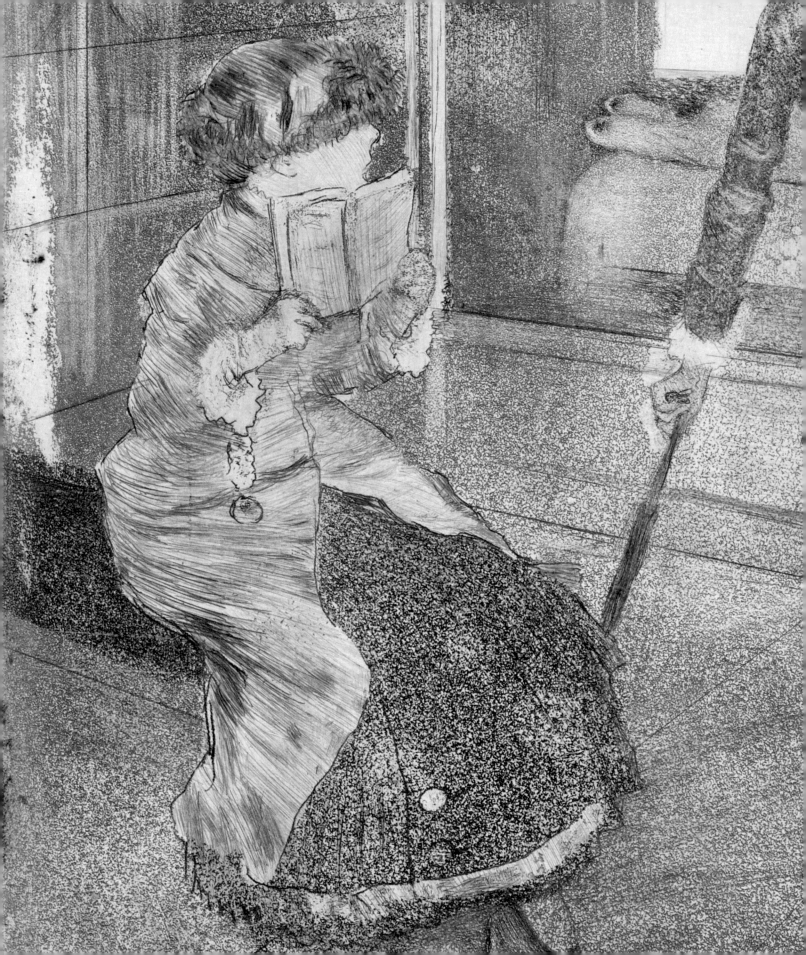

Impressionists in
Black and White

THE SOCIÉTÉ ANONYME DES ARTISTES, Peintres, Sculpteurs, Graveurs, etc., who banded together for the purpose of organizing a series of group shows between 1874 and 1886 did not share a coherent style. In fact, what united them above all else was their shared opposition to the tyranny of the government-organized Salon exhibitions. Not surprisingly, this community of artists, loosely allied by their very independence of spirit, worked in a variety of manners and techniques. One of their innovations was to integrate works on paper into their displays of paintings, as opposed to the traditional segregation by medium of the official Salons. Indeed, a significant component of black-and-white work appeared throughout the eight Independent exhibitions, and just as the Impressionists broke new ground in the field of painting, several members of the group approached the graphic arts with a fresh outlook. "With very few exceptions, one must admit that everything in this new movement is new or wants to be free," wrote Edmond Duranty in his seminal essay "The New Painting" (1876), making specific reference to the printmaking component of the Impressionist exhibitions.[1]

FIG. 51.
Félix Bracquemond,
Edmond de Goncourt, 1882.
Etching, 50.6 × 33.7 cm
(19¹⁵⁄₁₆ × 13¼ in.)

The group's inherent diversity of style and technique is encapsulated in a pair of etchings of modern writers by fellow Independents Félix Bracquemond (who exhibited graphic works in the first, fourth, and fifth Impressionist exhibitions) and Paul Gauguin (who showed paintings and sculpture in the fourth through eighth exhibitions). In 1880 Bracquemond exhibited his final preparatory drawing in charcoal for his etched portrait of the great connoisseur Edmond de Goncourt (fig. 51).[2] A far cry from the aesthetic

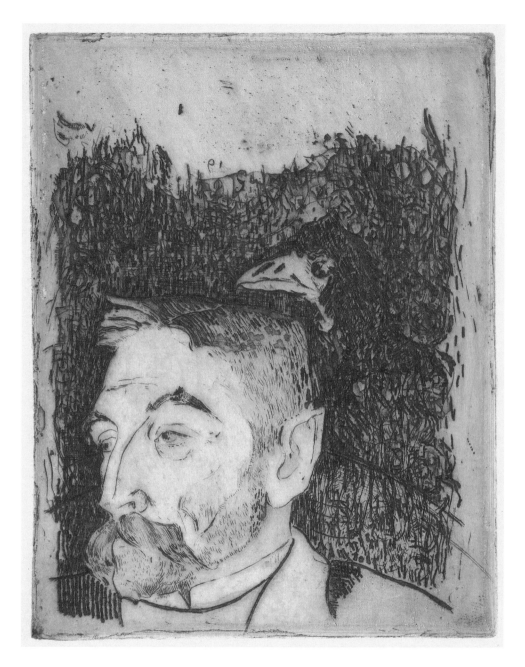

of "painting quickly" associated with the Impressionists, Bracquemond's detailed and finely wrought portrait harkens back to the manner of northern Renaissance artists such as Hans Holbein the Younger. By contrast, Gauguin's preliminary pen-and-ink portrait of the symbolist poet Stéphane Mallarmé of 1891, along with the etched version that circulated among his close friends and colleagues (fig. 52), is an exercise in spontaneity. From the eccentric placement of the subject within the frame to the ragged

FIG. 52.
Paul Gauguin, *Stéphane Mallarmé,* 1891. Etching with aquatint, open-bite, and drypoint printed in dark brown-black ink, with plate tone, 18.2 × 14.4 cm (7³⁄₁₆ × 5¹¹⁄₁₆ in.)

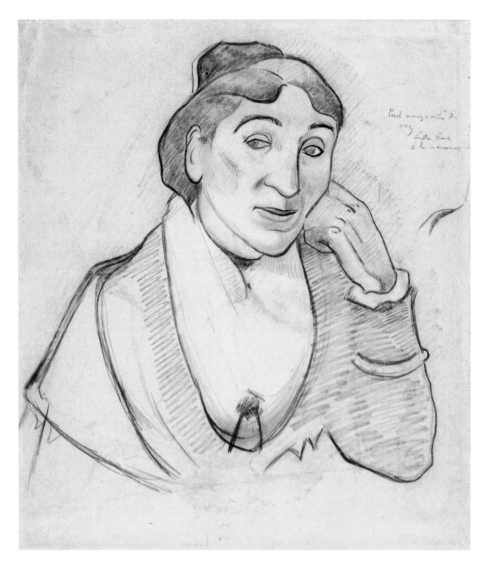

FIG. 53.
Paul Gauguin, *L'arlésienne,
Mme. Ginoux (The Woman from
Arles, Madame Ginoux)*, 1888.
Colored chalks and charcoal
with white chalk, 56.1 × 49.2 cm
(22¹⁄₁₆ × 19⅜ in.)

cross-hatching that half-conceals a raven's head in the background—a motif copied from Edouard Manet's frontispiece to Mallarmé's translation of Edgar Allan Poe—the effect is hallucinatory rather than photographic.

Gauguin's power as a draftsman is further revealed in his large charcoal study of "the *arlésienne*" of 1888 (fig. 53). The sitter is Marie Ginoux, the wife of the proprietor of a café in Arles frequented by Gauguin and Vincent van Gogh. The sheet, dating from Gauguin's stay with Van Gogh in the fall of 1888, was given to his host with an instructive note in the upper right corner: *l'oeil moins a costé du / nez / arête vive / à la naissance* ("the eye should be placed farther away from the ridge of the nose"). Van Gogh used the drawing as the basis for at least four paintings of the *arlésienne*, noting in an unfinished and unsent letter to Gauguin, "I tried to be respectfully faithful to your drawing while taking the liberty of interpreting through the medium of colour the sober character and the style of the drawing in question."[3]

Within the larger group of Independent artists, Degas and the members of his immediate circle were the most active as printmakers. Degas owned an etching press and in 1879 hatched a plan for an illustrated journal called *Le Jour et la Nuit* (*Day and Night*), in reference to its planned black-and-white content. Besides his own contribution, the publication was to include prints by Bracquemond, Gustave Caillebotte, Mary Cassatt, Jean-Louis Forain, Camille Pissarro, Jean-François Raffaëlli, and Stanislas-Henri Rouart.[4] While the journal never materialized, a few of the intended contributions were shown in the fifth Impressionist exhibition of 1880, including

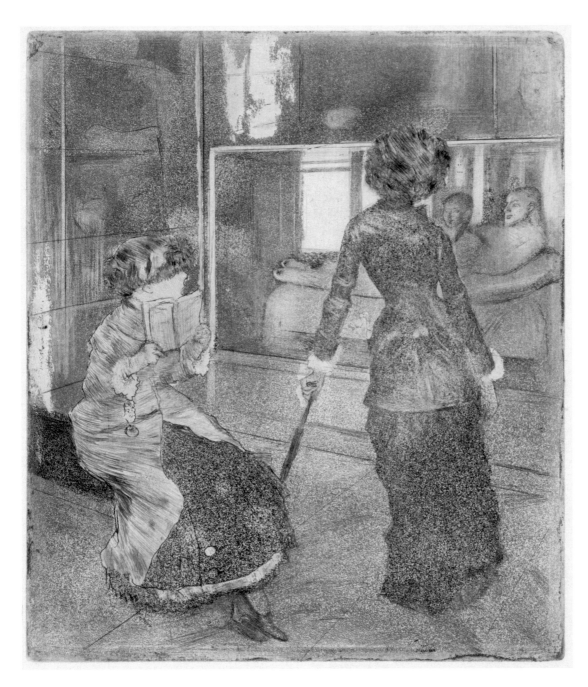

FIG. 54.
Edgar Degas, *Au Louvre,
la peinture Mary Cassatt (Mary
Cassatt at the Louvre: The Etruscan
Gallery)*, 1879–1880. Aquatint,
drypoint, soft-ground etching,
and etching with burnishing,
26.8 × 23.6 cm (10⁹⁄₁₆ × 9⁵⁄₁₆ in.)

Degas' whimsical portrait of the Cassatt sisters at the Louvre (fig. 54). Mary leans on her umbrella, contemplating the Etruscan *Sarcophagus of the Spouses*, a terracotta acquired by Napoléon III in 1861, while her companion glances up from her guidebook. In this heavily worked plate, Degas made especially sophisticated use of aquatint to evoke the gallery's atmosphere of shadows and reflections.

FIG. 55.
Camille Pissarro, *La masure*
(*The Old Cottage*), 1879.
Etching and aquatint with
scraping and burnishing,
16.6 × 17.2 cm (6⁹⁄₁₆ × 6¾ in.)

Among Degas' closest colleagues, Pissarro and Cassatt were the most susceptible
to his infectious enthusiasm for etching and related intaglio techniques (aquatint, soft-
ground, drypoint). In the 1880 exhibition, Pissarro showed three impressions of his
aquatint *La masure* (*The Old Cottage*) (fig. 55) representing progressive stages or "states"
of development of his plate. In daring to exhibit multiple states, Pissarro offered an

ingenious response to Baudelaire's reflection that "a harmoniously-conducted picture consists of a series of pictures superimposed on one another, each layer conferring greater reality on the dream."[5] Cassatt exhibited several soft-ground etchings with aquatint in 1880 and continued to use these techniques to great effect in her prints of the 1880s and 1890s (see fig. 56).

During this same period of intense engagement with printmaking leading up to the exhibition of 1880, Degas became enamored by monotype, a hybrid technique that combines elements of both drawing and printmaking. It is a straightforward and spontaneous process in which a smooth surface, usually a copper plate, is used as the support for a drawing in ink. While the ink is still wet, the plate is run through a printing press, and the drawing is thereby transferred to a sheet of paper. Monotype yields only one strong impression, hence its name: "mono: one" and "type: print." Despite its lack of commercial value in the art market, Degas was fanatical about monotype, producing more than four hundred prints using this technique. The drawing process, as revealed in his complex monotype of a woman before a mirror (fig. 57), was much more fluid and flexible than putting pen or pencil to paper. To create this image he employed a traditional brush and ink along with rags, gauzes, and the tips of his fingers. While Degas probably introduced Pissarro to the process in the late 1870s, Pissarro did not own his own printing press until the mid-1890s, and only then did he produce a body of some two dozen monotypes (see fig. 58).

FIG. 56.
Mary Cassatt, *Nurse and Baby Bill, No. 2*, ca. 1889–1890. Soft-ground etching and aquatint printed in dark brown ink, 21.6 × 13.8 cm (8½ × 5⁷⁄₁₆ in.)

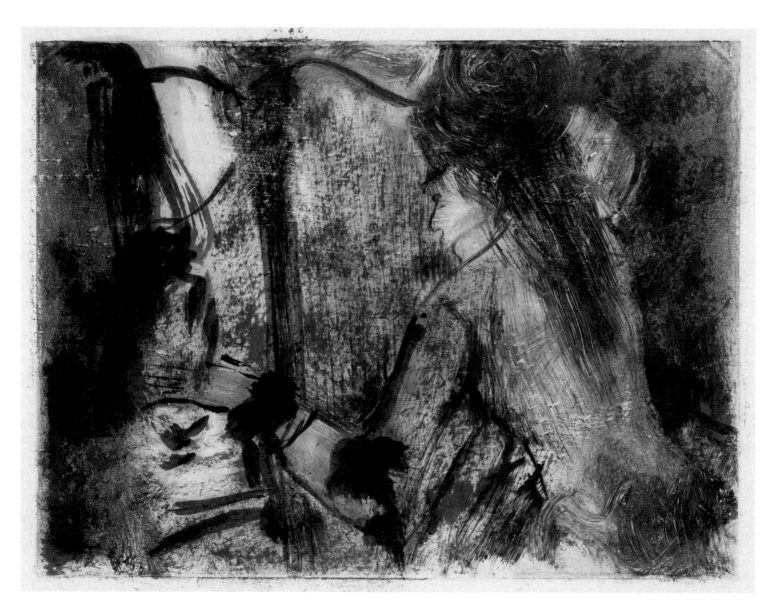

FIG. 57.
Edgar Degas, *Derniers préparatifs de toilette* (*Final Touches in the Toilette*), ca. 1877–1880. Monotype with black ink additions on China paper, 16 × 21.5 cm (6⁵⁄₁₆ × 8⁷⁄₁₆ in.)

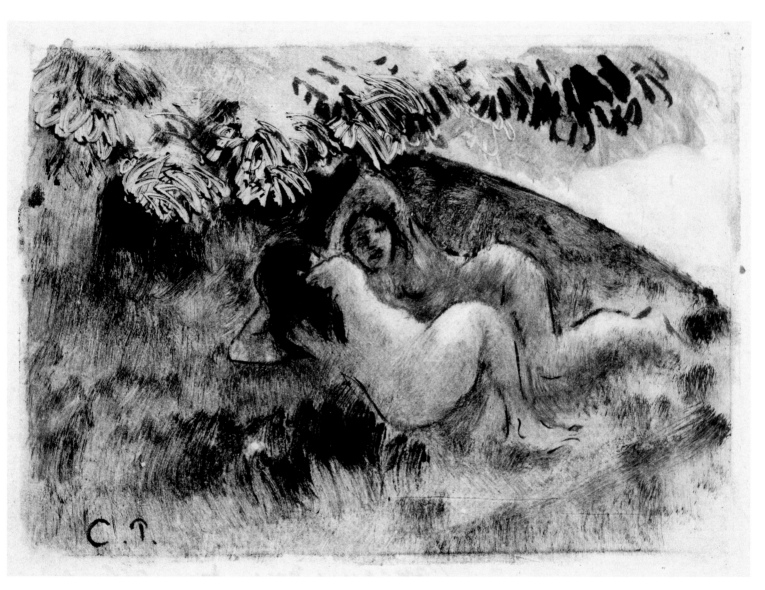

FIG. 58.
Camille Pissarro, *Paysannes nues dans l'herbe (Nude Peasants in the Grass)*, ca. 1894–1895. Monotype, 12.6 × 17.7 cm (4¹⁵⁄₁₆ × 6¹⁵⁄₁₆ in.)

Not all members of the core Impressionist group took to printmaking. Monet, for one, kept himself at arm's length from the accoutrements of etching and lithography, and only on rare occasions—as in the first Impressionist exhibition, when he showed a group of pastels—did he exhibit graphic works. In the previous decade, he created a series of confident black chalk drawings of the Normandy coast (see fig. 59), all close in scale and probably derived from a single sketchbook.[6] These sheets reveal his debt to the draftsmanship of Eugène Boudin and Johan Barthold Jongkind, who were also active in this region, and recall Monet's own oil paintings of the period. Their purpose is uncertain, but they may have been intended as studies toward an unrealized series of prints akin to Jongkind's *Vues de Hollande* (*Views of Holland*) of 1862.

Georges Seurat shared Monet's indifference toward printmaking, but he earned a reputation as one of the most highly esteemed draftsmen of the Independent painters. He exhibited his dark and moody conté-crayon drawings in a number of prominent venues during his brief career, including the final Impressionist exhibition of 1886. A preparatory study for a painting rather than a finished work in its own right, his ethereal lineup of circus performers materializes out of the regular texture of the laid Michallet paper (fig. 60). The texture functions as a fine unifying screen, a graphic equivalent to the artist's Pointillist painting technique. Luminous and solemn, Seurat's ghostly figures radiate from the page as if developed like a soft photographic image within the fibers of the paper.

NOTES

1. Louis Emile Edmond Duranty, "The New Painting: Concerning the Group of Artists Exhibiting at the Durand–Ruel Galleries," translated in Charles S. Moffett et al., *The New Painting: Impressionism 1874–1886*, exh. cat. (San Francisco: Fine Arts Museums of San Francisco, 1986), 45.

2. The charcoal drawing on canvas is in the collection of the Musée du Louvre (fonds d'Orsay). In 2004 the Musée du Dessin et de l'Estampe Originale de Gravelines organized a dossier-style exhibition around Bracquemond's portrait of Edmond de Goncourt. See Jean-Paul Bouillon, *Bracquemond/Goncourt*, exh. cat. (Gravelines, France: Musée du Dessin et de l'Estampe Originale, 2004).

3. Vincent van Gogh to Paul Gauguin, Auvers-sur-Oise, on or about June 17, 1890, in Vincent van Gogh, Leo Jansen, Hans Luijten, and Nienke Bakker, *Vincent van Gogh: The Letters* (Amsterdam: Van Gogh Museum, Huygens Institute KNAW, 2009); available online at http://www.vangoghletters.org/vg/letters/RM23/letter.html (accessed February 16, 2010).

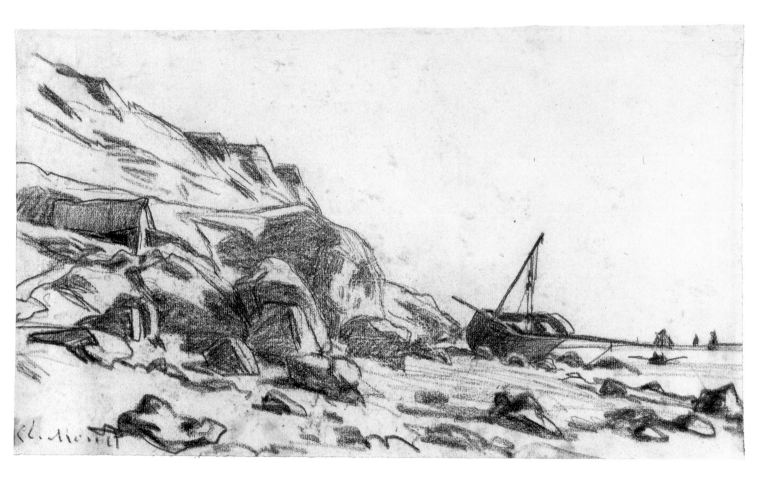

FIG. 59.
Claude Monet, *The Coast of
Normandy Viewed from Sainte-
Adresse*, ca. 1864. Black chalk,
17.5 × 30.8 cm (6⅞ × 12⅛ in.)

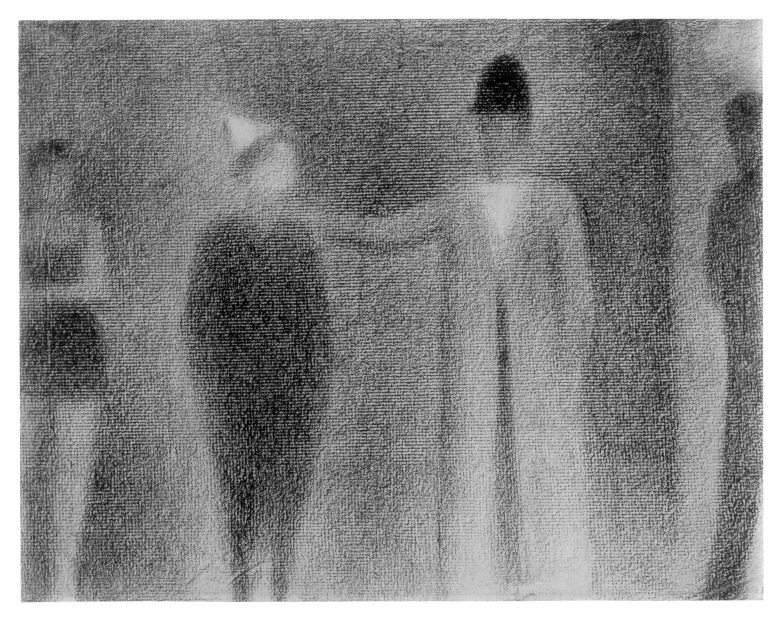

FIG. 60.
Georges Seurat, study
for *La parade de cirque*
(*The Circus Parade*), 1886–1887.
Conté crayon, 23.3 × 30.8 cm
(9³⁄₁₆ × 12⅛ in.)

4. On this project, see Barbara Stern Shapiro, "A Printmaking Encounter," in Ann Dumas et al., *The Private Collection of Edgar Degas*, exh. cat. (New York: Metropolitan Museum of Art, 1997), 234–245.

5. Charles Baudelaire, "The Salon of 1859," in *Art in Paris, 1845–1862: Salons and Other Exhibitions Reviewed by Charles Baudelaire*, trans. and ed. Jonathan Mayne (London: Phaidon, 1965), 160.

6. James A. Ganz and Richard Kendall, *The Unknown Monet: Pastels and Drawings*, exh. cat. (Williamstown, Mass.: Sterling and Francine Clark Art Institute, 2007), 87–96.

Artist Alliances

D URING THE IMPRESSIONIST ERA, THE
Romantic archetype of the lone artistic genius was
tempered by the formation of alliances for exhibit-
ing, publishing, and, above all, selling works of art.
Through informal artists' cafés and weekly dinner salons as well as
private societies, group exhibitions, and collaborative print albums,
artists banded together in their efforts to seek alternatives to the
primary official outlet for reaching the public, the state-run Salon.
While finding strength in numbers, artists faced off in a highly
competitive environment, and the value of celebrity only intensified
in a climate increasingly driven by dealers, marketing, and public
relations.

Dealer Alfred Cadart was the mastermind behind one of the
first artists' societies devoted to a specific technique—etching
—and his gallery on rue de Richelieu served as its headquarters
(fig. 61). Founded in 1862, the Société des Aqua-fortistes (Society
of Etchers) capitalized on the critical and popular enthusiasm for
a medium that had become a fashionable pastime for amateurs
and an accessible niche in the art market for budding collectors

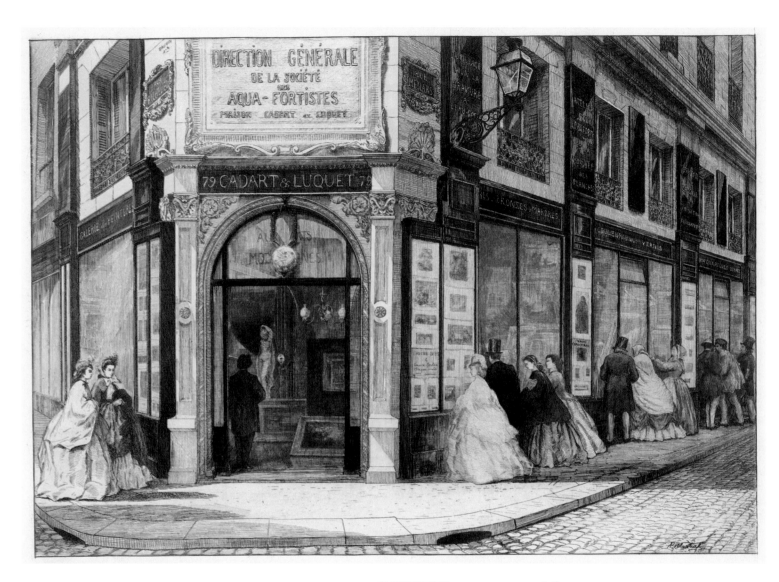

FRONTISPIECE
Henri Gabriel Ibels,
Au cirque (At the Circus),
1893, detail of fig. 65

FIG. 61.
Adolphe Martial Potémont,
Siège de la Société des Aqua-fortistes
(*Headquarters of the Etching Society*),
1867. Etching, 28.8 × 39 cm
(11⁵⁄₁₆ × 15³⁄₈ in.)

of modest means. In the words of Charles Baudelaire, etching was "à la mode."[1] Individual etchings published by the Society cost no more than one franc fifty centimes, and an annual subscription for the full run of sixty prints (five per month) was offered for fifty francs. While the plates were all steel-faced and professionally printed under the supervision of Auguste Delâtre, their unevenness as works of art reflects the diversity of the Society's membership, which would be echoed in the makeup of the group of Independent artists known as the Impressionists. The Society's ranks ran the gamut from professional printmakers (Félix Bracquemond, Jules Jacquemart, Maxime Lalanne) to multiple generations of painters (Camille Corot, Eugène Delacroix, Edouard Manet) and aristocratic amateurs (Vicomte Ludovic-Napoléon Lepic, King Charles XV of Sweden and Norway). Cadart published Lalanne's *Traité de la gravure à l'eau-forte* (*Treatise on Etching*) and sold the tools and equipment needed by would-be etchers, including a portable press. With its Gallic rooster heralding the dawn of the French etching revival, Jacquemart's memorable frontispiece *Le réveil de l'eau-forte* (*The Awakening of Etching*) (fig. 62) became an icon for Cadart's enterprise. For the 1877 volume of Cadart's subsequent etching venture, *L'illustration nouvelle* (*New Illustration*), Félix Hilaire Buhot designed a clever allegorical frontispiece in which a burin, typically used by reproductive engravers, flies off to heaven while a modern etching press arrives aboard a powerful steam locomotive (fig. 63).

During the mid-1860s, critic Philippe Burty, one of the cheerleaders of the modern etching movement, edited *Sonnets et eaux-fortes* (*Sonnets and Etchings*), an anthology of contemporary poems and prints. Burty paired forty-two authors and artists, distributed copper plates to the contributors, and coordinated the difficult process of assembling the manuscript. Inevitably, a few feathers were ruffled along the way. For instance, upon learning of the rejection of his poem, Stéphane Mallarmé vented to a friend, "Burty, the impresario of this stupid affair, now has more sonnets than etchers, and isn't accepting any more, even a sonnet by God himself."[2] On June 28, 1868, Burty sent an invitation to Manet: "I have the utmost desire for you to take part. The etching does not have to be larger than 20 by 13 centimeters. It could be smaller. If you want, I could have a copper plate of these dimensions sent to you. Here is a sonnet [Armand Renaud's *"Fleur exotique"* ("Exotic Flower")] that appears to me to harmonize perfectly with what we know of you. If the combination is agreeable, please send word so I can register you."[3] At the time of this solicitation, Manet was absorbed in the art of Spain, and his submission,

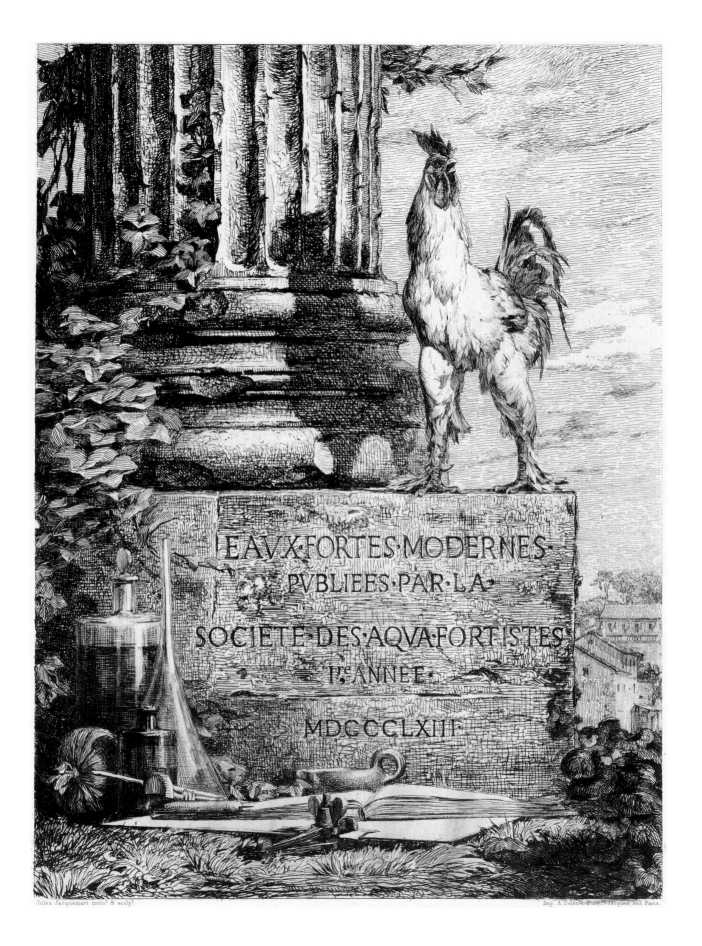

EAVX·FORTES·MODERNES·
·PVBLIEES·PAR·LA·

·SOCIETE·DES·AQVÆ·FORTISTES·

·I^e·ANNEE·

·MDCCCLXIII·

Jules Jacquemart invent & sculpt. Imp. A. Delâtre, rue St Jacques, 303, Paris.

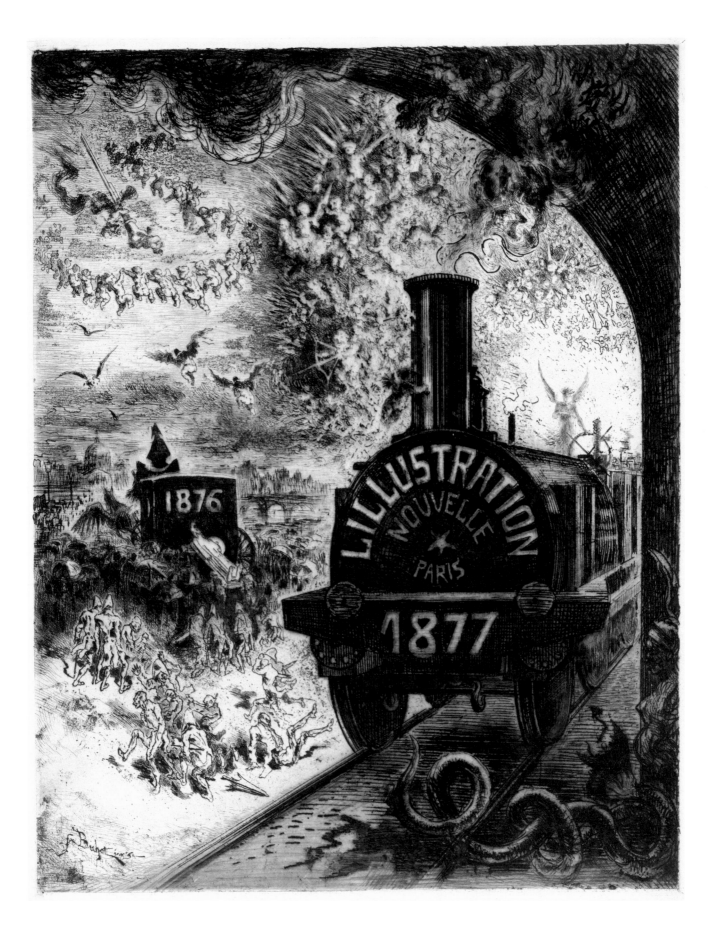

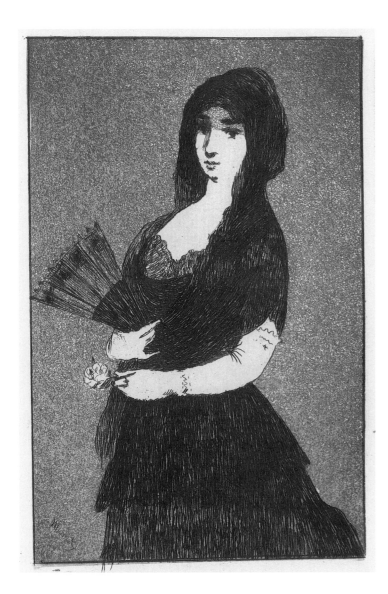

an aquatint of a woman wearing a mantilla (fig. 64), reflects his deep admiration for the graphic works of Francisco de Goya.

The idea of the group album of original prints by contemporary artists available at a modest price gained ground in the coming decades. Originality and modernity came to be the two key selling points in the marketing of such productions. In describing a print, the term *originale* had dual connotations: first, that its composition did not reproduce a work of art in another medium but was invented specifically for the print itself; and second, that the work was a bona fide lithograph, etching, or woodcut rather than a photo-mechanical reproduction. Then as now, *moderne* implied a work of art that in its style and subject matter reflects the spirit of the times.

One of the most successful collaborative ventures was André Marty's *L'estampe originale* (*The Original Print*) (1893–1895), which published ninety-five prints by seventy-four artists in nine quarterly albums. An annual subscription was offered at 150 francs. Marty was a journalist who was inspired, in part, by his ardent patriotism to promote quality and taste in the French applied arts and crafts.[4] Marty marketed prints of all kinds (etchings, lithographs, woodcuts) as collector's items and accessible alternatives to stained glass, tapestries, and other more expensive forms of interior decoration. The first album of *L'estampe originale* featured prints by several of the Nabi artists, including the colorful lithograph *Au cirque* (*At the Circus*) (fig. 65) by the young painter and illustrator Henri Gabriel Ibels. Jean-François Raffaëlli's self-portrait in the form of a four-color drypoint (fig. 66) appeared in volume two.

Ambroise Vollard played a decisive role in the print revival of the 1890s by commissioning original lithographs from painters. In June 1896 the up-and-coming dealer launched his own series of group print albums at his new gallery on rue Lafitte.

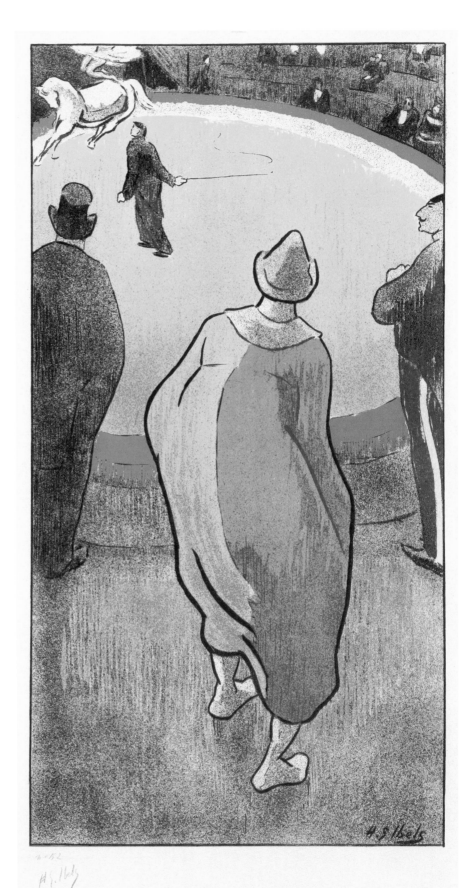

FIG. 65.
Henri Gabriel Ibels, *Au cirque*
(*At the Circus*), from the album
L'estampe originale, 1893.
Color lithograph with crayon,
brush, and spatter, 49.5 × 26.5 cm
(19½ × 10⁷⁄₁₆ in.)

FIG. 66.
Jean-François Raffaëlli, *Raffaëlli, par lui-même* (*Self-Portrait*), from the album *L'estampe originale*, 1893. Color drypoint, 18.7 × 15.8 cm (7⅜ × 6¼ in.)

FIG. 67 (*facing*).
Odilon Redon, *Béatrice*, from *L'album d'estampes originales de la Galerie Vollard*, 1897. Color lithograph on chine collé, 33.3 × 29.1 cm (13⅛ × 11⁷⁄₁₆ in.)

Vollard's first *Album des peintres-graveurs* (*Album of Painter-Printmakers*) consisted of twenty-two prints offered in an edition of one hundred impressions and priced at 100 francs. In the following year, a second album of thirty-two prints appeared under the title *Album d'estampes originales de la Galerie Vollard* (*Album of Original Prints from the Vollard Gallery*) at the higher price of 150 francs. A third album was prepared for 1898 but remained unpublished. Vollard especially showcased color lithography, and he actively encouraged the participation of painters who lacked hands-on experience in this complex process by offering the services of master printer Auguste Clot. In color lithographs such as Odilon Redon's ethereal *Béatrice* (fig. 67), which re-creates a pastel in

FIG. 68.
Paul Cézanne, *Baigneurs*
(*The Small Bathers*), 1896–1897,
from *L'album d'estampes originales
de la Galerie Vollard*, 1897.
Color lithograph on China paper,
22.9 × 29 cm (9 × 11⁷⁄₁₆ in.)

Vollard's possession by overlaying and blending the delicate hues on three separate litho-stones, the artist's direct involvement may have been limited to supervision, approval, and the all-important signing of the edition.[5] Similarly, Clot had a heavy hand in the preparation of the multiple-color stones for Paul Cézanne's composition of bathers (fig. 68). While admiring the beauty and craftsmanship of such productions, critic André Mellerio, a great supporter of color lithography, questioned Vollard's lack of transparency in suppressing Clot's key contributions to certain of his *"originale"* offerings. "[Clot's] fault would be not a lack of skill," noted Mellerio, "but rather a tendency to substitute his own judgment for that of the artists when their personality is not strong or assertive."[6]

From May 1897 to April 1899, the tradition of the collaborative print album was carried on in a series of twenty-four monthly portfolios of four prints each under the imprint *L'estampe moderne*. Copublished by Charles Masson and Henri Piazza, *L'estampe moderne* was printed in an edition of 150, somewhat larger than Vollard's print albums, and on lesser-quality paper. The price, accordingly, was three francs fifty centimes per issue within Paris, or just under one franc per print; an annual subscription was offered at the affordable price of forty francs. The brilliant graphic artist Alphonse Mucha designed the template for the cover sheet (fig. 69), a stylized rendering of a somber-faced muse delicately holding a pen. One of the standout contributors to the series was the Belgian painter Henri-Jacques-Edouard Evenepoel, a student of Gustave Moreau and friend of Henri Matisse whose career was tragically cut short in 1899. From the fourth fascicule, Evenepoel's exuberant image of a fashionable mother promenading with her obstinate young daughter (fig. 70) is a technical tour de force, wrought from a full arsenal of drawing methods (litho-crayon, brush, and spatter) separated into five colors.

At century's end, German art critic Julius Meier-Graefe published the group print album *Germinal* (1899) to mark the opening of La Maison Moderne, the gallery devoted to Art Nouveau that he operated for several years on rue des Petits-Champs in Paris. *Germinal* is the first month of spring in the French Republican calendar and had also served as the title of an 1885 novel by Emile Zola. Meier-Graefe intended *Germinal* as a visual anthology of modernism through a collection of twenty original and facsimile prints by an international roster of living artists. Paul Gauguin's contribution, the etching *La femme aux figues* (*Woman with Figs*) (fig. 71), dates from around 1894, but apart from a few trial proofs it remained unpublished until the *Germinal* edition.

FIG. 69 (*overleaf left*). Alphonse Mucha, cover of the album *L'estampe moderne*, May 1897. Relief halftone and letterpress, 41.2 × 31.4 cm (16¼ × 12⅜ in.)

FIG. 70 (*overleaf right*). Henri-Jacques-Edouard Evenepoel, *Au square* (*At the Square*), from the album *L'estampe moderne*, May 1897. Color lithograph with crayon, brush, and spatter, 33.2 × 23.2 cm (13¹¹⁄₁₆ × 9⅛ in.)

Numéro 1 Mai 1897

L'ESTAMPE
Moderne

Directeurs :

CH. MASSON & H. PIAZZA

✡

Publication Mensuelle

Contenant

Quatre estampes originales inédites

en Couleurs et en Noir

des

principaux Artistes Modernes

Français et Étrangers

éditée par

L'IMPRIMERIE CHAMPENOIS

ABONNEMENTS D'UN AN :

Paris 40 frs.
Dépar⁻ et Etranger 43 frs.

LE NUMÉRO :

Paris 3 frs. 50
Dépar⁻ et Etranger 4 frs.

SOMMAIRE

Direction et Administration : 66, Boulevard Saint-Michel, Paris.

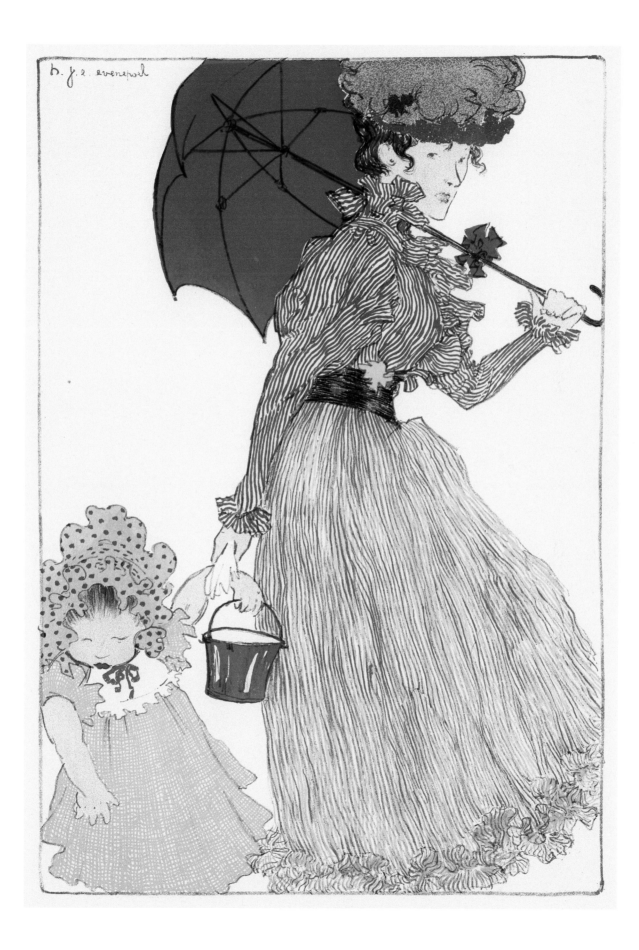

FIG. 71.
Paul Gauguin, *La femme aux figues*
(*Woman with Figs*), 1894, from the
album *Germinal*, 1899. Etching,
open-bite, and soft-ground etching,
27 × 44.5 cm (10⅝ × 17½ in.)

It bears some evidence of the hand of his close colleague, Armand Séguin, who had far greater experience as an etcher and likely provided Gauguin with technical assistance. The barely legible inscription *chez Séguin à St Julien* ("at the home of Séguin at Saint-Julien") in the upper left corner implies that Séguin printed the trial proofs at his residence in Le Pouldu.[7] Whatever its germination, *Woman with Figs* combines the distinctive calligraphy of Séguin's foliage with the figure style of Gauguin and represents the product of a true artistic alliance.

NOTES

1. Charles Baudelaire, "L'eau-forte est à la mode," *Revue Anecdotique*, April 2, 1862; expanded as "Painters and Etchers," *Le Boulevard*, September 14, 1862.

2. Quoted in Carl Paul Barbier, ed., *Documents Mallarmé* (Paris: Nizet, 1968), vol. 1, 378.

3. Quoted in Marcel Guérin, *L'oeuvre gravé de Manet* (Paris: Librairie Floury, 1944), in entry for no. 51 (not paginated). A cache of correspondence to Burty from a number of participants, consisting mainly of letters of apology offering excuses for tardiness, is bound into a unique extra-illustrated copy of the book in the collection of the Achenbach Foundation for Graphic Arts.

4. See Patricia Eckert Boyer, "*L'estampe originale* and the Revival of Decorative Art and Craft in Late Nineteenth-Century France," in *L'Estampe Originale: Artistic Printmaking in France, 1893–1895*, exh. cat., by Patricia Eckert Boyer and Phillip Dennis Cate (Zwolle, Netherlands: Waanders Publishers; Amsterdam: Van Gogh Museum, 1991), 26–45.

5. Pat Gilmour, "*Cher Monsieur Clot . . .* Auguste Clot and His Role as a Colour Lithographer," in *Lasting Impressions: Lithography as Art*, ed. Pat Gilmour (Philadelphia: University of Pennsylvania Press, 1988), 162, 372n107.

6. André Mellerio, *La lithographie originale en couleurs* (Original Color Lithography) (1898), trans. Margaret Needham, in *The Color Revolution: Color Lithography in France, 1890–1900*, exh. cat., by Phillip Dennis Cate and Sinclair Hamilton Hitchings (New Brunswick, N.J.: Rutgers University Art Gallery, 1978), 91.

7. The best discussion of the plate's disputed authorship can be found in Caroline Boyle-Turner, *The Prints of the Pont-Aven School: Gauguin and His Circle in Brittany*, exh. cat. (Washington, D.C.: Smithsonian Institution Traveling Exhibition Service, 1986), 114–115.

Spectacles
and Spectators

PARIS IS A BIG THEATER, WHOSE PROPERTY-room holds machinery that has served for every variety of drama, be it spectacle, farce, or tragedy."[1] The words of this unnamed contributor to the July 1867 issue of *Harper's New Monthly Magazine* were echoed by the French writer Edmond Deschaumes in his guidebook of 1889: "Paris is the real . . . and permanent exposition of all of France."[2] During the second half of the nineteenth century, the number and variety of Parisian entertainment venues multiplied exponentially in response to an overall rise in disposable income. In addition, hordes of tourists rubbed shoulders with the emergent middle class in the city's many restaurants, dance halls, cabarets, and theaters. Conspicuous consumption was no longer the exclusive pastime of the aristocracy; likewise, the performance space was not limited to the stage but extended into the balconies, the foyers, and indeed out onto the grand boulevards. Paris was a city of spectacles and spectators, a place to see and, just as important, to be seen.

Artists played a significant role in the new consumer culture, feeding the demand for subjects related to all aspects of

contemporary amusements. Along with his friend Degas, Jean-Louis Forain was one of the principal Impressionist painters to specialize in theatrical subject matter, giving equal attention to performers and members of the audience. For both men, the spectacular new Paris Opéra became a favorite haunt. Forain's magnificent painting of the foyer of the Opéra (fig. 72) portrays a typical cast of characters: a pair of nimble young women chaperoned by an older "mother" figure, hurrying through a gauntlet of potential suitors. The synchronized motion of the two principal figures, their ethereal white gowns, and the delicately pointed toe of the young woman leading the way underscore the impression of a balletic prelude to the evening's main event.

The loge functioned as another impromptu performance space. Theater boxes were reserved for the wealthiest spectators, offering superior views of the stage as well as the audience. They also provided a wealth of pictorial possibilities. In effect, the loge functioned as a miniature stage, complete with a curtain. Pierre-Auguste Renoir's iconic representation of *La loge* (in the collection of the Courtauld Gallery, London) earned acclaim at the first Impressionist exhibition of 1874.[3] A more intimate one-third-scale version (fig. 73) painted by Renoir shortly afterward retains the freshness as well as the coloristic and textural virtuosity of the larger canvas. Beyond the beautiful young woman's lavish gown, pink lips, and matching flowers, the most important props are the opera glasses. While her male companion directs his binoculars upward toward another balcony, the woman lowers her glasses and makes eye contact with the viewer, effectively breaking the invisible fourth wall of this theatrical picture.

The orchestra provided its own form of drama. Honoré Daumier produced a large body of theatrical imagery and recognized the comic potential of setting bored musicians against the action onstage (fig. 74). Degas elevated the subject to new heights in a number of paintings of the early 1870s, perhaps most notably the *Orchestra of the Opéra* (ca. 1870; collection of the Musée d'Orsay), the central feature of which is a portrait of the bassoonist Désiré Dihau. Dihau appears at the left in a sketchy compositional study (fig. 75), alongside a double-bass player whose identity remains uncertain.[4] The setting is the old opera house on rue Le Peletier, a building destroyed by fire in 1873. As an obsessive fan of the ballet, Degas knew inside and out both the old Paris Opéra and its replacement that opened in 1875. Following literally in Degas' footsteps, Charles Paul Renouard, a technically if not creatively gifted printmaker, published an attractive album of aquatints of the new Paris Opéra in 1881 that includes an imposing view of the orchestra's percussion section (fig. 76).

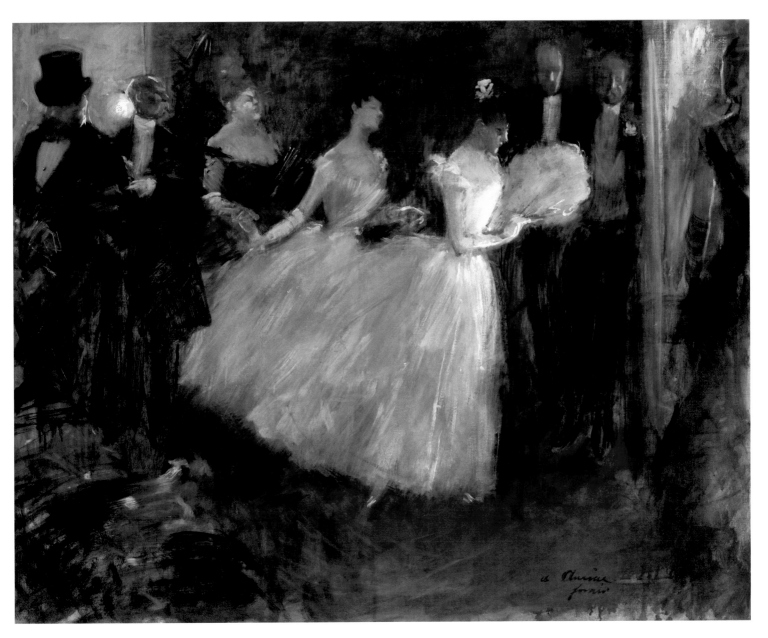

FIG. 72.
Jean-Louis Forain, *Foyer of the Opéra*, ca. 1880–1890. Oil on canvas, 61 × 80 cm (24 × 31½ in.). Collection of Diane B. Wilsey

L'orchestre pendant qu'on joue une tragédie.

FIG. 73 (*facing*).
Pierre-Auguste Renoir,
La loge (*The Theater Box*), 1874.
Oil on canvas, 27.3 × 21.9 cm
(10¾ × 8⅝ in.). Collection of
Diane B. Wilsey

FIG. 74.
Honoré Daumier, *L'orchestre
pendant qu'on joue une tragédie*
(*The Orchestra during the
Performance of a Tragedy*),
1852, from the series *Croquis
musicaux* (*Musical Sketches*).
Crayon lithograph, 26.1 × 21.6 cm
(10¼ × 8½ in.)

The slick descriptive manner of Renouard's aquatints could not be farther removed from the grainy abstraction of Degas' intaglio prints of the same period. *Danseuses dans la coulisse* (*Dancers in the Wings*) of 1879–1880 (fig. 77) offers an oblique perspective preferred by Degas. As a special class of subscriber known as an *abonné*, he held a backstage pass that gave access to the wings as well as the rehearsal halls. In this emphatically ambiguous composition, a group of partially obscured ballerinas emerges from among organic fragments of stage scenery. Two mysterious haloes appear in the distance like a pair of enormous eye sockets returning the artist's gaze. The legibility of Edouard

FIG. 75.
Edgar Degas, *L'orchestre de l'Opéra*
(*Musicians in the Orchestra*
[*Portrait of Désiré Dihau*]), ca. 1870.
Oil on canvas, 48.9 × 59.7 cm
(19¼ × 23½ in.)

FIG. 76 (*facing*).
Charles Paul Renouard, *Batterie
de l'orchestre* (*Percussion Section
of the Orchestra*), from the album
Le nouvel Opéra (*The New Opéra*),
1881. Etching and aquatint,
30.8 × 24.7 cm (12⅛ × 9¾ in.)

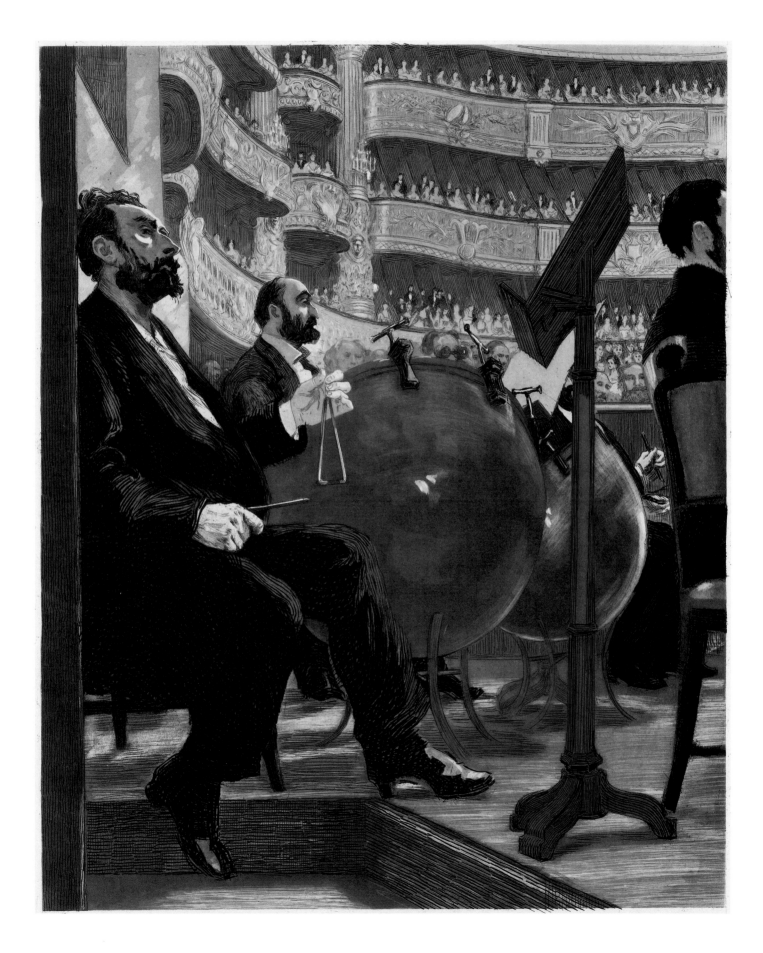

Vuillard's later pastel *Scéne du théâtre ibsénien* (*Scene from a Play by Ibsen*) (fig. 78) offers similar challenges. Like Degas, Vuillard obscures the performance, framing it behind the silhouettes of oddly shaped scenery and the asymmetrical curved proscenium. His deliberate blending of pastel gives a gauze-like effect to the set, which is marked by striking complementary colors and the glowing form of a white picket fence. The pastel likely represents a scene from Henrik Ibsen's *Rosmersholm* (1886) that was staged by Aurélien Lugné-Poe's avant-garde company at the Théâtre des Bouffes du Nord in October 1893—a production with sets and a playbill designed by Vuillard himself.[5]

FIG. 77.
Edgar Degas, *Danseuses dans la coulisse* (*Dancers in the Wings*), 1879–1880. Etching, aquatint, and drypoint, 14 × 10.3 cm (5½ × 4¹⁄₁₆ in.)

FIG. 78 (*facing*).
Edouard Vuillard, *Scène du théâtre ibsénien* (*Scene from a Play by Ibsen*), 1893. Pastel, 30 × 25 cm (11¹³⁄₁₆ × 9¹³⁄₁₆ in.). Collection of Marie and George Hecksher

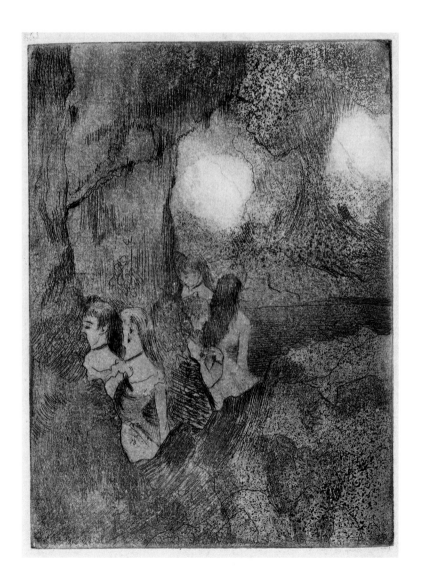

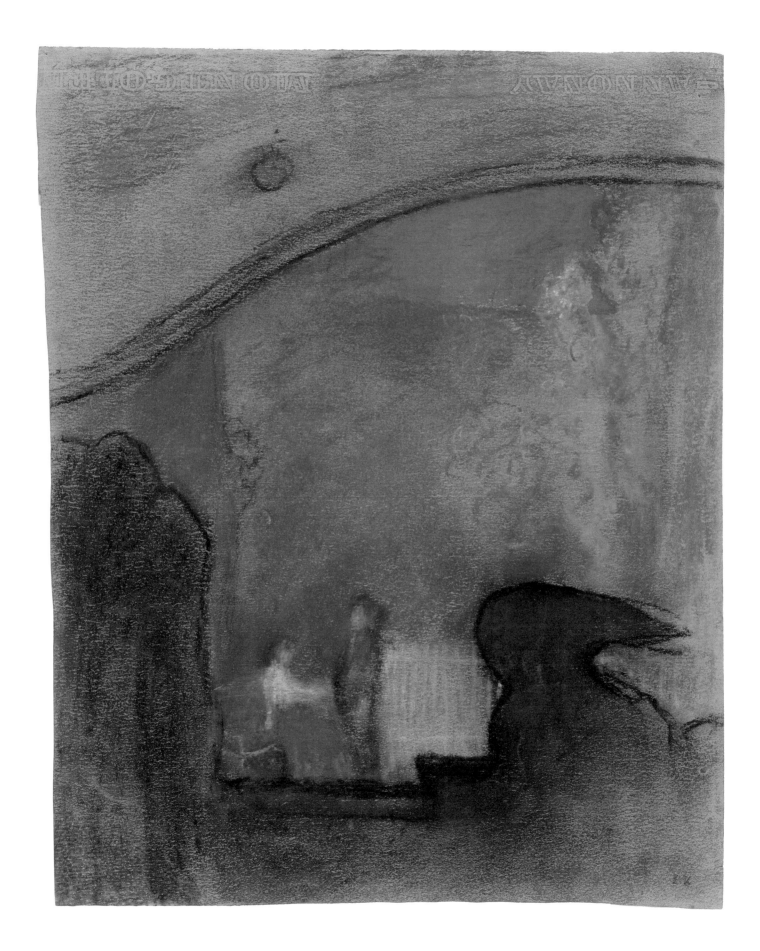

Application du Cercle Chromatique de Mr Ch. Henry.

P. Signac

Lith. EUGENE VERNEAU, 108, Rue de la Folie Méricourt, Paris.

FIG. 79.
Paul Signac, *Application du cercle chromatique de Mr. Ch. Henry* (*Application of Charles Henry's Chromatic Circle*), 1888. Color lithograph, 15.5 × 17.8 cm (6⅛ × 7 in.)

FIG. 80 (*facing*).
Henri de Toulouse-Lautrec, theater program for Fabre's *L'argent* (*Money*), 1895. Color lithograph with brush, crayon, and spatter, 31.8 × 23.6 cm (12½ × 9⁵⁄₁₆ in.)

Montmartre's revolutionary Théâtre Libre, which staged more than a hundred plays from 1887 to 1896, commissioned theater programs from a number of young artists. One of the first of these commissions was Paul Signac's inventive program for a trio of plays presented on December 10, 1888 (fig. 79). With the details of the program relegated to the verso of the sheet, the recto displays the theater's large initials above an aperture showing the back of a man's head seated in the audience. The design and unusual color scheme reflect the aesthetic theories of Charles Henry (1859–1926), whose *Cercle chromatique* (*Chromatic Circle*) of 1888 was taken to heart by Signac and Georges Seurat. Similarly audacious in conception is Henri de Toulouse-Lautrec's program for Emile Fabre's comedy *L'argent* (*Money*) staged toward the end of the Théâtre Libre's run on May 5, 1895 (fig. 80). Influenced by the aesthetic of Japanese prints, Toulouse-Lautrec simplifies the flat silhouettes of the play's central characters, Monsieur and Madame Reynard, both of whom are shown from behind. The oblique perspective contributes to the disorienting

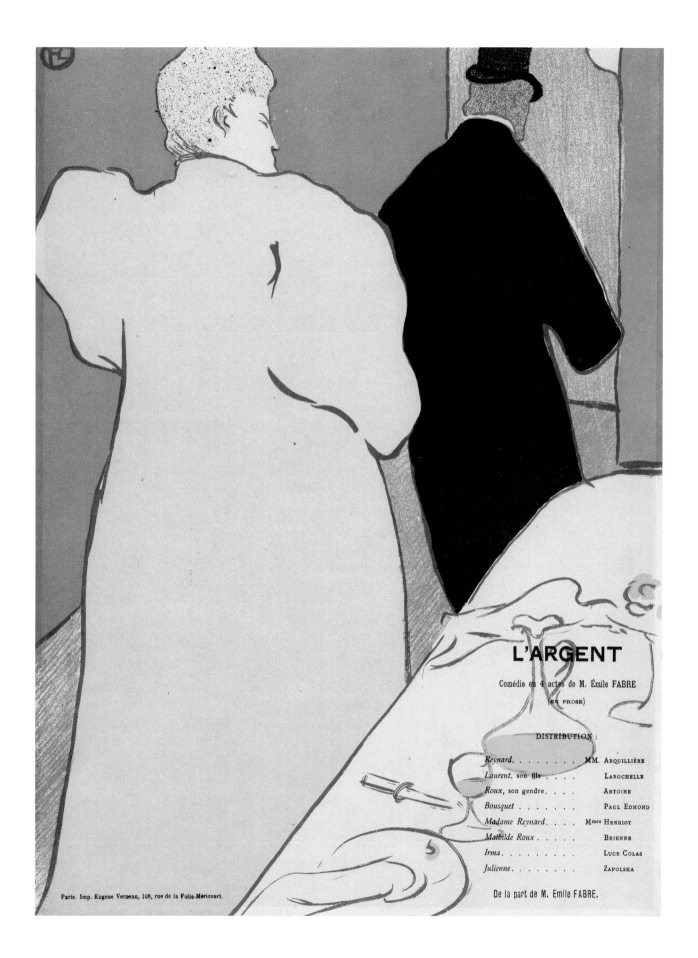

L'ARGENT

Comédie en 4 actes de M. Émile FABRE

(EN PROSE)

DISTRIBUTION :

Reynard.	MM.	ARQUILLIÈRE
Laurent, son fils		LAROCHELLE
Roux, son gendre		ANTOINE
Bousquet		PAUL EDMOND
Madame Reynard. . . .	Mmes	HENRIOT
Mathilde Roux		BRIENNE
Irma.		LUCE COLAS
Julienne.		ZAPOLSKA

De la part de M. Émile FABRE.

Paris. Imp. Eugène Verneau, 108, rue de la Folie-Méricourt.

construction; whether the figures are exiting stage left or stage right is not clear.

Toulouse-Lautrec's last great project centered on one of the most popular forms of public spectacle, the circus. During the spring of 1899, while confined to a sanitarium, he created from memory a series of drawings of circus subjects that he intended to publish in book form. *Au cirque: Cheval pointant* (*At the Circus: Rearing Horse*) (fig. 81) represents a death-defying act in which a pudgy trainer positions himself beneath the hooves of a powerful rearing horse. It is noteworthy that the bleachers remain empty, as this performance was for an audience of one. Through this sheet and the others composing the circus album, the infirm artist sought to demonstrate that his creative faculties, and his supreme powers of draftsmanship, remained intact. They were not enough, however, to spare his life before the circus drawings would finally appear in print.

Feats of horsemanship also feature in one of James Tissot's late artistic projects, an intended series of fifteen paintings and reproductive etchings entitled *La femme à Paris* (*The Parisian Woman*) that he worked on from 1883 to 1885. Based on his original painting now in the collection of the Rhode Island School of Design, *Ces dames des chars* (*Ladies of the Chariots*) (fig. 82) was one of only five etchings that he completed before abandoning the venture. The setting is the great Paris Hippodrome, an immense iron-and-glass structure located at place de l'Alma. Prior to blowing down in a windstorm in 1892, the Hippodrome was home

FIG. 82.
James Tissot, *Ces dames des chars* (*Ladies of the Chariots*), 1885. Etching and drypoint, 40 × 25.4 cm (15¾ × 10 in.)

FIG. 83.
Jean-Emile Laboureur,
Le Bal Bullier, 1898. Woodcut,
22.2 × 28.8 cm (8¾ × 11⁵⁄₁₆ in.).
Collection of Ronald E. Bornstein

to a renowned circus company and often featured chariot races in the manner of the ancient Greeks and Romans. In this spectacular modern space, which had been recently converted from gas lighting to electricity, thousands of Parisians could attend a single performance, cheering on the stunning Amazons in their shimmering, form-fitting costumes.[6] With the eye of a photojournalist, Tissot captured every detail from a dramatic ringside seat.

The great urban masses that congregated in cavernous entertainment venues such as the Hippodrome and spilled out afterward onto the broad boulevards became a fundamental component of the spectacle of modern Paris. At century's end, explicit crowd imagery—as in Jean-Emile Laboureur's packed woodcut of the famous Bal Bullier dance hall (fig. 83)—enhanced the pictorial repertoire of the metropolis. Perhaps no graphic

work embodies this concept more vividly than Félix Vallotton's woodcut of fireworks at the Exposition Universelle of 1900 (fig. 84). In this bold image, an endless sea of spectators competes with the spectacle of falling rockets to light the darkness of the frame.

NOTES

1. "The Great Show at Paris," *Harper's New Monthly Magazine* 35, no. 206 (July 1867): 238.

2. Edmond Deschaumes, *Pour vien voir Paris* (Paris: Maurice Dreyfous, 1889), 84; translated in Vanessa R. Schwartz, *Spectacular Realities: Early Mass Culture in Fin-de-siècle Paris* (Berkeley: University of California Press, 1998), 1.

3. See John House et al., *Renoir at the Theater: Looking at "La Loge,"* exh. cat. (London: Courtauld Gallery, 2008).

4. A full discussion of this painting, including the identification of the figures, appears in Jean Sutherland Boggs et al., *Degas*, exh. cat. (New York: Metropolitan Museum of Art, 1988), 161–163.

5. For additional discussion of this pastel, see Guy Cogeval et al., *Edouard Vuillard*, exh. cat. (Washington, D.C.: National Gallery of Art, 2003), 116–117. Cogeval identifies the play as *Rosmersholm*. It has also been identified as a scene from Ibsen's *Fruen fra havet* (*The Lady from the Sea*, 1890) staged in December 1892 at the Théâtre Moderne; see Patricia Eckert Boyer, *Artists and the Avant-Garde Theater in Paris, 1887–1900*, exh. cat. (Washington, D.C.: National Gallery of Art, 1998), 103.

6. On the Hippodrome's system of electric lighting, see Edouard Hospitalier, *The Modern Applications of Electricity*, trans. Julius Maier (London: Kegan Paul, Trench, 1883), vol. 1, 422–424.

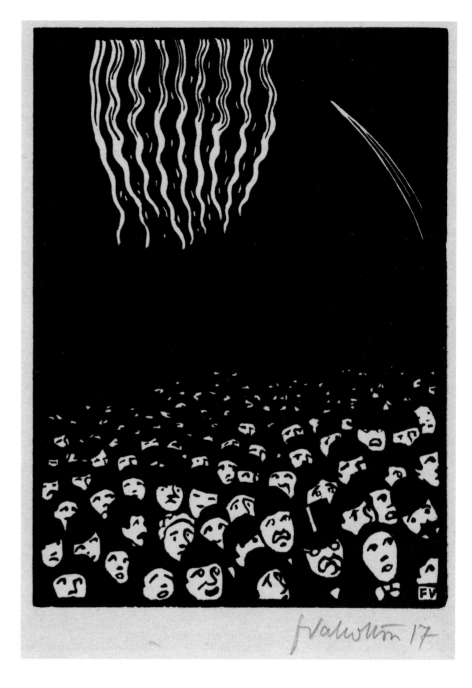

FIG. 84.
Félix Vallotton, *Feu d'artifice (Fireworks)*, from the series *L'Exposition Universelle (World's Fair)*, 1901. Woodcut, 16.4 × 12.2 cm (6⁷⁄₁₆ × 4¹³⁄₁₆ in.)

1889: A Towering Achievement

OF ALL THE SPECTACLES THAT LIT UP THE French capital, none were more spectacular than the Expositions Universelles. At intervals of roughly eleven years, Paris was the site of five world's fairs between 1855 and 1900, each attempting to outshine not only the previous French efforts but also the fairs organized in intervening years by other nations. While the primary theme of these immense public events was progress in the sense of technological innovation and industrialization, the fine arts were given significant attention. The official Salon exhibitions were timed to coincide with the fairs, and artists working in all media took advantage of the unparalleled opportunities to reach international audiences numbering well into the millions.

The 1878 Exposition Universelle showed the world that Paris was alive and well in the wake of the Franco-Prussian War and Commune. Commemorating the hundredth anniversary of the French Revolution, the fair of 1889 made an even bolder statement, enhanced by a singular attraction the likes of which had never been seen before. Upon its completion for the opening of the fair,

Gustave Eiffel's 312-meter (1,024-foot) tower became the tallest man-made structure in the world. Its audacious industrial profile violated every design stricture of Haussmann's Paris, and it did so without so much as a nod to historical canons of French architecture. As the monument erupted skyward in advance of the fair's opening, so too did controversies over its form and height. Were it not for two critical factors—its location in the fairgrounds on the Champ de Mars, away from the heart of the city, and its planned demolition after twenty years—the tower might never have been built.

Even before it was completed, the Eiffel Tower captured the imagination of artists and photographers whose views contributed to its iconic status as a symbol of Paris. Georges Seurat was one of the first to paint the tower (fig. 85). Precious in scale but monumental in conception, his luminous oil dates from the early months of 1889 before the third level was finished. Seurat applied his distinctive Pointillist technique to evoke the dappled sunlight penetrating and reflecting off the tower's iron latticework. At the top, the partial structure appears to dissolve into the shimmering sky.

Graphic artist Henri Rivière, a regular contributor to the journal of the Chat Noir cabaret, took a number of snapshots during a press preview of the Eiffel Tower prior to its inauguration. Several of these photographs would later serve as studies for Rivière's compelling homage to the tower, the color lithographic volume *Les trente-six vues de la Tour Eiffel* (*Thirty-six Views of the Eiffel Tower*) (figs. 86, 87, 93), published in 1902. In addition to images of workmen finishing its construction, the book offers a variety of perspectives on the monument through the seasons, evoking its seeming omnipresence in the Parisian cityscape. The model for Rivière's serial project was Katsushika Hokusai's renowned print series *Fugaku sanjurokkei* (*Thirty-six Views of Mount Fuji*) of the 1830s, one of many classics of the Japanese woodcut that was discovered by French artists and collectors of the Impressionist era.

One of the most striking features of the tower was its artificial illumination. Auguste Louis Lepère's nocturnal wood engraving (fig. 88) shows the original gas lighting system put to use during the 1889 fair. In a contemporary New York trade journal, an unnamed "American Electrician" expressed his disappointment in the relative paucity of electrical exhibits at the fair but lavished praise on the lighting of the tower:

> The really grand and impressive Eiffel Tower, with the beautiful grand dome on the one side, and the magnificent Trocadero with its terraces of basins on the

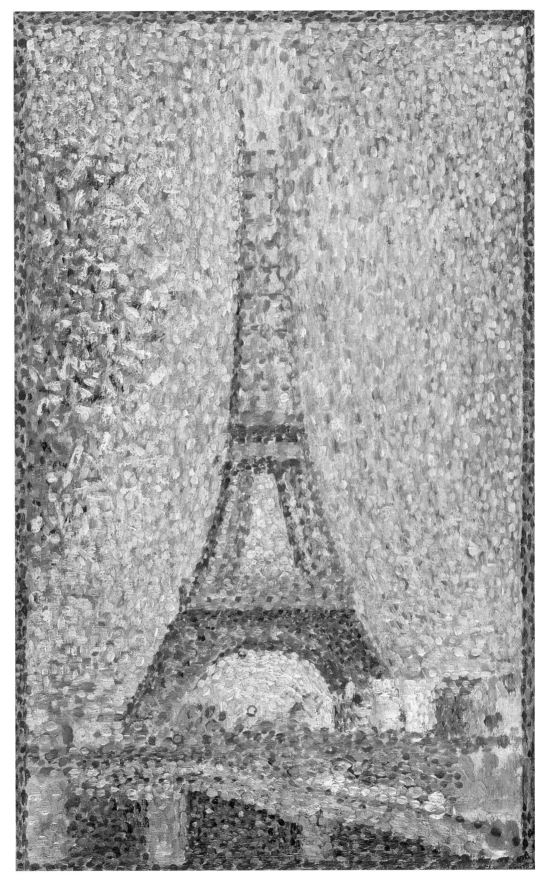

FIG. 85.
Georges Seurat, *Eiffel Tower,*
ca. 1889. Oil on panel,
24.1 × 15.2 cm (9½ × 6 in.)

FIG. 86.
Henri Rivière, *En haut de la Tour*
(*At the Top of the Tower*), from the
book *Les trente-six vues de la Tour
Eiffel* (*Thirty-six Views of the Eiffel
Tower*), 1902. Color lithograph,
17 × 21.1 cm (6¹¹⁄₁₆ × 8⁵⁄₁₆ in.)

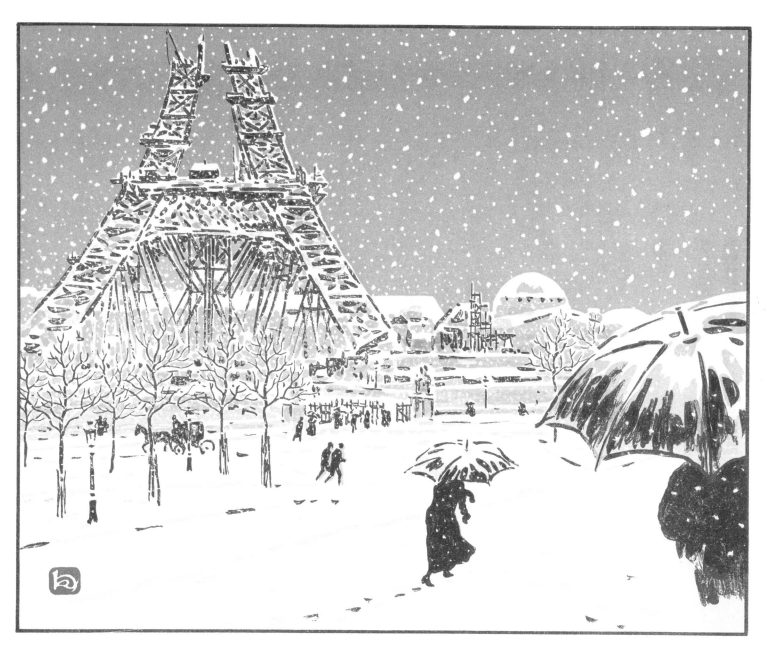

FIG. 87.
Henri Rivière, *La Tour en construction, vue de Trocadéro* (*The Tower under Construction, As Seen from the Trocadéro*), from the book *Les trente-six vues de la Tour Eiffel* (*Thirty-six Views of the Eiffel Tower*), 1902. Color lithograph, 17 × 21.1 cm (6¹¹⁄₁₆ × 8⁵⁄₁₆ in.)

other, are all lit up with millions of gas jets artistically placed in rows and groups, outlining the general contour of the structure. The effect is unquestionably magnificent; the slight flickering of the gas lights in the wind, which could not have been produced by incandescent lights, adds very much to the effect. Among the most imposing exhibits of electrical illumination are the large light-house lamps at the top of the tower, alternately red, white, and blue, which [are] visible for 50 or 60 miles.[1]

In fact, the rotating beacon light was sequenced blue, white, and red to coincide with the tricolor French flag.

Had this same writer returned to Paris for the Exposition Universelle of 1900, he would have been pleased to find the lighting of the Eiffel Tower now fully electrified. Indeed, at the very heart of the fair was the Palais de l'Electricité, a high-tech Palace of Electricity that housed exhibits and provided power to the other attractions. Other technological wonders of the 1900 fair included the Grande Roue de Paris (Great Wheel of Paris), a hundred-meter Ferris wheel that remained the tallest in the world until its demolition in 1920. The Great Wheel is visible in the distance in Gabriel Loppé's crisp nighttime photograph of the Champ de Mars from his balcony at no. 14, avenue du Trocadéro (subsequently renamed avenue du Président Wilson) (fig. 89). Helping transport the massive crowds

FIG. 89.
Gabriel Loppé, *Vue de la Tour Eiffel et de la Grande Roue* (*View of the Eiffel Tower and the Great Wheel*), ca. 1900. Gelatin silver print, 13 × 17.8 cm (5⅛ × 7 in.)

FIG. 90.
Félix Vallotton, *Le trottoir roulant*
(*The Moving Sidewalk*), from the
series *L'Exposition Universelle*
(*World's Fair*), 1901. Woodcut,
12.2 × 15.8 cm (4¹³⁄₁₆ × 6¼ in.)

FIG. 91 (*facing*).
Manuel Orazi, *Théâtre de Loïe Fuller*,
1900. Color lithograph, 201.5 × 64 cm
(79⁵⁄₁₆ × 25³⁄₁₆ in.)

were three variable-speed moving sidewalks, a novelty captured on film by Thomas Edison and in woodcut by Félix Vallotton (fig. 90). Among the sights visible from the walkway was an elaborate re-creation of a medieval French village, a quaint reminder of the past amid the futuristic wonders. Seemingly presiding over this spectacle was the American dancer Loïe Fuller, the so-called Electricity Fairy and unofficial queen of the fair, who performed state-of-the-art shows in her own pavilion.[2] Manuel Orazi's mesmerizing poster designed in high Art Nouveau style hints at the magical world of color and light awaiting audiences for her daily performances (fig. 91).

The Eiffel Tower, one of the few remnants of the great nineteenth-century fairs, has continued to inspire generations of native Parisians and visitors to the City of Light. On the eve of its twentieth anniversary, the tower played a role in an iconic work by the modernist photographer Pierre Dubreuil entitled *Eléphantaisie* (fig. 92). At first glance, the photograph recalls a print from Rivière's *Thirty-six Views of the Eiffel Tower* that similarly incorporates a sculpture by Emmanuel Frémiet in the foreground (fig. 93). Dubreuil's atmospheric photograph focuses on Frémiet's life-size bronze of a young elephant caught in a trap that stood on a pedestal before the Palais du Trocadéro (it is now situated near the entrance to the Musée d'Orsay). Commissioned for the Exposition Universelle of 1878, Frémiet's elephant represented the height of academic realism in the specialized genre of animal sculpture, showing the kind of exquisite detail that led Degas to dismiss the sculptor as pandering to bourgeois taste.[3] Employing a telephoto lens to compress the intervening space, Dubreuil engages Frémiet's and Eiffel's mismatched monuments in a stylistic clash of the titans. Dubreuil's bold juxtaposition shocked viewers when his *Eléphantaisie* was exhibited in London in 1910;[4] it continues to resonate a century after its creation.

NOTES

1. "Notes on the French Exhibition," *The Electrical Engineer* 8, no. 10 (October 1889): 427.

2. See Rhonda K. Garelick, "Electric Salome: Loie Fuller at the *Exposition*

Universelle of 1900," in *Imperialism and Theatre: Essays on World Theatre, Drama, and Performance*, ed. J. Ellen Gainor (London: Routledge, 1995), 85–103.

3. From the memoirs of the critic François Thiebault-Sisson, quoted in Richard Kendall, ed., *Degas by Himself: Drawings, Prints, Paintings, Writings* (1987; repr., Edison, N.J.: Chartwell Books, 2000), 246.

4. Tom Jacobson, *Pierre Dubreuil: Photographs, 1896–1935*, exh. cat. (San Diego: Dubroni Press, 1987), 16–18.

City of Color
and Light

DURING THE BELLE EPOQUE, LITHOGRAPHIC posters bursting with color brought a new form of illumination to the City of Light. "[Jules] Chéret's task was to rescue the drab streets from the monotony of the perfectly straight rows of houses and fill them with the firework of colour, the animation of movement and radiance of joy; to convert the foundations into decorable surfaces; and to compel this open-air museum to reflect the character of the nation and to promote the unconscious training of taste. A thousand magical and laughing visions, masked as advertisements, sprang from the impulses of his genius."[1] So wrote the art critic Roger Marx in 1889 of poster artist Chéret, whom he christened "the decorator of modern Paris." The context of Marx's statement—the preface to an exhibition catalogue of the artist's posters—underscores Chéret's astonishing elevation into the modern pantheon by the art intelligentsia so early in his career.

"Poster mania" reached epidemic proportions during the last decade of the nineteenth century. The incredible popularity of Chéret's images of effervescent young women—*chérettes*, as they

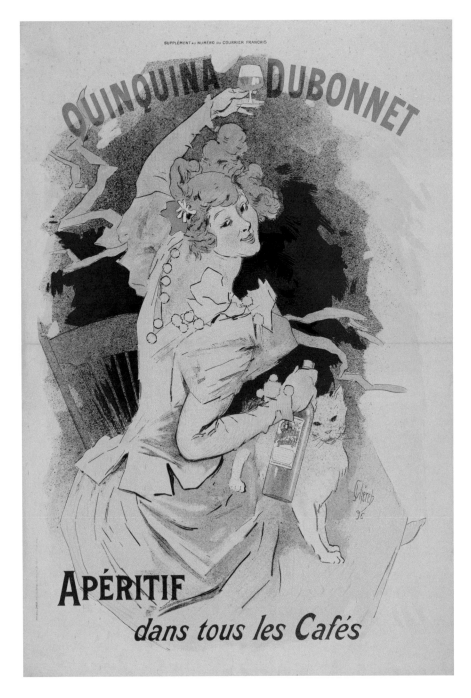

FRONTISPIECE
Henri de Toulouse-Lautrec,
Le photographe Sescau
(*The Photographer Sescau*), 1896,
detail of fig. 98

became known—led to unlawful thefts of countless posters from public display. To help meet the demand, Chéret funneled a portion of his editions directly into the print trade and made smaller versions of certain posters available for sale to aficionados through a series entitled *Les maîtres de l'affiche* (*Masters of the Poster*). Other reduced prints, such as his advertisement for a popular medicinal bitter made from quinine (fig. 94), were folded into subscribers' editions of the weekly magazine *Courrier Français*. The distribution of miniature posters through the mass media was mutually beneficial for graphic designers, advertisers, and poster lovers. While providing an added source of income for artists and feeding the insatiable demand of collectors, they spread commercial messages from the streets of Paris into the homes of potential consumers.

Literary and art journals also commissioned posters to advertise their publications as well as the exhibitions that they sponsored. In addition to fulfilling numerous orders for illustrations from *La Revue Blanche*, Pierre Bonnard designed a large poster advertising the monthly journal in 1894 (fig. 95). While the color scheme is relatively subdued, the design is an explosion of bold shapes and playful typography. Three dark figures—an elegant *parisienne*, a scruffy newsboy, and a hulking man seen from behind—share a single silhouette. They are tightly sandwiched between a magazine rack and the large letters shouting the name of the journal. Bonnard clearly understood the poster's primary raison d'être: to command attention.

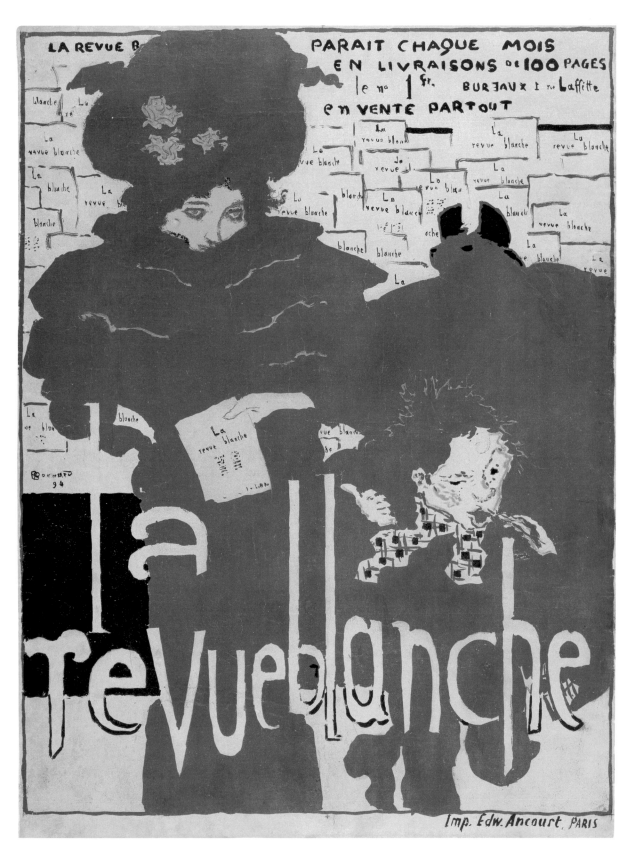

FIG. 94 (*facing*).
Jules Chéret, *Quinquina
Dubonnet*, 1896. Color
lithograph with pen,
crayon, and spatter,
52.6 × 34.5 cm
(20¹¹⁄₁₆ × 13⁹⁄₁₆ in.)

FIG. 95.
Pierre Bonnard,
La Revue Blanche, 1894.
Color lithograph,
74 × 57.5 cm
(29⅛ × 22⅝ in.)

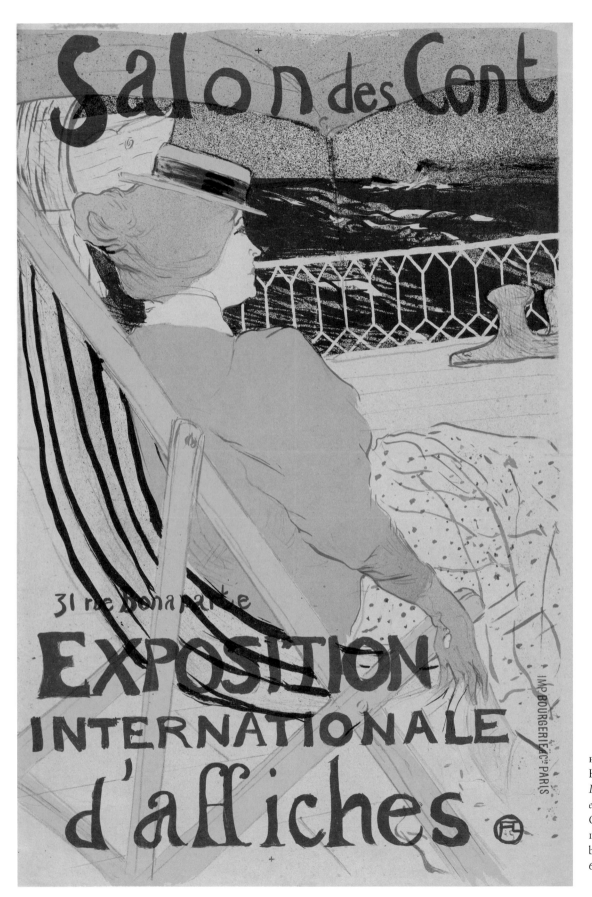

FIG. 96.
Henri de Toulouse-Lautrec,
La passagère du 54—Promenade en yacht (*The Passenger from Cabin 54—On a Cruise*),
1896. Color lithograph with brush, crayon, and spatter,
60.5 × 40 cm (23¹³⁄₁₆ × 15¾ in.)

In 1896, Henri de Toulouse-Lautrec designed the elegant sheet advertising an international exhibition of posters at the Salon des Cent, a gallery run by the literary journal *La Plume* (fig. 96). Entitled *La passagère du 54—Promenade en yacht* (*The Passenger from Cabin 54—On a Cruise*), the poster immortalizes an unnamed woman who caught the artist's eye during a summer cruise. The object of his gaze stares out to sea in a private moment, apparently oblivious that her likeness has been co-opted for public consumption.

By the mid-1890s Toulouse-Lautrec had eclipsed Chéret's stardom in the poster universe. Trained initially as a painter, Toulouse-Lautrec set up a studio amid the dance halls, cabarets, and brothels of Montmartre. Although his activity as a designer of posters lasted a mere eight years, his output created a sensation. The performer and nightclub owner Aristide Bruant was one of his first patrons. In an 1893 poster advertising "soon, at this theater, Aristide Bruant in his cabaret" (fig. 97), Toulouse-Lautrec presents a back view of Bruant's jaunty frame outfitted in his typical black costume with trademark broad-brimmed hat. The collar and sleeve of Bruant's red shirt are indicated by touches of watercolor. In the lower right corner, the artist's circular monogram appears in a form inspired by the seals found on Japanese woodblock prints, then all the rage among Parisian connoisseurs, not the least of whom was Toulouse-Lautrec himself.

A pair of poster commissions from 1896 reveals the range of Toulouse-Lautrec's clientele, which extended beyond the immediate world of popular entertainment. Photographer Paul Sescau, a friend who appeared in a

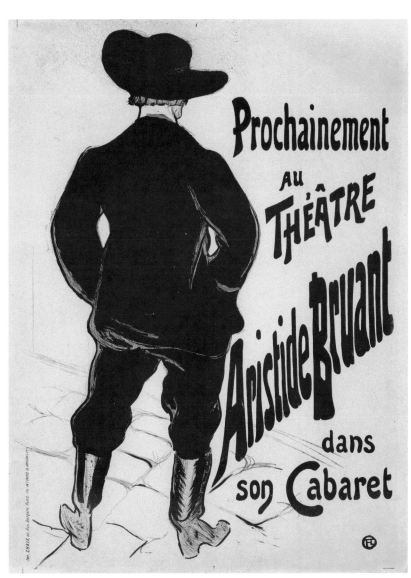

FIG. 97.
Henri de Toulouse-Lautrec, *Aristide Bruant*, 1893. Lithograph with crayon, brush, and spatter, and opaque watercolor additions, 80.1 × 56.5 cm (31⁹⁄₁₆ × 22¼ in.)

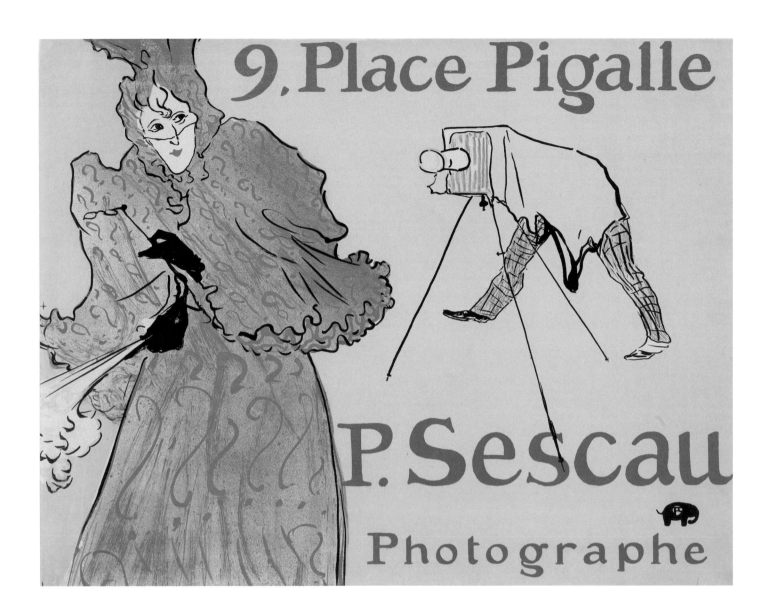

FIG. 98.
Henri de Toulouse-Lautrec,
Le photographe Sescau (*The
Photographer Sescau*), 1896. Color
lithograph with brush, crayon, and
spatter, 61 × 80 cm (24 × 31½ in.)

number of the artist's paintings, advertises his place Pigalle studio in one of Toulouse-Lautrec's most humorous posters (fig. 98). Here the photographer and his bulky camera form a hybrid creature sporting two legs and a single protruding eye, undeniably phallic in appearance. Sescau's lens points toward a fashionable woman in a domino and veil who seems to recoil from his peculiar apparatus. A mirrored form of the distinctive pattern of question marks on her dress recurs in the background of another poster that also places one of Toulouse-Lautrec's cohorts in a suggestive encounter with the opposite sex.[2] L'Artisan Moderne was a line of limited-edition objets d'art, jewelry, and home furnishings marketed by André Marty, the creator of the print albums *L'estampe originale*. In Toulouse-Lautrec's poster (fig. 99) an eager craftsman, the medalist Henri

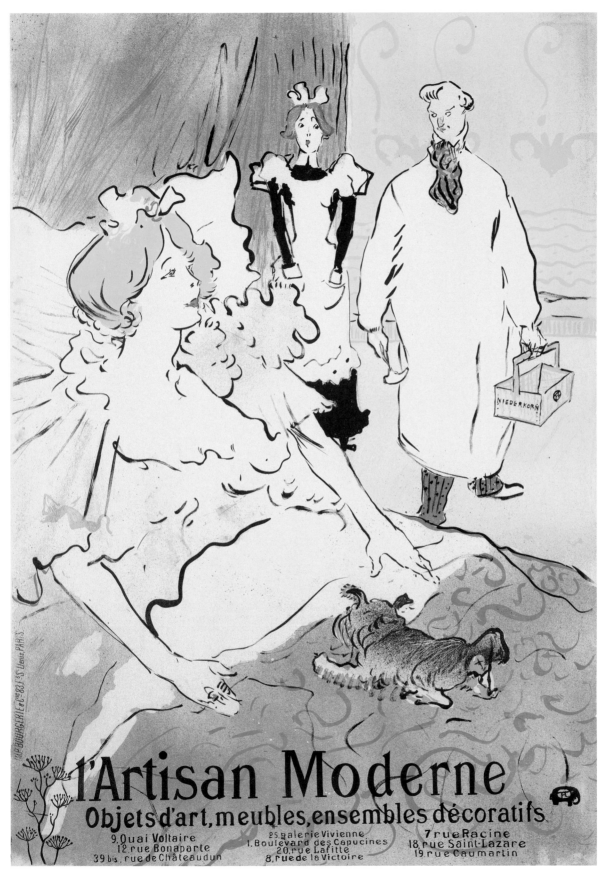

FIG. 99.
Henri de Toulouse-Lautrec,
L'Artisan Moderne
(*The Modern Artisan*),
1896. Color lithograph
with crayon, brush,
and spatter, 90 × 64 cm
(35⁷⁄₁₆ × 25³⁄₁₆ in.)

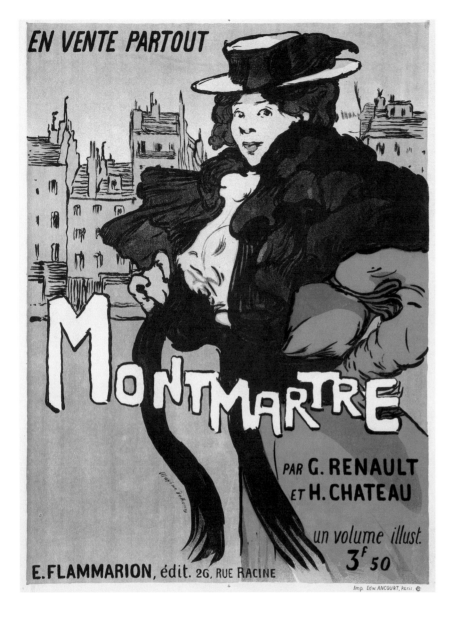

EN VENTE PARTOUT

MONTMARTRE

PAR G. RENAULT
ET H. CHATEAU

un volume illust.
3ᶠ 50

E. FLAMMARION, édit. 26, RUE RACINE

Imp. Edw. ANCOURT, Paris.

Nocq, resembles a doctor making a house call, tools in hand, as he is shown into the bedroom of an attractive *parisienne*.

Among Toulouse-Lautrec's many followers, the young artist Maxime Dethomas was also one of his closest friends during the 1890s, joining him on occasion in partaking of the many guilty pleasures of Montmartre. Toward the end of the decade, Dethomas began designing posters, including an advertisement for a definitive four-hundred-page guidebook and history of Montmartre (fig. 100), the *quartier* that owed its reputation of permissiveness to the fact that it technically fell outside the city limits of Paris.[3] The poster relies on the image of an attractive woman to call attention to its product, a formula established by Chéret that was based on a simple premise: the sight of a pretty woman will turn the head of a male consumer.

The quintessential proponent of the Art Nouveau style, Czech-born Alphonse Mucha, made a specialty of the commodification of women. His poster for JOB cigarette papers (fig. 101) exploits every trick of modern advertising to entice the target audience: a gorgeous model, plenty of bare skin, and an almost hypnotically beautiful design incorporating the brand name. Mucha revels equally in natural and geometric forms: the swirling locks of hair and the decorative pattern in the background. Setting aside the elements of anecdote and humor that characterize Toulouse-Lautrec's productions, Mucha was entranced by his own vision of the poster as a precious thing of beauty, a receptacle of visual splendor that just happens to sell a product.

FIG. 100.
Maxime Dethomas, *Montmartre par G. Renault et H. Château* (*Montmartre by G. Renault and H. Château*), ca. 1897. Color lithograph with brush and spatter, 78.5 × 58.5 cm (30⅞ × 23¹/₁₆ in.)

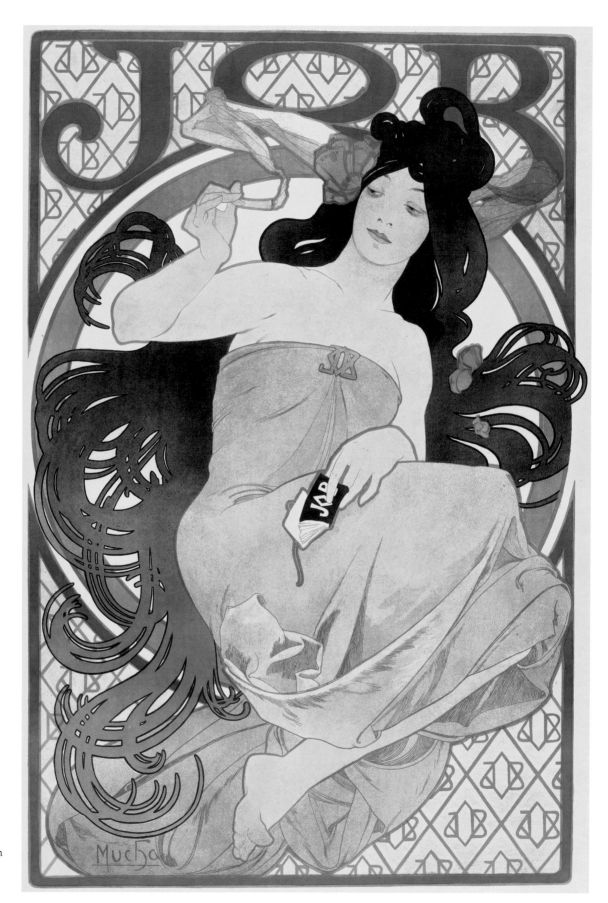

FIG. 101.
Alphonse Mucha, *JOB*, ca. 1898.
Color lithograph, 138.5 × 92.5 cm
(54½ × 36⁷⁄₁₆ in.)

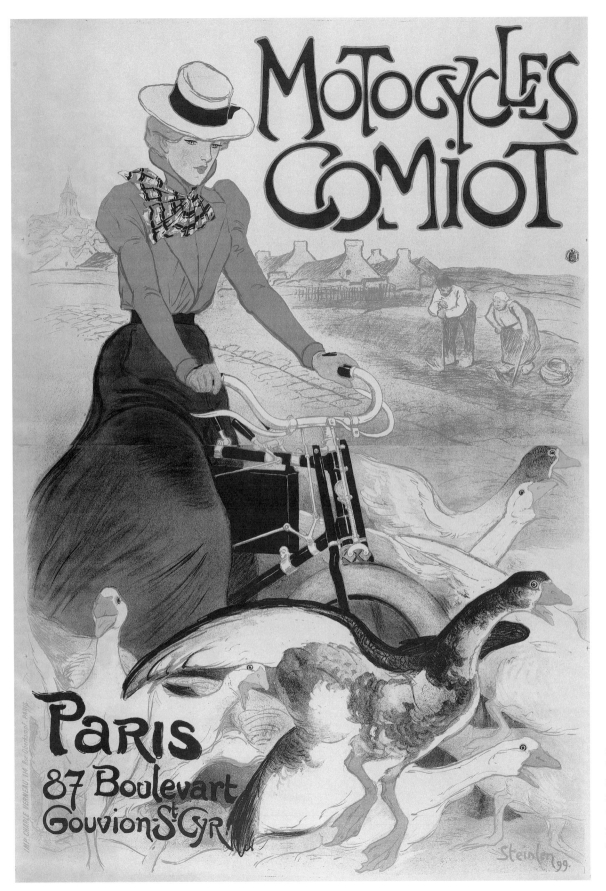

FIG. 102.
Théophile Alexandre
Steinlen, *Motocycles Comiot*,
1899. Color lithograph
with crayon and brush
printed on two joined
sheets, 200 × 140 cm
(78¾ × 55⅛ in.)

A more down-to-earth vision of the modern woman is shown in Théophile Alexandre Steinlen's magnificent poster for *Motocycles Comiot* (1899) (fig. 102). At the turn of the century, Comiot manufactured a popular line of petroleum-powered tricycles that were available at its showroom on boulevard Gouvion-Saint-Cyr, not far from the Porte Maillot entrance to the Bois de Boulogne. An item in the *Almanach Hachette* (1900) enthused, "The tricycle, which was a rarity only two years ago, is now a means of transportation for everyone. The tricycle furrows the city streets and country roads. One cannot take 100 steps without hearing the characteristic *teuf teuf*."[4] Printed on two sheets of paper, Steinlen's enormous poster provides but a glimpse of the motorized tricycle itself, relying instead on humor to sell its product: a female driver has steered the contraption into a flock of geese.

The great French posters of the fin de siècle preserve an essential aspect of the Belle Epoque. They encapsulate the glamour, wit, and taste of a society that did not fear but rather celebrated the turn of the century. While marking the end of an era, the colorful posters of Chéret, Toulouse-Lautrec, and Steinlen heralded the dawn of a new golden age of materialism, a booming consumer culture in which advertising would become a science and an industry as well as an art.

NOTES

1. Roger Marx, preface to *Catalogue de l'exposition des oeuvres de Jules Chéret*, exh. cat. (Paris: Bodinière Gallery, 1889), translated in Patricia Eckert Boyer, "*L'Estampe Originale* and the Revival of Decorative Art and Craft in Late Nineteenth-Century France," in *L'Estampe Originale: Artistic Printmaking in France, 1893–1895*, exh. cat., by Patricia Eckert Boyer and Phillip Dennis Cate (Zwolle, Netherlands: Waanders Publishers; Amsterdam: Van Gogh Museum, 1991), 28.

2. Riva Castleman, *Toulouse-Lautrec: Posters and Prints from the Collection of Irene and Howard Stein*, exh. cat. (Atlanta: High Museum of Art, 1998), 106–108.

3. Georges Renault and Henri Château, *Montmartre* (Paris: E. Flammarion, 1897). Dethomas appears in Toulouse-Lautrec's painting *Maxime Dethomas: Au bal de l'Opéra* (1896), which is in the collection of the National Gallery of Art, Washington, D.C.

4. "Sports: Le Tour de France en tricycle," *Almanach Hachette—La vie practique*, 1900, L.

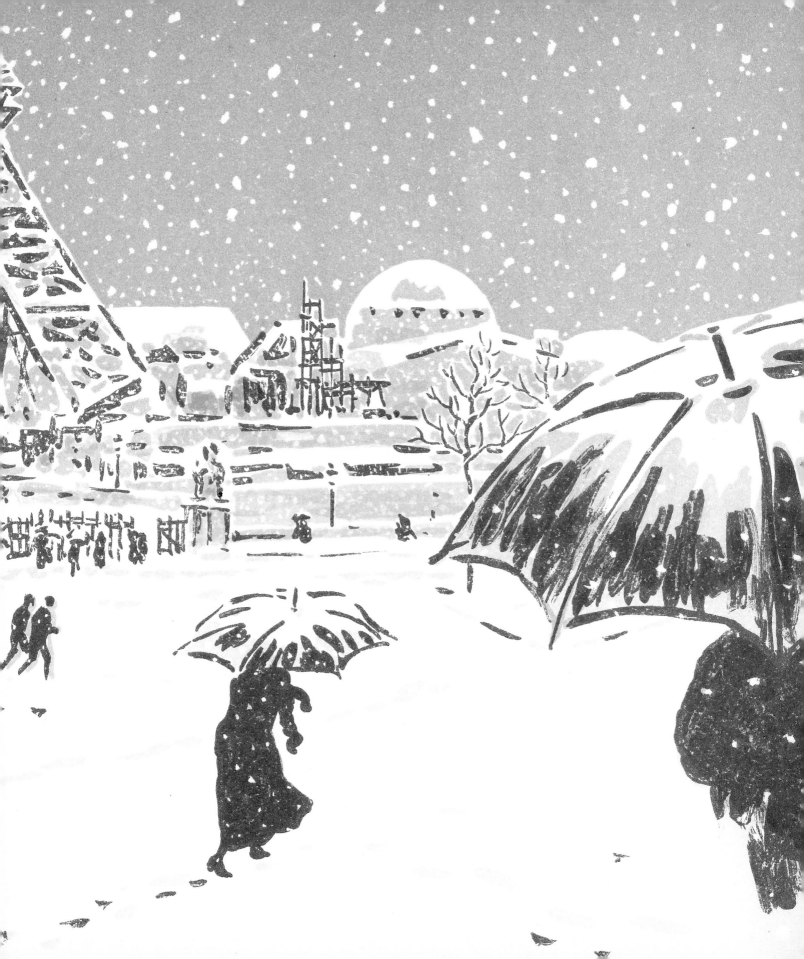

SUGGESTED FURTHER READING

Benjamin, Walter. *The Arcades Project.* Translated by Howard Eiland and Kevin McLaughlin. Cambridge, Mass.: Belknap Press of Harvard University Press, 1999.

Boyer, Patricia Eckert, and Phillip Dennis Cate. *L'Estampe Originale: Artistic Printmaking in France, 1893–1895,* exh. cat. Zwolle, Netherlands: Waanders Publishers; Amsterdam: Van Gogh Museum, 1991.

Brenneman, David A., et al. *Paris in the Age of Impressionism: Masterworks from the Musée d'Orsay,* exh. cat. Atlanta: High Museum of Art, 2002.

Carmona, Michel. *Haussmann: His Life and Times, and the Making of Modern Paris.* Translated by Patrick Camiller. Chicago: Ivan R. Dee, 2002.

Cate, Phillip Dennis. *The Graphic Arts and French Society, 1871–1914.* New Brunswick, N.J.: Rutgers University Press, 1988.

———. *Prints Abound: Paris in the 1890s,* exh. cat. Washington, D.C.: National Gallery of Art, 2000.

Clayson, Hollis. *Paris in Despair: Art and Everyday Life under Siege (1870–1871).* Chicago: University of Chicago Press, 2002.

Jordan, David P. *Transforming Paris: The Life and Labors of Baron Haussmann.*

Chicago: University of Chicago Press, 1995.

Melot, Michel. *The Impressionist Print.* Translated by Caroline Beamish. New Haven, Conn.: Yale University Press, 1996.

Parshall, Peter. *The Darker Side of Light: Arts of Privacy, 1850–1900,* exh. cat. Washington, D.C.: National Gallery of Art, 2009.

Rice, Shelley. *Parisian Views.* Cambridge, Mass.: MIT Press, 1997.

Shapiro, Barbara Stern. *Pleasures of Paris: Daumier to Picasso,* exh. cat. Boston: Museum of Fine Arts, 1991.

FINE ARTS MUSEUMS OF SAN FRANCISCO PUBLICATIONS

Berson, Ruth, ed. *The New Painting: Impressionism 1874–1886: Documentation.* 2 vols.: vol. 1 reviews, vol. 2 exhibited works. San Francisco: Fine Arts Museums of San Francisco, 1996.

Guégan, Stéphane, and Alice Thomine-Berrada, eds. *Birth of Impressionism: Masterpieces from the Musée d'Orsay,* exh. cat. San Francisco: Fine Arts Museums of San Francisco; New York: DelMonico Books / Prestel, 2010.

Hattis, Phyllis. *Four Centuries of French Drawings in the Fine Arts Museums of San Francisco.* San Francisco: Fine Arts Museums of San Francisco, 1977.

Johnson, Robert Flynn, and Joseph R. Goldyne. *Master Drawings from the Achenbach Foundation for Graphic Arts,* exh. cat. San Francisco: Fine Arts Museums of San Francisco, 1985.

Johnson, Robert Flynn, Karin Breuer, and Joseph R. Goldyne. *Treasures of the Achenbach Foundation for Graphic Arts,* exh. cat. San Francisco: Fine Arts Museums of San Francisco, 1995.

Moffett, Charles S., et al. *The New Painting: Impressionism 1874–1886,* exh. cat. San Francisco: Fine Arts Museums of San Francisco, 1986.

Patry, Sylvie, and Stéphane Guégan, eds. *Van Gogh, Gauguin, Cézanne, and Beyond: Post-Impressionist Masterpieces from the Musée d'Orsay,* exh. cat. San Francisco: Fine Arts Museums of San Francisco; New York: DelMonico Books / Prestel, 2010.

Rivière, Henri. *Thirty-Six Views of the Eiffel Tower: A Turn-of-the-Century Tribute to the City of Light.* San Francisco: Fine Arts Museums of San Francisco / Chronicle Books, 2010.

FRONTISPIECE: Henri Rivière, *La Tour en construction, vue de Trocadéro* (*The Tower under Construction, As Seen from the Trocadéro*), 1902, detail of fig. 87

CATALOGUE OF
THE EXHIBITION

Unless denoted with an asterisk, all objects in this checklist are part of the collections of the Fine Arts Museums of San Francisco. Height precedes width in all measurements. Measurements for etchings are of the plate mark. Measurements for lithographs and woodcuts are of image size. Measurements for drawings are of the sheet, unless otherwise noted. Following the checklist is full bibliographic information for the print, drawing, and painting catalogues raisonnés cited.

CITY OF LIGHT
AND SHADOW

LOUIS JULES ARNOUT
French, 1814–1868
Paris en 1860, Vue à vol d'oiseau prise au dessus du rond-point des Champs-Elysées (Bird's-Eye View from above the Champs-Elysées Round-about), plate 2 of the portfolio *Paris dans sa splendeur, vues monuments, histoire (Paris in Its Splendor, Monumental and Historic Views)*, 1861
After Félix Benoist (French, 1818–1896)
Lithograph with tint stone
25.9 × 39.3 cm (10³⁄₁₆ × 15½ in.)
Achenbach Foundation for Graphic Arts Library

EDOUARD BALDUS
French, 1813–1889
Decorative Vase with Seated Man in the Tuileries, ca. 1856
Salt print from wet-collodion-on-glass negative
22.5 × 15 cm (8⅞ × 5⅞ in.)
*Collection of the Troob Family Foundation
[Fig. 10]

Tuileries Palace, plate 6 of the album *Vues de Paris en photographie (Photographic Views of Paris)*, 1858
Albumen silver print from wet-collodion-on-glass negative
18.1 × 26.1 cm (7⅛ × 10¼ in.)

Gift of Drs. Joseph and Elaine Monsen, 1986.3.52

The Louvre and Tuileries, plate 7 of the album *Vues de Paris en photographie (Photographic Views of Paris)*, 1858
Albumen silver print from wet-collodion-on-glass negative
18.3 × 26.3 cm (7³⁄₁₆ × 10⅜ in.)
Gift of Drs. Joseph and Elaine Monsen, 1986.3.53

FÉLIX BRACQUEMOND
French, 1833–1914
Vue du pont des Saints-Pères (View from the Pont des Saints-Pères), 1877
Published in *L'Art*, vol. 12, 1878
Etching, Beraldi 217 iv/iv
19.5 × 24.7 cm (7¹¹⁄₁₆ × 9¾ in.)
Achenbach Foundation for Graphic Arts, 1963.30.1240

CHARLES FRANÇOIS DAUBIGNY
French, 1817–1878
Flying Buttresses of Notre-Dame, ca. 1850
Graphite
20.4 × 24.9 cm (8¹⁄₁₆ × 9¹³⁄₁₆ in.)
Museum purchase, Achenbach Foundation for Graphic Arts Endowment Fund, 1990.2.17
[Fig. 1]

LOUIS-EMILE DURANDELLE
French, 1839–1917
Sculpture ornementale (Ornamental Sculpture),

plate 30 of the book *Le nouvel Opéra de Paris (The New Paris Opéra)* (Paris: Ducher et Cie., 1875–1881), ca. 1865–1872
Albumen silver print from wet-collodion-on-glass negative
28 × 38.4 cm (11 × 15⅛ in.)
Museum purchase, Achenbach Foundation for Graphic Arts Endowment Fund, 1997.81

Sculpture ornementale (Ornamental Sculpture), plate 34 of the book *Le nouvel Opéra de Paris (The New Paris Opéra)* (Paris: Ducher et Cie., 1875–1881), ca. 1865–1872
Albumen silver print from wet-collodion-on-glass negative
27 × 37.5 cm (10⅝ × 14¾ in.)
Museum purchase, Mrs. Milton S. Latham Fund, 1990.3.13

Sculpture ornementale (Ornamental Sculpture), plate 40 of the book *Le nouvel Opéra de Paris (The New Paris Opéra)* (Paris: Ducher et Cie., 1875–1881), ca. 1865–1872
Albumen silver print from wet-collodion-on-glass negative
38.5 × 28 cm (15³⁄₁₆ × 11 in.)
Museum purchase, Mrs. Milton S. Latham Fund, 1988.3.2

JOHAN BARTHOLD JONGKIND
Dutch, 1819–1891
Le Pont de la Tournelle, Paris, 1859

Oil on canvas, Stein and Jongkind 82
45.4 × 73.3 cm (17⅞ × 28⅞ in.)
Gift of Count Cecil Pecci-Blunt, 1958.11

MAXIME LALANNE
French, 1827–1886
Démolitions pour le percement du boulevard Saint-Germain (Demolition for Cutting through Boulevard Saint-Germain), 1862
Etching, Villet 2 iv/ix
31.8 × 23.9 cm (12½ × 9⁹⁄₁₆ in.)
Achenbach Foundation for Graphic Arts, 1963.30.30709
[Fig. 9]

GABRIEL LOPPÉ
French, 1825–1913
Paris, quai de la Seine, péniches (Paris, Quay on the Seine, Barges), ca. 1900
Gelatin silver print
17.8 × 12.9 cm (7 × 5¹⁄₁₆ in.)
Museum purchase, Achenbach Foundation for Graphic Arts Endowment Fund, 1996.106.2

EDOUARD MANET
French, 1832–1883
Under the Arch of the Bridge, in the book *Le fleuve (The River)* by Charles Cros (Paris: Librairie de l'Eau-Forte, 1874)
Etching, Harris 79f
11.6 × 15.5 cm (4⁹⁄₁₆ × 6⅛ in.)
Bruno and Sadie Adriani Collection, 1957.120

ADOLPHE MARTIAL POTÉMONT
French, 1828–1883
Ossuaire des catacombes (Ossuary in the Catacombs), 1862, from the series *L'ancien Paris (Old Paris)*, ca. 1864
After Gaspard-Félix Tournachon (Nadar) (French, 1820–1910)
Etching, Beraldi 1
21.5 × 29.1 cm (8⁷⁄₁₆ × 11⁷⁄₁₆ in.)
Achenbach Foundation for Graphic Arts, 1963.30.33494
[Fig. 6]

Rue Tirechape, 1863, from the series *L'ancien Paris (Old Paris)*, ca. 1864
Etching, Beraldi 1
21.5 × 9.8 cm (8⁷⁄₁₆ × 3⅞ in.)
Achenbach Foundation for Graphic Arts, 1963.30.33497
[Fig. 7]

Rue Tirechape, 1863, from the series *L'ancien Paris (Old Paris)*, ca. 1864
Etching, Beraldi 1
19.5 × 10.5 cm (7¹¹⁄₁₆ × 4⅛ in.)
Achenbach Foundation for Graphic Arts, 1963.30.33485

Pont Notre-Dame, l'arche du diable, 1850 *(Pont Notre-Dame, the Devil's Arch, 1850)*, from the series *L'ancien Paris (Old Paris)*, ca. 1864
After Henri Le Secq (French, 1818–1882)
Etching, Beraldi 1
21.5 × 29.3 cm (8⁷⁄₁₆ × 11⁹⁄₁₆ in.)
Achenbach Foundation for Graphic Arts, 1963.30.33453
[Fig. 5]

Ancien Paris, rue Saint-Eloi (Cité) (Old Paris, Rue Saint-Eloi [Ile de la Cité]), from the series *Eaux-fortes sur Paris (Etchings of Paris)*, 1874
Etching, not in Beraldi
31.2 × 23.8 cm (12⁵⁄₁₆ × 9⅜ in.)
Achenbach Foundation for Graphic Arts, 1963.30.33488

CHARLES MARVILLE
French, 1816–1879
Rue Saint-Germain l'auxerrois de la rue des Prêtres (Rue Saint-Germain l'Auxerrois from Rue des Prêtres), ca. 1865
Albumen silver print from wet-collodion-on-glass negative
28.2 × 27.2 cm (11⅛ × 10¹¹⁄₁₆ in.)
Museum purchase, Mrs. Milton S. Latham Fund, 1989.3.7

Rue des Sept-Voies de la rue Saint-Hilaire (Rue des Sept-Voies from Rue Saint-Hilaire), ca. 1865
Albumen silver print from wet-collodion-on-glass negative on lithographed mount
28.7 × 26.7 cm (11⁵⁄₁₆ × 10½ in.)
*Collection of the Troob Family Foundation
[Fig. 8]

Street Lamp, Courtyard of the Railway Station at Sceaux, 1870s
Albumen silver print from wet-collodion-on-glass negative
36.5 × 26 cm (14⁵⁄₁₆ × 9½ in.)
Museum purchase, Achenbach Foundation for Graphic Arts Endowment Fund, 2009.35.2
[Fig. 14]

Street Lamp, 8 Place de l'Opéra, 1870s
Albumen silver print from wet-collodion-on-glass negative
36.3 × 24.1 cm (14⁵⁄₁₆ × 9½ in.)
Museum purchase, Achenbach Foundation for Graphic Arts Endowment Fund, 2009.35.1
[Fig. 15]

CHARLES MERYON
French, 1821–1868
Le Petit Pont, 1850
Etching with engraving on blue paper, Schneiderman and Raysor 20 iii/ix
26 × 18.9 cm (10¼ × 7⁷⁄₁₆ in.)
Museum purchase, Achenbach Foundation for Graphic Arts Endowment Fund, 1963.32.14
[Fig. 2]

La Galerie Notre-Dame (The Gallery of Notre-Dame), 1853
Etching on chine collé, Schneiderman and Raysor 29 iv/vi
28.3 × 17.5 cm (11⅛ × 6⅞ in.)
Achenbach Foundation for Graphic Arts, 1963.30.384

Le Pont-au-Change, 1854
Etching with drypoint, Schneiderman and Raysor 40 v/xii
15.5 × 33.5 cm (6⅛ × 13³⁄₁₆ in.)
Achenbach Foundation for Graphic Arts, 1963.30.392

Le Pont-au-Change, 1854
Etching with drypoint and graphite, Schneiderman and Raysor 40 vii/xii
15.5 × 33.5 cm (6⅛ × 13³⁄₁₆ in.)
Museum purchase, Elizabeth Ebert and Arthur W. Barney Fund, 1977.1.44
[Fig. 3]

Le Pont-au-Change, 1854
Etching with drypoint on China paper, Schneiderman and Raysor 40 x/xii
15.5 × 33.5 cm (6⅛ × 13³⁄₁₆ in.)
Gift of Osgood Hooker, 1959.124.13
[Fig. 4]

AUGUSTE MESTRAL
French, 1812–1884
Statue of an Angel, Sainte-Chapelle, 1852–1853
Salted paper print from wax paper negative
34.7 × 20.9 cm (13¹¹⁄₁₆ × 8¼ in.)
*Collection of the Troob Family Foundation
[Fig. 11]

Statue of an Angel, Sainte-Chapelle, 1852–1853
Salted paper print from wax paper negative
35.3 × 20.6 cm (13⅞ × 8⅛ in.)
Museum purchase, Prints and Drawings Art
Trust Fund, 1999.194.5
[Fig. 12]

THÉODORE MULLER
French, 1819–1879
*Paris en 1860, Vue à vol d'oiseau prise au dessus
du quartier de Saint-Gervais (Bird's-Eye View
from above the Quartier Saint-Gervais)*, plate 3
of the portfolio *Paris dans sa splendeur, vues
monuments, histoire (Paris in Its Splendor,
Monumental and Historic Views)*, 1861
After Félix Benoist (French, 1818–1896)
Lithograph with tint stone
26 × 39.9 cm (10¼ × 15¹¹⁄₁₆ in.)
Achenbach Foundation for Graphic Arts
Library
[Back jacket]

CÉLESTIN FRANÇOIS NANTEUIL
French, 1813–1873
Rue de la Vieille-Lanterne, 1855
Crayon lithograph on chine collé, Beraldi 94
20.5 × 12.5 cm (8¹⁄₁₆ × 4¹⁵⁄₁₆ in.)
Museum purchase, Achenbach Foundation for
Graphic Arts Endowment Fund, 1987.1.99

GABRIELLE-MARIE NIEL
French, ca. 1830–after 1894
*Ruines de l'hôtel de Bretonvilliers, à la
Pointe de l'Ile Saint-Louis (Ruins of the
Hotel de Bretonvilliers, at the Point of
Ile Saint-Louis)*, 1875
Etching on chine collé, state before letters
24 × 32 cm (9⁷⁄₁₆ × 12⅝ in.)
Achenbach Foundation for Graphic Arts,
1963.30.31151

STREET LIFE

ANONYMOUS
French, active nineteenth century
Perspective du boulevard des Italiens,
from the album *Views of Paris*, ca. 1887
Albumen silver print
9.7 × 15.3 cm (3¹³⁄₁₆ × 6 in.)
Gift of Serge Millan, 1989.3.13.19

PIERRE BONNARD
French, 1867–1947
*Coin de rue vue d'en haut (Street Corner Seen
from Above)*, 1896–1897, from the album
*Quelques aspects de la vie de Paris (Some Scenes
of Parisian Life)*, 1899
Color lithograph with scraping, Roger-Marx 68
37 × 21 cm (14⁹⁄₁₆ × 8¼ in.)
Museum purchase, Achenbach Foundation for
Graphic Arts Endowment Fund, 1964.142.41
[Fig. 22]

*Rue le soir sous la pluie (Street on a Rainy
Evening)*, 1896–1897, from the album
*Quelques aspects de la vie de Paris (Some
Scenes of Parisian Life)*, 1899
Color lithograph with scraping, Roger-Marx 66
25.6 × 35.1 cm (10¹⁄₁₆ × 13¹³⁄₁₆ in.)
Museum purchase, Achenbach Foundation for
Graphic Arts Endowment Fund, 1966.80.53
[Fig. 21]

FÉLIX HILAIRE BUHOT
French, 1847–1898
*L'hiver à Paris, ou La neige à Paris (Parisian
Winter, or Paris in the Snow)*, 1879
Etching, drypoint, aquatint, and roulette,
Bourcard 128 ix/ix
23.8 × 34.7 cm (9⅜ × 13¹¹⁄₁₆ in.)
Gift of Dr. Ludwig A. Emge, 1971.17.61
[Fig. 18]

JEANNE CHAPUIS
French, active late nineteenth century
*Pardessus et toilettes d'hiver (Overcoats and
Winter Accessories)*, 1895
Published in *La Mode Illustrée*,
October 6, 1895
Gillotage
32 × 51.3 cm (12⅝ × 20³⁄₁₆ in.)
Gift of Bud Johns in memory of Judith Clancy,
1995.69.3

HERMANN-PAUL (PSEUDONYM OF
RENÉ GEORGES HERMANN PAUL)
French, 1864–1940
Modistes (Milliners), from the album *L'estampe
originale*, album VI, 1894
Color lithograph with crayon and spatter,
IFF 24
24.5 × 35.4 cm (9⅝ × 13¹⁵⁄₁₆ in.)
Achenbach Foundation for Graphic Arts,
1963.30.29004

AUGUSTE LOUIS LEPÈRE
French, 1849–1918
Place de l'Opéra, from the portfolio *Le long de*
*la Seine et des boulevards (Along the Seine and
the Boulevards)*, 1890
Wood engraving on gampi tissue, Lotz-
Brissonneau 225
11.8 × 20.1 cm (4⅝ × 7¹⁵⁄₁₆ in.)
Achenbach Foundation for Graphic Arts,
1963.30.39018.15
[Fig. 16]

*Retour du bois, place de l'Etoile (Back from the
Bois du Boulogne, Place de l'Etoile)*, from the
portfolio *Le long de la Seine et des boulevards
(Along the Seine and the Boulevards)*, 1890
Wood engraving on gampi tissue, Lotz-
Brissonneau 221
11.7 × 20.1 cm (4⅝ × 7¹⁵⁄₁₆ in.)
Achenbach Foundation for Graphic Arts,
1963.30.39018.12

Brouillard (Fog), 1899
Transparent and opaque watercolor and black
chalk over graphite
22.3 × 27 cm (8¾ × 10⅝ in.)
Museum purchase, Achenbach Foundation
for Graphic Arts Endowment Fund, 1965.50
[Fig. 17]

ADOLPHE MARTIAL POTÉMONT
French, 1828–1883
Théâtre du Vaudeville, from the series
*Notes et eaux-fortes pour 1868 (Notes and
Etchings from 1868)*, 1868
Etching, Beraldi 6
27.8 × 42.4 cm (10¹⁵⁄₁₆ × 16¹¹⁄₁₆ in.)
Achenbach Foundation for Graphic Arts,
1963.30.29780

JEAN-FRANÇOIS RAFFAËLLI
French, 1850–1924
Street Scene with Two Figures and a Dog,
ca. 1890
Oil on canvas
50.5 × 66.4 cm (19⅞ × 26⅛ in.)
*Private collection
[Fig. 13]

*Elégante sur le boulevard des Italiens, Paris
(Fashionable Young Woman on Boulevard des
Italiens, Paris)*, ca. 1899
Oil on canvas
133.4 × 118.1 cm (52½ × 46½ in.)
*Collection of Diane B. Wilsey
[Fig. 24]

FÉLIX VALLOTTON
Swiss, active in France, 1865–1925
L'accident (The Accident), 1893, from the series
Paris Intense, 1894
Zincograph on tan paper, Vallotton
et al. 50d
22.2 × 31.1 cm (8¾ × 12¼ in.)
Gift of Edward Tyler Nahem, 2003.151.71
[Fig. 20]

Le coup de vent (The Gust of Wind), 1894
Woodcut, Vallotton et al. 145a
17.8 × 22.3 cm (7 × 8¾ in.)
*Collection of Jack and Margrit Vanderryn
[Fig. 19]

EDOUARD VUILLARD
French, 1868–1940
La pâtisserie (The Pastry Shop), from the
album *Paysages et intérieurs (Landscapes and
Interiors)*, 1899
Color lithograph on China paper, Roger-
Marx 41
35.5 × 27 cm (14 × 10⅝ in.)
Achenbach Foundation for Graphic Arts,
1963.30.415
[Fig. 23]

HENRY WOLF
American, 1852–1916
*A Thorough Parisienne—Boulevard des
Italiens*, 1891
After Georges Jeanniot (French, 1848–1934)
Wood engraving on gampi tissue
25.5 × 13 cm (10⅟₁₆ × 5⅛ in.), including
remarques
Achenbach Foundation for Graphic Arts,
1963.30.26018

PRIVILEGED VIEWS

PIERRE BONNARD
French, 1867–1947
Maison dans la cour (House in the Courtyard),
1895–1896, from the album *Quelques aspects
de la vie de Paris (Some Scenes of Parisian
Life)*, 1899
Color lithograph, Roger-Marx 59 trial proof
(unrecorded early state)
34.7 × 26 cm (13⅟₁₆ × 10¼ in.)
Museum purchase, Prints and Drawings Art
Trust Fund, 2009.31
[Fig. 27]

CHARLES COURTNEY CURRAN
American, 1861–1942
Afternoon in the Cluny Garden, Paris, 1889
Oil on panel
23.5 × 30.5 cm (9¼ × 12 in.)
Bequest of Constance Coleman Richardson,
2002.55

EDGAR DEGAS
French, 1834–1917
La coiffure (Woman Dressing), ca. 1885
Charcoal and pastel on gray paper, not in
Lemoisne
58.5 × 43 cm (23⅟₁₆ × 16¹⁵⁄₁₆ in.)
Memorial gift from Dr. T. Edward and
Tullah Hanley, Bradford, Pennsylvania,
69.30.42
[Fig. 30]

*Femme s'essuyant (Seated Bather Drying Her
Neck)*, ca. 1905–1910
Charcoal and pastel on two joined sheets
of tracing paper mounted on board,
Lemoisne 1172
68.7 × 58.1 cm (27⅟₁₆ × 22⅞ in.)
Gift of Mrs. John Jay Ide, 1995.62
[Fig. 31]

HENRI GABRIEL IBELS
French, 1867–1936
Woman Reading, ca. 1890s
Black chalk and gouache with graphite
on tan paper
24.1 × 31.8 cm (9½ × 12½ in.) (image)
*Private collection

GEORGES SEURAT
French, 1859–1891
Woman Bending, Viewed from Behind,
ca. 1881–1882
Conté crayon, Hauke 494
31.1 × 24.2 cm (12¼ × 9½ in.)
Memorial gift from Dr. T. Edward and Tullah
Hanley, Bradford, Pennsylvania, 69.30.187
[Fig. 26]

PAUL SIGNAC
French, 1863–1935
Le dimanche (Sunday), 1887–1888
Published in *La Revue Indépendante*, Edition
de luxe (Edition des Fondateurs-Patrons),
no. 15, tome 6, January 1888
Crayon lithograph, Kornfeld and Wick 2
17.3 × 12 cm (6¹³⁄₁₆ × 4¾ in.)

Achenbach Foundation for Graphic Arts,
1963.30.2733
[Fig. 25]

JAMES TISSOT
French, 1836–1902
Soirée d'été (Summer Evening), 1882
Drypoint and etching, Wentworth 56 ii/ii
23 × 39.7 cm (9⅟₁₆ × 15⅝ in.)
Achenbach Foundation for Graphic Arts,
1963.30.1392
[Fig. 32]

EDOUARD VUILLARD
French, 1868–1940
Interior with Mother and Child, 1898
Oil on paper board, Salomon and Cogeval
VII-32
42.5 × 34.9 cm (16¾ × 13¾ in.)
Bequest of Mrs. Ruth Haas Lilienthal, 1975.3.8

La cuisinière (The Cook), from the album
*Paysages et intérieurs (Landscapes and
Interiors)*, 1899
Color lithograph on China paper, Roger-
Marx 42 ii/ii
35.6 × 27.3 cm (14 × 10¾ in.)
Museum purchase, gift of the Achenbach
Graphic Arts Council, 2009.30
[Fig. 28]

La partie de dames (The Game of Checkers),
from the album *Paysages et intérieurs
(Landscapes and Interiors)*, 1899
Color lithograph on China paper, Roger-
Marx 32 iii/iii
34 × 26.5 cm (13⅜ × 10⅟₁₆ in.)
Museum purchase, Prints and Drawings Art
Trust Fund, 2009.32
[Fig. 29]

JAMES MCNEILL WHISTLER
American, 1834–1903
En plein soleil (In Full Sunlight), from the
series *Douze eaux-fortes d'après nature
(Twelve Etchings from Nature)*, 1858
Etching, Kennedy 15 ii/ii
10 × 13.5 cm (3¹⁵⁄₁₆ × 5⅟₁₆ in.)
Achenbach Foundation for Graphic Arts,
1963.30.442

1871: A CITY OF THE DEAD

HONORÉ DAUMIER
French, 1808–1879
L'empire c'est la paix (The Empire Means Peace),

no. 232 of the series *Actualités* (*Current Events*), 1870
Published in *L'album du siège*, ca. 1871
Gillotage, Noack 3814 iii/iii
23 × 18.5 cm (9⅟₁₆ × 7⁵⁄₁₆ in.)
Achenbach Foundation for Graphic Arts,
1963.30.29629
[Fig. 34]

Square Napoléon, no. 244 of the series *Actualités* (*Current Events*), 1870
Published in *L'album du siège*, ca. 1871
Gillotage, Noack 3824 iii/iii
21.8 × 17.9 cm (8⁹⁄₁₆ × 7⅟₁₆ in.)
Bruno and Sadie Adriani Collection, 1956.360

Un paysage en 1870 (*A Landscape in 1870*),
no. 255 of the series *Actualités* (*Current Events*), 1870
Published in *L'album du siège*, ca. 1871
Gillotage, Noack 3828 iii/iv
22.5 × 17.9 cm (8⅞ × 7⅟₁₆ in.)
Bruno and Sadie Adriani Collection, 1956.359

Epouvantée de l'héritage (*Appalled by the Legacy*), no. 280 of the series *Actualités* (*Current Events*), 1871
Published in *L'album du siège*, ca. 1871
Gillotage, Noack 3838 iii/iii
23 × 18 cm (9⅟₁₆ × 7⅟₁₆ in.)
Achenbach Foundation for Graphic Arts,
1963.30.3311
[Fig. 35]

ANDRÉ ADOLPHE-EUGÈNE DISDÉRI
French, 1819–1889
Pont d'Asnières, ca. 1871
Albumen silver print from wet-collodion-on-glass negative
19.6 × 28.8 cm (7¹¹⁄₁₆ × 11⁵⁄₁₆ in.)
Gift of Joseph A. Baird Jr., 1987.3.5

DRANER (PSEUDONYM OF
JULES RENARD)
Belgian, 1833–1923/26
Paris assiégé (*Paris Besieged*), title page of the series *Paris assiégé, scènes de la vie parisienne pendant le siège* (*Paris Besieged, Scenes of Parisian Life during the Siege*), ca. 1871
Pen lithograph with hand-coloring, IFF 24
26.2 × 20.8 cm (10⁵⁄₁₆ × 8³⁄₁₆ in.)
Achenbach Foundation for Graphic
Arts, A049737

La chasse au dîner (*The Hunt for Dinner*),
plate 2 of the series *Paris assiégé, scènes de la vie parisienne pendant le siège* (*Paris Besieged, Scenes of Parisian Life during the Siege*), ca. 1871
Pen lithograph with hand-coloring, IFF 24:2
21.8 × 16 cm (8⁹⁄₁₆ × 6⁵⁄₁₆ in.)
Achenbach Foundation for Graphic Arts,
A049739

Les ambulances de théâtre (*The Field Hospital Theaters*), plate 10 of the series *Paris assiégé, scènes de la vie parisienne pendant le siège* (*Paris Besieged, Scenes of Parisian Life during the Siege*), ca. 1871
Pen lithograph with hand-coloring, IFF 24:10
21.5 × 15.8 cm (8⁷⁄₁₆ × 6¼ in.)
Achenbach Foundation for Graphic Arts,
1963.30.11055
[Fig. 37]

Tambours et clairons de la Gde. Natle. (*Drums and Bugles of the Garde Nationale*), plate 13 of the series *Paris assiégé, scènes de la vie parisienne pendant le siège* (*Paris Besieged, Scenes of Parisian Life during the Siege*), ca. 1871
Pen lithograph with hand-coloring, IFF 24:13
21.9 × 16.3 cm (8⅝ × 6⁷⁄₁₆ in.)
Achenbach Foundation for Graphic Arts,
1963.30.11056

Les guetteurs (*The Lookouts*), plate 15 of the series *Paris assiégé, scènes de la vie parisienne pendant le siège* (*Paris Besieged, Scenes of Parisian Life during the Siege*), ca. 1871
Pen lithograph with hand-coloring, IFF 24:15
21.4 × 15.9 cm (8⁷⁄₁₆ × 6¼ in.)
Achenbach Foundation for Graphic Arts,
1963.30.11057

Les comestibles (*Edibles*), plate 16 of the series *Paris assiégé, scènes de la vie parisienne pendant le siège* (*Paris Besieged, Scenes of Parisian Life during the Siege*), ca. 1871
Pen lithograph with hand-coloring, IFF 24:16
21.8 × 15.9 cm (8⁹⁄₁₆ × 6¼ in.)
Achenbach Foundation for Graphic Arts,
1963.30.11058

Les comestibles (*Edibles*), plate 17 of the series *Paris assiégé, scènes de la vie parisienne pendant le siège* (*Paris Besieged, Scenes of Parisian Life during the Siege*), ca. 1871
Pen lithograph with hand-coloring, IFF 24:17
21.2 × 16 cm (8⅜ × 6⁵⁄₁₆ in.)

Achenbach Foundation for Graphic Arts,
1963.30.11059

Les effets du bombardement (*The Effects of the Bombardment*), plate 20 of the series *Paris assiégé, scènes de la vie parisienne pendant le siège* (*Paris Besieged, Scenes of Parisian Life during the Siege*), ca. 1871
Pen lithograph with hand-coloring, IFF 24:20
21.3 × 15.9 cm (8⅜ × 6¼ in.)
Achenbach Foundation for Graphic Arts,
1963.30.11062

Les billets de logement (*Lodging for the Troops*), plate 21 of the series *Paris assiégé, scènes de la vie parisienne pendant le siège* (*Paris Besieged, Scenes of Parisian Life during the Siege*), ca. 1871
Pen lithograph with hand-coloring, IFF 24:21
21.4 × 16 cm (8⁷⁄₁₆ × 6⁵⁄₁₆ in.)
Achenbach Foundation for Graphic Arts,
1963.30.11063

Menu de siège (*Menu of the Siege*), plate 22 of the series *Paris assiégé, scènes de la vie parisienne pendant le siège* (*Paris Besieged, Scenes of Parisian Life during the Siege*), ca. 1871
Pen lithograph with hand-coloring, IFF 24:22
21.8 × 15.9 cm (8⁹⁄₁₆ × 6¼ in.)
Achenbach Foundation for Graphic Arts,
1963.30.11064
[Fig. 36]

Pendant le bombardement (*During the Shelling*), plate 23 of the series *Paris assiégé, scènes de la vie parisienne pendant le siège* (*Paris Besieged, Scenes of Parisian Life during the Siege*), ca. 1871
Pen lithograph with hand-coloring, IFF 24:23
21.4 × 15.7 cm (8⁷⁄₁₆ × 6³⁄₁₆ in.)
Achenbach Foundation for Graphic Arts,
1963.30.11065

Le commerce des éclats d'obus (*The Trade in Shell Fragments*), plate 26 of the series *Paris assiégé, scènes de la vie parisienne pendant le siège* (*Paris Besieged, Scenes of Parisian Life during the Siege*), ca. 1871
Pen lithograph with hand-coloring, IFF 24:26
21.9 × 15.4 cm (8⅝ × 6⅟₁₆ in.)
Achenbach Foundation for Graphic Arts,
1963.30.11067

FRANÇOIS-MARIE-LOUIS-ALEXANDRE
FRANCK
French, 1816–1906
Rue Royale, Paris, 1871

Albumen silver print from wet-collodion-on-glass negative
19 × 25 cm (7½ × 9¹³/₁₆ in.)
Museum purchase, Joseph M. Bransten Memorial Fund and gift of James D. Hart, 1990.3.3
[Fig. 39]

EDOUARD MANET
French, 1832–1883
Guerre civile (Civil War), 1871–1874
Crayon lithograph with scraping on chine collé, Harris 72 ii/ii
39.9 × 50.7 cm (15¹¹/₁₆ × 19¹⁵/₁₆ in.)
Museum purchase, Achenbach Foundation for Graphic Arts Endowment Fund, 1964.142.8
[Fig. 33]

JAMES TISSOT
French, 1836–1902
Le foyer de la Comédie-Française pendant le siège de Paris (The Green Room of the Comédie-Française during the Siege of Paris), 1877
Etching, Wentworth 27
38.1 × 27.6 cm (15 × 10⅞ in.)
Museum purchase, Achenbach Foundation for Graphic Arts Endowment Fund, 1978.1.32
[Fig. 38]

J. WULFF, JEUNE
French, active ca. 1871
Rue de Rivoli, from the series *Insurrection de Paris, 1871 (Paris Insurrection, 1871)*, 1871
Albumen silver print from wet-collodion-on-glass negative
21.2 × 16.3 cm (8⅜ × 6⁷/₁₆ in.)
Museum purchase, Achenbach Foundation for Graphic Arts Endowment Fund, 2003.16.3
[Fig. 40]

POWER OF THE PRESS

FÉLIX BRACQUEMOND
French, 1833–1914
Margot la critique [Une pie] (Margot the Critic [A Magpie]), 1854
Published in *L'Artiste*, November 7, 1858
Etching on chine collé, Bouillon Ac4 iii/iv
24 × 20.5 cm (9⁷/₁₆ × 8¹/₁₆ in.)
Gift of Mr. and Mrs. George Hopper Fitch, 1976.1.457
[Fig. 41]

Le lièvre (The Hare), 1872
After Albert de Balleroy (French, 1828–1873)
Published in *The Portfolio*, 1872
Etching, Beraldi 277
17.9 × 25.2 cm (7¹/₁₆ × 9¹⁵/₁₆ in.)
Gift of Ludwig A. Emge, 1971.17.51
[Fig. 47]

ETIENNE CARJAT
French, 1828–1906
Charles Baudelaire, ca. 1863
Published in *Galerie Contemporaine, Littéraire, Artistique*, semestre 1, series 1, 1878
Woodburytype from wet-collodion-on-glass negative
23.2 × 18.3 cm (9⅛ × 7³/₁₆ in.)
Museum purchase, Mrs. Milton S. Latham Fund and Achenbach Foundation for Graphic Arts Endowment Fund, 1993.22

Victor Hugo, ca. 1876
Published in *Galerie Contemporaine, Littéraire, Artistique*, semestre 1, series 1, 1876
Woodburytype from wet-collodion-on-glass negative
23.7 × 19.2 cm (9⁵/₁₆ × 7⁹/₁₆ in.)
Museum purchase, Achenbach Foundation for Graphic Arts Endowment Fund, 1994.136
[Fig. 49]

HONORÉ DAUMIER
French, 1808–1879
La dernière semaine avant l'ouverture du Salon de peinture (The Final Week Before the Opening of the Painting Salon), no. 399 of the series *Actualités (Current Events)*, 1857
Published in *Le Charivari*, May 9, 1857
Crayon lithograph, Noack 2966 ii/ii
20.7 × 25.7 cm (8⅛ × 10⅛ in.)
Gift of Joan and Bill Hamerman Robbins, 1989.1.9

Ma femme . . . , comme nous n'aurions pas . . . (My dear . . . , since we would not have time to see it all in a day . . .), no. 3 of the series *L'exposition de 1859 (The Exhibition of 1859)*, 1859
Published in *Le Charivari*, April 18, 1859
Crayon lithograph, Noack 3137 ii/ii
21.9 × 26.7 cm (8⅝ × 10½ in.)
Bruno and Sadie Adriani Collection, 1956.323

A travers les ateliers (Around the Studios), no. 285 of the series *Souvenirs d'artistes*, 1862

Published in *Le Boulevard*, April 20, 1862
Crayon lithograph with scraping, Noack 3246 ii/ii
25.2 × 21 cm (9¹⁵/₁₆ × 8¼ in.)
Bruno and Sadie Adriani Collection, 1956.331
[Fig. 43]

GILL (PSEUDONYM OF ANDRÉ GOSSET DE GUINES)
French, 1840–1885
Marie Sass (du théâtre de l'Opéra) (Madame Marie Sass [Opera Singer]), 1867
Published in *La Lune*, April 28, 1867
Gillotage with pochoir, IFF 11
47 × 33 cm (18½ × 13 in.)
Theater and Dance Collection, gift of Jerome A. Margala in memory of Nancy Van Norman Baer, 2004.63.1

Portrait authentique de Rocambole, 1867
Published in *La Lune*, November 17, 1867
Gillotage with pochoir, IFF 11
67.6 × 49.2 cm (26⅝ × 19⅜ in.)
Museum purchase, Reva and David Logan Fund, 2005.48.23

Henri Rochefort, 1868
Published in *L'Eclipse*, June 7, 1868
Gillotage with pochoir, IFF 23
33 × 26.2 cm (13 × 10⅝ in.)
Museum purchase, Reva and David Logan Fund, 2005.48.2

Gambetta, 1870
Published in *L'Eclipse*, April 17, 1870
Gillotage with pochoir, IFF 27
36.2 × 27.4 cm (14¼ × 10¹³/₁₆ in.)
Museum purchase, Reva and David Logan Fund, 2005.48.7

L'Eclipse et la censure (L'Eclipse and Censorship), 1871
Published in *L'Eclipse*, November 26, 1871
Gillotage with pochoir, IFF 29
33.3 × 26.7 cm (13⅛ × 10½ in.)
Museum purchase, Reva and David Logan Fund, 2005.48.20
[Fig. 44]

EDOUARD MANET
French, 1832–1883
Le rendez-vous des chats (The Cats' Rendezvous), 1868
Published in *La Chronique Illustrée*, October 25, 1868

Gillotage, Harris 58
44 × 33.5 cm (17⁵⁄₁₆ × 13³⁄₁₆ in.)
Gift of Vincent Price in memory of Coral
Browne Price, 1991.1.153
[Fig. 46]

MARS (PSEUDONYM OF BONVOISIN
MAURICE)
Belgian, 1849–1912
Année 1874 (The Year 1874)
Published in *Le Journal Amusant*, 1874
Gillotage
31 × 26 cm (12³⁄₁₆ × 10¼ in.)
Achenbach Foundation for Graphic Arts,
1963.30.18929

PAUL-ADOLPHE RAJON
French, 1842/43–1888
Victor Hugo, 1879
After Léon Bonnat (French, 1833–1922)
Published in *L'Art*, vol. 18, 1879
Etching, Beraldi 124
31 × 22.8 cm (12³⁄₁₆ × 9 in.)
Achenbach Foundation for Graphic Arts,
1963.30.22997
[Fig. 48]

AUGUSTE RODIN
French, 1840–1917
*Victor Hugo, de face (Victor Hugo, Front
View)*, 1885
Published in the *Gazette des Beaux-Arts*,
March 1889
Drypoint, Thorson 9 iv/ix
22.5 × 17.5 cm (8⅞ × 6⅞ in.)
Museum purchase, Achenbach Foundation
for Graphic Arts Endowment Fund, 1966.80.56
[Fig. 50]

PAUL SIGNAC
French, 1863–1935
Les démolisseurs (The Wreckers), 1896
Published in *Les Temps Nouveaux*,
October 1, 1896
Crayon lithograph, Kornfeld and Wick
15 iv/iv (b)
47 × 30.5 cm (18½ × 12 in.)
Gift of the Goldyne Family, 1983.1.151
[Fig. 45]

STOP (PSEUDONYM OF LOUIS PIERRE
GABRIEL MOREL-RETZ)
French, 1825–1899
Selection of views from *Le Salon de 1874*

Published in *Le Journal Amusant*, 1874
Gillotages
Each approx. 44 × 62 cm (17⅜ × 24½ in.)
(sheet)
Achenbach Foundation for Graphic Arts,
1963.30.18878, 18895, 18899, 18906
[Fig. 42]

IMPRESSIONISTS IN
BLACK AND WHITE

FÉLIX BRACQUEMOND
French, 1833–1914
Edmond de Goncourt, 1882
Etching, Beraldi 54 v/viii
50.6 × 33.7 cm (19¹⁵⁄₁₆ × 13¼ in.)
Museum purchase, Achenbach Foundation
for Graphic Arts Endowment Fund, 1997.34
[Fig. 51]

MARY CASSATT
American, 1844–1926
Bill Lying on His Mother's Lap, ca. 1889
Soft-ground etching and aquatint printed in
dark brown ink, Breeskin 101 iii/v
18 × 13.8 cm (7¹⁄₁₆ × 5⁷⁄₁₆ in.)
California State Library long loan, L43.1966

Nurse and Baby Bill, No. 2, ca. 1889–1890
Soft-ground etching and aquatint printed in
dark brown ink, Breeskin 109 ii/ii
21.6 × 13.8 cm (8½ × 5⁷⁄₁₆ in.)
Museum purchase, Achenbach Foundation for
Graphic Arts Endowment Fund, 1965.68.21
[Fig. 56]

EDGAR DEGAS
French, 1834–1917
*Derniers préparatifs de toilette (Final Touches in
the Toilette)*, ca. 1877–1880
Monotype with black ink additions on China
paper, Janis 45
16 × 21.5 cm (6⁵⁄₁₆ × 8⁷⁄₁₆ in.)
Museum purchase, Achenbach Foundation for
Graphic Arts Endowment Fund, 1964.142.15
[Fig. 57]

*Au Louvre, la peinture Mary Cassatt (Mary
Cassatt at the Louvre: The Etruscan Gallery)*,
1879–1880
Aquatint, drypoint, soft-ground etching, and
etching with burnishing, Reed and Shapiro
51 ix/ix
26.8 × 23.6 cm (10⁹⁄₁₆ × 9⁵⁄₁₆ in.)

Museum purchase, Achenbach Foundation
for Graphic Arts Endowment Fund, 1971.29.3
[Fig. 54]

MARCELLIN DESBOUTIN
French, 1823–1902
*L'homme à la pipe (Man with a Pipe: Self-
Portrait)*, ca. 1879
Drypoint with burnishing and traces of
roulette, Beraldi 1
45.6 × 38.2 cm (17¹⁵⁄₁₆ × 15¹⁄₁₆ in.)
Gift of André J. Kahn-Wolf, 1962.75.3

JEAN-LOUIS FORAIN
French, 1852–1931
L'ambulante (The Strolling Woman), 1880
Etching, Guérin 18
14.9 × 9.8 cm (5⅞ × 3⅞ in.)
Achenbach Foundation for Graphic Arts,
1963.30.30181

Les Folies-Bergère, 1880
Etching, Guérin 17
9.5 × 14.5 cm (3¾ × 5¹¹⁄₁₆ in.)
Achenbach Foundation for Graphic Arts,
1963.30.30195

PAUL GAUGUIN
French, 1848–1903
*L'arlésienne, Mme. Ginoux (The Woman from
Arles, Madame Ginoux)*, 1888
Colored chalks and charcoal with white chalk
56.1 × 49.2 cm (22¹⁄₁₆ × 19⅜ in.)
Memorial gift from Dr. T. Edward and Tullah
Hanley, Bradford, Pennsylvania, 69.30.78
[Fig. 53]

Stéphane Mallarmé, 1891
Etching with aquatint, open-bite, and drypoint
printed in dark brown-black ink, with plate
tone, Joachim et al. 12 ii/iv
18.2 × 14.4 cm (7³⁄₁₆ × 5¹¹⁄₁₆ in.)
Museum purchase, Prints and Drawings Art
Trust Fund, 2009.33
[Fig. 52]

CLAUDE MONET
French, 1840–1926
*The Coast of Normandy Viewed from Sainte-
Adresse*, ca. 1864
Black chalk, Wildenstein 419
17.5 × 30.8 cm (6⅞ × 12⅛ in.)
Memorial gift from Dr. T. Edward and Tullah
Hanley, Bradford, Pennsylvania, 69.30.141
[Fig. 59]

BERTHE MORISOT
French, 1841–1895
Jeune femme au repos (*Young Woman Resting*), 1889
Drypoint, Bailly-Herzberg 7 i/ii
8.1 × 11.9 cm (3³⁄₁₆ × 4¹¹⁄₁₆ in.)
Achenbach Foundation for Graphic Arts, 1963.30.1509

CAMILLE PISSARRO
French, 1830–1903
La masure (*The Old Cottage*), 1879
Etching and aquatint with scraping and burnishing, Delteil 20 iv/vii
16.6 × 17.2 cm (6⁹⁄₁₆ × 6¾ in.)
Museum purchase, Achenbach Foundation for Graphic Arts Endowment Fund, 1966.80.44
[Fig. 55]

Femme dans un potager (*Woman in a Kitchen Garden*), ca. 1880
Etching and aquatint printed in dark brown ink, Delteil 30 ii/ii
24.7 × 16.9 cm (9¾ × 6⅝ in.)
Museum purchase, Achenbach Foundation for Graphic Arts Endowment Fund, 1964.142.20

Paysannes nues dans l'herbe (*Nude Peasants in the Grass*), ca. 1894–1895
Monotype, Shapiro and Melot 8
12.6 × 17.7 cm (4¹⁵⁄₁₆ × 6¹⁵⁄₁₆ in.)
Museum purchase, Achenbach Foundation for Graphic Arts Endowment Fund, 1967.22.5
[Fig. 58]

ODILON REDON
French, 1840–1916
Profil de lumière (*Profile of Light*), 1886
Lithograph on China paper, Mellerio 61
34 × 24.2 cm (13⅜ × 9½ in.)
Gift of Mrs. Philip N. Lilienthal, Jr., 1967.23.2

PIERRE-AUGUSTE RENOIR
French, 1841–1919
Les deux baigneuses (*The Two Bathers*), from the album *L'estampe originale*, album IX, 1895
Etching, Delteil 9
26.2 × 24.1 cm (10⅝ × 9½ in.)
Bruno and Sadie Adriani Collection, 1957.93

GEORGES SEURAT
French, 1859–1891
Study for *La parade de cirque* (*The Circus Parade*), 1886–1887

Conté crayon, Hauke 675
23.3 × 30.8 cm (9³⁄₁₆ × 12⅛ in.)
Museum purchase, Archer M. Huntington Fund, 1947.1
[Fig. 60]

ARTIST ALLIANCES

PIERRE BONNARD
French, 1867–1947
Scène de famille (*Family Scene*), 1893
Color lithograph with watercolor, Roger-Marx 4
31.5 × 18 cm (12⅜ × 7¹⁄₁₆ in.)
Museum purchase, Prints and Drawings Artist Trust Fund and Achenbach Foundation for Graphic Arts Endowment Fund, 2009.34

FÉLIX HILAIRE BUHOT
French, 1847–1898
Frontispiece for *L'illustration nouvelle*, 1877
Etching and aquatint, Bourcard 124 v/v
34.5 × 27.4 cm (13⁹⁄₁₆ × 10¹³⁄₁₆ in.)
*Collection of Jack and Margrit Vanderryn
[Fig. 63]

PAUL CÉZANNE
French, 1839–1906
Baigneurs (*The Small Bathers*), 1896–1897, from *L'album d'estampes originales de la Galerie Vollard*, 1897
Color lithograph on China paper, Venturi 1159
22.9 × 29 cm (9 × 11⁷⁄₁₆ in.)
Bruno and Sadie Adriani Collection, 1971.28.92
[Fig. 68]

HENRI-JACQUES-EDOUARD EVENEPOEL
Belgian, 1872–1899
Au square (*At the Square*), from the album *L'estampe moderne*, no. 1, May 1897
Color lithograph with crayon, brush, and spatter, IFF vol. 7, p. 386
33.2 × 23.2 cm (13¹⁄₁₆ × 9⅛ in.)
Gift of Edward Tyler Nahem, 2003.151.12
[Fig. 70]

PAUL GAUGUIN
French, 1848–1903
La femme aux figues (*Woman with Figs*), 1894, no. 5 of the album *Germinal*, 1899
Etching, open-bite, and soft-ground etching, Joachim et al. 25 i(c)/iii

27 × 44.5 cm (10⅝ × 17½ in.)
Gift of Dr. William McPherson Fitzhugh, Jr., Pebble Beach, 1962.57.17
[Fig. 71]

LOUIS AUGUSTE GIRARDOT
French, 1856–1933
Femme du riff (*Woman on the Front*), from the album *L'estampe moderne*, no. 1, May 1897
Color lithograph, IFF 3
32 × 23.2 cm (12⅝ × 9⅛ in.)
Gift of Ronald E. Bornstein, 1986.1.283

HENRI GABRIEL IBELS
French, 1867–1936
Au cirque (*At the Circus*), from the album *L'estampe originale*, album I, 1893
Color lithograph with crayon, brush, and spatter, IFF 9
49.5 × 26.5 cm (19½ × 10⁷⁄₁₆ in.)
Achenbach Foundation for Graphic Arts, A036953
[Fig. 65]

JULES FERDINAND JACQUEMART
French, 1837–1880
Le réveil de l'eau-forte (*The Awakening of Etching*), 1862–1863
Etching and drypoint, Gonse 331
38.5 × 25.8 cm (15³⁄₁₆ × 10³⁄₁₆ in.)
*Private collection
[Fig. 62]

EDOUARD MANET
French, 1832–1883
Fleur exotique (*Exotic Flower*), 1868, in the book *Sonnets et eaux-fortes* (*Sonnets and Etchings*), ed. Philippe Burty (Paris: Alphonse Lemerre, 1869)
Etching and aquatint, Harris 57 ii/ii
17.4 × 11.5 cm (6⅞ × 4½ in.)
Museum purchase, William H. Noble Bequest Fund, 1979.1.12.35
[Fig. 64]

ADOLPHE MARTIAL POTÉMONT
French, 1828–1883
Siège de la Société des Aqua-fortistes (*Headquarters of the Etching Society*), 1867
Etching, Beraldi 2
28.8 × 39 cm (11⁵⁄₁₆ × 15⅜ in.)
Museum purchase, Achenbach Foundation for Graphic Arts Endowment Fund, 1970.25.40
[Fig. 61]

ALPHONSE MUCHA
Czech, 1860–1939
Cover of the album *L'estampe moderne*,
no. 1, May 1897
Relief halftone and letterpress, Bridges R10a
41.2 × 31.4 cm (16¼ × 12⅜ in.)
Gift of Ronald E. Bornstein, 1986.1.282
[Fig. 69]

JEAN-FRANÇOIS RAFFAËLLI
French, 1850–1924
Raffaëlli, par lui-même (Self-Portrait), from the
album *L'estampe originale*, album II, 1893
Color drypoint, Delteil 7 ii/ii
18.7 × 15.8 cm (7⅜ × 6¼ in.)
Achenbach Foundation for Graphic Arts,
1963.30.1511
[Fig. 66]

RICHARD RANFT
Swiss, 1862–1931
Trottins (Errand Girls), from the album
L'estampe originale, album VIII, 1894
Etching printed in reddish brown ink
39.9 × 25.9 cm (15¹¹⁄₁₆ × 10³⁄₁₆ in.)
Museum purchase, Achenbach Foundation for
Graphic Arts Endowment Fund, 1969.32.69

ODILON REDON
French, 1840–1916
Béatrice, from *L'album d'estampes originales de
la Galerie Vollard*, 1897
Color lithograph on chine collé, Mellerio 168
33.3 × 29.1 cm (13⅛ × 11⁷⁄₁₆ in.)
Museum purchase, Achenbach Foundation for
Graphic Arts Endowment Fund, 1971.29.2
[Fig. 67]

ALFRED SISLEY
French, 1839–1899
*Bords de rivière, ou Les oies (Riverbank, or
The Geese)*, from *L'album d'estampes originales
de la Galerie Vollard*, 1897
Color lithograph, Delteil 6
21.5 × 32.2 cm (8⁷⁄₁₆ × 12¹¹⁄₁₆ in.)
Gift of Dr. William McPherson Fitzhugh, Jr.,
Pebble Beach, A045662

EDOUARD VUILLARD
French, 1868–1940
*Le jardin devant l'atelier (Garden outside the
Studio)*, no. 11 of the album *Germinal*, 1899
Color lithograph on China paper, Roger-
Marx 45

63.5 × 48.5 cm (25 × 19⅛ in.)
Achenbach Foundation for Graphic Arts,
1963.30.418

SPECTACLES AND SPECTATORS

HONORÉ DAUMIER
French, 1808–1879
*L'orchestre pendant qu'on joue une tragédie
(The Orchestra during the Performance of a
Tragedy)*, no. 17 of the series *Croquis musicaux
(Musical Sketches)*, 1852
Crayon lithograph, Noack 2243
26.1 × 21.6 cm (10¼ × 8½ in.)
Bruno and Sadie Adriani Collection, 1956.300
[Fig. 74]

*Une loge au théâtre Ventadour pendant la
représentation d'une tragédie italienne (A Box in
the Ventadour Theater during the Portrayal of an
Italian Tragedy)*, no. 312 of the series *Actualités
(Current Events)*, 1856
Crayon lithograph, Noack 2764 ii/ii
18.8 × 23.7 cm (7⅜ × 9⁵⁄₁₆ in.)
Bruno and Sadie Adriani Collection, 1956.307

EDGAR DEGAS
French, 1834–1917
*L'orchestre de l'Opéra (Musicians in the
Orchestra [Portrait of Désiré Dihau])*, ca. 1870
Oil on canvas, Lemoisne 187
48.9 × 59.7 cm (19¼ × 23½ in.)
Museum purchase, Mildred Anna Williams
Collection, 1952.69
[Fig. 75]

Sur la scène (On Stage III), 1876–1877
Soft-ground etching, drypoint, and roulette,
Reed and Shapiro 24 v/v
9.9 × 12.7 cm (3⅞ × 5 in.)
Museum purchase, Achenbach Foundation for
Graphic Arts Endowment Fund, 1964.142.14

*Danseuses dans la coulisse (Dancers in the
Wings)*, 1879–1880
Etching, aquatint, and drypoint, Reed and
Shapiro 47 viii/viii
14 × 10.3 cm (5½ × 4¹⁄₁₆ in.)
Museum purchase, Achenbach Foundation for
Graphic Arts Endowment Fund, 1963.30.645
[Fig. 77]

JEAN-LOUIS FORAIN
French, 1852–1931
Foyer of the Opéra, ca. 1880–1890

Oil on canvas
61 × 80 cm (24 × 31½ in.)
*Collection of Diane B. Wilsey
[Fig. 72]

ALFRED JARRY
French, 1873–1907
Announcement for the premiere of *Ubu Roi* by
Alfred Jarry at the Théâtre de l'Oeuvre, 1896
Lithograph on pink paper
25 × 32.8 cm (9¹³⁄₁₆ × 12¹⁵⁄₁₆ in.)
Bequest of John Gutmann, 2000.119.3.123

JEAN-EMILE LABOUREUR
French, 1877–1943
Le Bal Bullier, 1898
Woodcut, Laboureur 579
22.2 × 28.8 cm (8¾ × 11⁵⁄₁₆ in.)
*Collection of Ronald E. Bornstein
[Fig. 83]

JEAN-FRANÇOIS RAFFAËLLI
French, 1850–1924
La Scala and *Spectateurs*, from *Les cafés-
concerts*, 1886
Published in *Paris Illustré*, 1886
Gillotage printed in black and orange-red ink,
not in Delteil
35.5 × 23.4 cm (14 × 9³⁄₁₆ in.) and 33 × 24 cm
(13 × 9⁷⁄₁₆ in.)
Achenbach Foundation for Graphic Arts,
A049759

PIERRE-AUGUSTE RENOIR
French, 1841–1919
La loge (The Theater Box), 1874
Oil on canvas, Daulte 115
27.3 × 21.9 cm (10¾ × 8⅝ in.)
*Collection of Diane B. Wilsey
[Fig. 73]

CHARLES PAUL RENOUARD
French, 1845–1924
*Batterie de l'orchestre (Percussion Section of the
Orchestra)*, plate 12 of the album *Le nouvel
Opéra (The New Opéra)*, 1881
Etching and aquatint, Beraldi vol. 11, p. 189
30.8 × 24.7 cm (12⅛ × 9¾ in.)
Achenbach Foundation for Graphic Arts,
1963.30.2731.13
[Fig. 76]

Loge de Mr. le Directeur (The Director's Box),
from the album *Le nouvel Opéra (The New
Opéra)*, 1881

Etching and aquatint, Beraldi vol. 11, p. 189
27.7 × 32.5 cm (10⅞ × 12¹³⁄₁₆ in.)
Achenbach Foundation for Graphic Arts,
1963.30.2731.29

PAUL SIGNAC
French, 1863–1935
*Application du cercle chromatique de Mr. Ch.
Henry (Application of Charles Henry's
Chromatic Circle)*, 1888
Color lithograph, Kornfeld and Wick 4
15.5 × 17.8 cm (6⅛ × 7 in.)
Museum purchase, Achenbach Foundation for
Graphic Arts Endowment Fund, 1977.1.329
[Fig. 79]

JAMES TISSOT
French, 1836–1902
Ces dames des chars (Ladies of the Chariots), 1885
Etching and drypoint, Wentworth 78
40 × 25.4 cm (15¾ × 10 in.)
Museum purchase, Achenbach Foundation for
Graphic Arts Endowment Fund, 1982.1.18
[Fig. 82]

HENRI DE TOULOUSE-LAUTREC
French, 1864–1901
*La loge au mascaron doré (Box with the Gilded
Mask)*, 1893
Color lithograph with crayon, brush, spatter,
and scraper, Wittrock and Kuehn 16
37.2 × 28.3 cm (14⅝ × 11⅛ in.)
Bruno and Sadie Adriani Collection, 1971.28.3

Theater program for Fabre's *L'argent
(Money)*, 1895
Color lithograph with brush, crayon, and
spatter, Wittrock and Kuehn 97
31.8 × 23.6 cm (12½ × 9⁵⁄₁₆ in.)
Gift of George Hopper Fitch, 1984.1.139
[Fig. 80]

*La clownesse assise (Mademoiselle Cha-U-Kao)
(The Seated Clown [Mademoiselle Cha-U-Kao])*,
from the series *Elles*, 1896
Color lithograph with crayon, brush, spatter,
and scraper, Wittrock and Kuehn 156
52.7 × 40.5 cm (20¾ × 15¹⁵⁄₁₆ in.)
Bruno and Sadie Adriani Collection,
1971.28.25

*Au cirque: Cheval pointant (At the Circus:
Rearing Horse)*, 1899
Black chalk with orange and yellow
pencil additions

35.7 × 25.4 cm (14¹⁄₁₆ × 10 in.)
Museum purchase, Elizabeth Ebert and
Arthur W. Barney Fund, 1977.2.5
[Fig. 81]

*Au cirque: Ecuyère de haute école—Le salut
(At the Circus: Horsewoman, Classical
Dressage—The Bow)*, 1899
Black chalk
35.7 × 25.4 cm (14¹⁄₁₆ × 10 in.)
Memorial gift from Dr. T. Edward and Tullah
Hanley, Bradford, Pennsylvania, 69.30.118

EDOUARD VUILLARD
French, 1868–1940
*Scène du théâtre ibsénien (Scene from a Play by
Ibsen)*, 1893
Pastel, Salomon and Cogeval III-38
30 × 25 cm (11¹³⁄₁₆ × 9¹³⁄₁₆ in.)
*Collection of Marie and George Hecksher
[Fig. 78]

Theater program for Ibsen's *Rosmersholm*, 1893
Crayon lithograph on tan paper, Roger-
Marx 16
21 × 31 cm (8¼ × 12³⁄₁₆ in.)
Gift of Edward Tyler Nahem, 2003.151.72

1889: A TOWERING
ACHIEVEMENT

PIERRE DUBREUIL
French, 1872–1944
Eléphantaisie, 1908
Gelatin silver print
24.7 × 19.5 cm (9¾ × 7¹⁄₁₆ in.)
Museum purchase, Prints and Drawings Art
Trust Fund, 2009.29
[Fig. 92]

AUGUSTE LOUIS LEPÈRE
French, 1849–1918
*La Tour Eiffel, fête de nuit (The Eiffel Tower,
Night Celebration)*, 1889
Wood engraving, Lotz-Brissonneau 193
24.6 × 16.1 cm (9¹¹⁄₁₆ × 6⁵⁄₁₆ in.)
*Collection of Ronald E. Bornstein
[Fig. 88]

GABRIEL LOPPÉ
French, 1825–1913
*Vue de la Tour Eiffel et de la Grande Roue
(View of the Eiffel Tower and the Great Wheel)*,
ca. 1900

Gelatin silver print
13 × 17.8 cm (5⅛ × 7 in.)
Museum purchase, Achenbach Foundation for
Graphic Arts Endowment Fund, 1996.106.1
[Fig. 89]

HENRI RIVIÈRE
French, 1864–1951
*La Tour en construction, vue de Trocadéro (The
Tower under Construction, As Seen from the
Trocadéro)*, plate 3 of the book *Les trente-six
vues de la Tour Eiffel (Thirty-six Views of the
Eiffel Tower)* (Paris: Eugène Verneau, 1902)
Color lithograph
17 × 21.1 cm (6¹¹⁄₁₆ × 8⁵⁄₁₆ in.)
Museum purchase, Achenbach Foundation for
Graphic Arts Endowment Fund, 1983.1.2.3
[Fig. 87]

En haut de la Tour (At the Top of the Tower),
plate 4 of the book *Les trente-six vues de la
Tour Eiffel (Thirty-six Views of the Eiffel Tower)*
(Paris: Eugène Verneau, 1902)
Color lithograph
17 × 21.1 cm (6¹¹⁄₁₆ × 8⁵⁄₁₆ in.)
Museum purchase, Achenbach Foundation for
Graphic Arts Endowment Fund, 1983.1.2.4
[Fig. 86]

*Du boulevard de Clichy (From the Boulevard de
Clichy)*, plate 10 of the book *Les trente-six vues
de la Tour Eiffel (Thirty-six Views of the Eiffel
Tower)* (Paris: Eugène Verneau, 1902)
Color lithograph
17 × 21.1 cm (6¹¹⁄₁₆ × 8⁵⁄₁₆ in.)
Museum purchase, Achenbach Foundation for
Graphic Arts Endowment Fund, 1983.1.2.10

Sur les toits (On the Rooftops), plate 21 of the
book *Les trente-six vues de la Tour Eiffel
(Thirty-six Views of the Eiffel Tower)* (Paris:
Eugène Verneau, 1902)
Color lithograph
17 × 21.1 cm (6¹¹⁄₁₆ × 8⁵⁄₁₆ in.)
Museum purchase, Achenbach Foundation for
Graphic Arts Endowment Fund, 1983.1.2.21

*Derrière l'élan de Frémiet (Trocadéro) (From
Behind Fremiet's Elk [Trocadéro])*, plate 27 of
the book *Les trente-six vues de la Tour Eiffel
(Thirty-six Views of the Eiffel Tower)* (Paris:
Eugène Verneau, 1902)
Color lithograph
21.1 × 17 cm (8⁵⁄₁₆ × 6¹¹⁄₁₆ in.)

Museum purchase, Achenbach Foundation for Graphic Arts Endowment Fund, 1983.1.2.27
[Fig. 93]

GEORGES SEURAT
French, 1859–1891
Eiffel Tower, ca. 1889
Oil on panel, Hauke 196
24.1 × 15.2 cm (9½ × 6 in.)
Museum purchase, William H. Noble Bequest Fund, 1979.48
[Fig. 85]

FÉLIX VALLOTTON
Swiss, active in France, 1865–1925
Cinq heures (Five O'clock), from the series *L'Exposition Universelle (World's Fair)*, 1901
Woodcut, Vallotton et al. 206a
16.5 × 12.2 cm (6½ × 4¹³⁄₁₆ in.)
Achenbach Foundation for Graphic Arts, 1963.30.423

Feu d'artifice (Fireworks), from the series *L'Exposition Universelle (World's Fair)*, 1901
Woodcut, Vallotton et al. 208a
16.4 × 12.2 cm (6⁷⁄₁₆ × 4¹³⁄₁₆ in.)
Achenbach Foundation for Graphic Arts, 1963.30.425
[Fig. 84]

Le trottoir roulant (The Moving Sidewalk), from the series *L'Exposition Universelle (World's Fair)*, 1901
Woodcut, Vallotton et al. 203a
12.2 × 15.8 cm (4¹³⁄₁₆ × 6¼ in.)
Achenbach Foundation for Graphic Arts, 1963.30.420
[Fig. 90]

CITY OF COLOR AND LIGHT

PIERRE BONNARD
French, 1867–1947
La Revue Blanche, 1894
Color lithograph, Roger-Marx 32
740 × 575 mm (29⅛ × 22⅝ in.)
Anonymous gift, 1982.1.5
[Fig. 95]

EUGÈNE CARRIÈRE
French, 1849–1906
Le fondeur (Steelworker), 1900
Color lithograph with brush and scraping, Delteil 41

108.5 × 79.5 cm (42¹¹⁄₁₆ × 31⁵⁄₁₆ in.)
Museum purchase, Achenbach Foundation for Graphic Arts Endowment Fund, 2006.109.1

JULES CHÉRET
French, 1836–1932
Quinquina Dubonnet, 1896
Color lithograph with pen, crayon, and spatter, Broido 881
52.6 × 34.5 cm (20¹¹⁄₁₆ × 13⁹⁄₁₆ in.)
Gift of Mr. and Mrs. David M. Houston, 1980.1.55
[Fig. 94]

Musée Grévin: Fantoches de John Hewelt (Musée Grévin: John Hewelt's Puppet Theater), 1900
Color lithograph, Broido 471 state before letters
42.2 × 33.2 cm (16⅝ × 13¹⁄₁₆ in.)
Gift of Joseph M. Bransten, 1979.1.72

MAXIME DETHOMAS
French, 1867–1929
Montmartre par G. Renault et H. Château (Montmartre by G. Renault and H. Château), ca. 1897
Color lithograph with brush and spatter, IFF 4
78.5 × 58.5 cm (30⅞ × 23¹⁄₁₆ in.)
Gift of Mr. and Mrs. David M. Houston, 1980.1.51
[Fig. 100]

GEORGES FAY
French, d. 1916
Le quartier cabaret-salon, 1897
Color lithograph, state before letters
106 × 76 cm (41¾ × 29¹⁵⁄₁₆ in.)
Gift of Mr. and Mrs. David M. Houston, 1980.1.49

JULES-ALEXANDRE GRUN
French, 1868–1934
Loïe Fuller, 1901
Color lithograph, IFF 15
160 × 110.5 cm (63 × 43½ in.)
Gift of George Hopper Fitch, 1973.14

ALPHONSE MUCHA
Czech, 1860–1939
JOB, ca. 1898
Color lithograph, Bridges A36
138.5 × 92.5 cm (54½ × 36⁷⁄₁₆ in.)

Museum purchase, Achenbach Foundation for Graphic Arts Endowment Fund, 1978.1.23
[Fig. 101]

MANUEL ORAZI
Italian, active in France, 1860–1934
Théâtre de Loïe Fuller, 1900
Color lithograph, Malhotra 675
201.5 × 64 cm (79⁵⁄₁₆ × 25³⁄₁₆ in.)
Gift of the Bay Area Graphic Arts Council, 1973.13
[Fig. 91]

THÉOPHILE ALEXANDRE STEINLEN
Swiss, 1859–1923
Motocycles Comiot, 1899
Color lithograph with crayon and brush printed on two joined sheets, de Crauzat 505
200 × 140 cm (78¾ × 55⅛ in.)
Gift of Mr. and Mrs. David M. Houston, 1980.1.56
[Fig. 102]

HENRI DE TOULOUSE-LAUTREC
French, 1864–1901
Aristide Bruant, 1893
Lithograph with crayon, brush, and spatter, and opaque watercolor additions, Wittrock and Kuehn P10B
80.1 × 56.5 cm (31⁹⁄₁₆ × 22¼ in.)
Anonymous gift, 1984.1.175
[Fig. 97]

Divan japonais, 1893
Color lithograph with crayon, brush, spatter, and transferred screen, Wittrock and Kuehn P11
79.5 × 60 cm (31⁵⁄₁₆ × 23⅝ in.)
Bruno and Sadie Adriani Collection, 1958.88

Confetti, 1894
Color lithograph with brush, spatter, and crayon, Wittrock and Kuehn P13
56.4 × 38.7 cm (22³⁄₁₆ × 15¼ in.)
Bruno and Sadie Adriani Collection, 1958.87

May Belfort, 1895
Color lithograph with brush, spatter, and crayon, Wittrock and Kuehn P14A
81 × 62 cm (31⅞ × 24⁷⁄₁₆ in.)
Bruno and Sadie Adriani Collection, 1958.86

L'Artisan Moderne (The Modern Artisan), 1896
Color lithograph with crayon, brush, and spatter, Wittrock and Kuehn P24A

90 × 64 cm (35⁷⁄₁₆ × 25³⁄₁₆ in.)
Achenbach Foundation for Graphic Arts,
1963.30.110
[Fig. 99]

*La passagère du 54—Promenade en yacht (The
Passenger from Cabin 54—On a Cruise)*, 1896
Color lithograph with brush, crayon, and
spatter, Wittrock and Kuehn P20 iii/iii
60.5 × 40 cm (23¹³⁄₁₆ × 15¾ in.)
Bruno and Sadie Adriani Collection, 1968.11.2
[Fig. 96]

*Le photographe Sescau (The Photographer
Sescau)*, 1896
Color lithograph with brush, crayon, and
spatter, Wittrock and Kuehn P22B
61 × 80 cm (24 × 31½ in.)
Achenbach Foundation for Graphic Arts,
1963.30.111
[Fig. 98]

CATALOGUES RAISONNÉS CITED

Bailly-Herzberg, Janine. "Les estampes de
Berthe Morisot." *Gazette des Beaux-Arts*,
6th ser. 93 (May–June 1979): 215–227.

Beraldi, Henri. *Les graveurs du XIXe siècle,
guide de l'amateur d'estampes modernes*, vols.
1–12. Paris: Librairie L. Conquet, 1885–1892.

Bouillon, Jean-Paul. *Félix Bracquemond:
Le réalisme absolu, Oeuvre gravé 1849–1859
catalogue raisonné*. Geneva: Editions d'Art
Albert Skira S.A., 1987.

Bourcard, Gustave. *Félix Buhot . . . catalogue
descriptif de son oeuvre gravé*. Paris:
H. Floury, 1899.

Breeskin, Adelyn D. *The Graphic Work of
Mary Cassatt: A Catalogue Raisonné*, 1st ed.
New York: H. Bittner and Co., 1948.

Bridges, Ann, et al. *Alphonse Mucha: The
Complete Graphic Works*, 2nd ed. New York:
Harmony Books, 1980.

Broido, Lucy. *The Posters of Jules Chéret*. New
York: Dover Publications, 1980.

Crauzat, A. de. *Steinlen, peintre-graveur et
lithographe*. N.p.: Société de propagation des
livres d'art, 1902.

Daulte, François. *Auguste Renoir: catalogue
raisonné de l'oeuvre peint*. Lausanne:
Durand-Ruel, 1971.

Delteil, Loys. *Le peintre-graveur illustré*. Paris:
Loys Delteil, 1906–1926.

Gonse, Louis. *L'oeuvre de Jules Jacquemart*.
Paris: Gazette des Beaux-Arts, 1876.

Guérin, Marcel. *J.-L. Forain aquafortiste: Cata-
logue raisonné de l'oeuvre gravé de l'artiste*.
Paris: H. Floury, 1912.

Harris, Jean C. *Edouard Manet, Graphic
Works: A Definitive Catalogue Raisonné*.
New York: Collector's Editions, 1970.

Hauke, César M. de. *Seurat et son oeuvre*.
2 vols. Paris: Gründ, 1961.

Inventaire du fonds français après 1800. Paris:
Bibliothèque nationale, 1930–ongoing.

Janis, Eugenia Parry, comp. *Degas Monotypes:
Essay, Catalogue, and Checklist*. Cambridge,
Mass.: Fogg Art Museum, 1968.

Joachim, Harold, Elizabeth Mongan,
Eberhard W. Kornfeld, and Christine E.
Stauffer. *Paul Gauguin: Catalogue Raisonné
of His Prints*. Bern: Galerie Kornfeld, 1988.

Kennedy, Edward Guthrie. *The Etched Work
of Whistler, Illustrated by Reproductions in
Collotype of the Different States of the Plates*.
New York: Grolier Club, 1910.

Kornfeld, Eberhard W., and Peter A. Wick.
*Catalogue raisonné de l'oeuvre gravé et litho-
graphié de Paul Signac*. Berne: Kornfeld and
Klipstein, 1974.

Laboureur, Sylvain. *Catalogue complet de
l'oeuvre de Jean-Emile Laboureur*. Neuchâtel:
Ides et Calendes, 1989.

Lemoisne, Paul-André. *Degas et son oeuvre*.
4 vols. Paris: P. Brame et C. M. de Hauke,
aux Arts et métiers graphiques, 1946–1949.

Lotz-Brissonneau, A. *Catalogue raisonné de
l'oeuvre gravé d'Auguste Lepère, 1849–1918*.
Dijon: L'Echelle de Jacob; Paris: Antoine
Laurentin, 2002.

Malhotra, R., et al., eds. *Das frühe Plakat
in Europa und den USA*, vol. 2, *Frankreich
und Belgien*. Berlin: Gebr. Mann Verlag,
1977.

Mellerio, André. *Odilon Redon, peintre, des-
sinateur et graveur*. Paris: Henri Floury, 1923.

Noack, Dieter, and Lilian Noack. Daumier
Register. www.daumier.org.

Reed, Sue Welsh, and Barbara Stern Shapiro.
Edgar Degas, the Painter as Printmaker.
Boston: Museum of Fine Arts, 1984.

Roger-Marx, Claude. *Bonnard lithographe*.
Monte Carlo, Monaco: André Sauret, 1952.
———. *L'oeuvre gravé de Vuillard*. Monte
Carlo, Monaco: André Sauret, 1948.

Salomon, Antoine, and Guy Cogeval. *Vuillard,
the Inexhaustible Glance: Critical Catalogue
of Paintings and Pastels*. Milan: Skira, 2003.

Schneiderman, Richard S., and Frank W.
Raysor II. *The Catalogue Raisonné of the
Prints of Charles Meryon*. London: Garton
& Co.; London: Scolar Press, 1990.

Shapiro, Barbara Stern, and Michel Melot.
"Catalogue sommaire des monotypes de
C. Pissarro." *Nouvelles de l'Estampe* 6, no. 16
(January–February 1975): 16–23.

Stein, Adolphe, and Johan Barthold Jongkind.
Jongkind: Catalogue critique de l'oeuvre.
Paris: Brame & Lorenceau, 2003.

Thorson, Victoria. *Rodin Graphics: A Cata-
logue Raisonné of Drypoints and Book Illus-
trations*. San Francisco: Fine Arts Museums
of San Francisco, 1975.

Vallotton, Félix, Maxime Vallotton, and
Charles Goerg. *Félix Vallotton: Catalogue
raisonné de l'oeuvre gravé et lithographié /
Catalogue Raisonné of the Printed Graphic
Work*. Geneva: Editions de Bonvent,
1972.

Venturi, Lionello. *Cézanne, son art—son
oeuvre*. Paris: Paul Rosenberg éditeur, 1936.

Villet, Jeffrey M. *Etchings of Maxime Lalanne:
A Catalogue Raisonné*, 2nd ed. rev. and
expanded. Washington, D.C.: Jeff Villet,
2006.

Wentworth, Michael. *James Tissot: Catalogue
Raisonné of His Prints*. Minneapolis:
Minneapolis Institute of Arts, 1978.

Wildenstein, Daniel, and Claude Monet.
*Claude Monet: Biographie et catalogue
raisonné*. Lausanne: La Bibliothèque des
Arts, 1974.

Wittrock, Wolfgang, and Catherine E.
Kuehn, eds. *Toulouse-Lautrec: The Complete
Prints*. London: For Sotheby's Publica-
tions by P. Wilson Publishers; New York:
Harper & Row, 1985.

The following index includes personages and artworks discussed or reproduced in the main chapters of this publication. Additional artists and works may be found in the catalogue of the exhibition on pages 135–146. Page numbers in **bold** refer to illustrations.